THE BLING RING

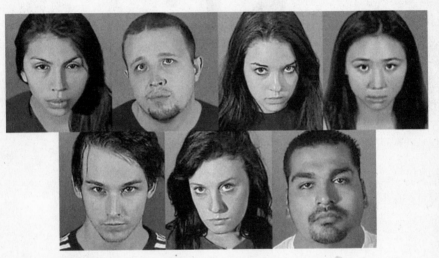

Clockwise, from top left: Diana Tamayo, Jonathan Ajar, Alexis Neiers, Rachel Lee, Roy Lopez, Courtney Ames, and Nick Prugo.

THE BLING RING

How a Gang of Fame-Obsessed Teens Ripped
Off Hollywood and Shocked the World

NANCY JO SALES

itbooks

AN IMPRINT OF HARPERCOLLINS PUBLISHERS

HarperCollins books may be purchased for educational, business, or sales promotional use. For information please e-mail the Special Markets Department at SPsales@harpercollins.com.

FIRST EDITION

Designed by Ruth Lee–Mui

Library of Congress Cataloging-in-Publication Data available upon request.

ISBN 978-0-06-224553-3

13 14 15 16 17 DIX/RRD 10 9 8 7 6 5 4 3 2

For Zazie

CONTENTS

PREFACE

In the spring of 2010 I got a message from someone in Sofia Coppola's office saying that Sofia was interested in optioning my *Vanity Fair* story, "The Suspects Wear Louboutins," which had just run in that year's Hollywood Issue. I was thrilled, but also wondered what in this story could possibly appeal to Sofia Coppola. It was about a teenage burglary ring that had targeted the homes of Young Hollywood between 2008 and 2009. The burglars, most of them recent high school graduates, had made off with nearly $3 million in designer clothing, jewelry, luggage and art from a collection of "stars" you wouldn't exactly expect to see in a Sofia Coppola movie—Paris Hilton, Lindsay Lohan, Audrina Patridge (one of the girls on the reality show *The Hills)*, to name a few. They were famous mainly for being famous, defined by a new kind of celebrity that was all about Facebooking and tweeting and the flashing of thongs. Or maybe the Instagramming of thongs.

It was also a story about kids from an affluent suburb in the Valley—another factor that seemed to make it an unlikely subject for Sofia. She made beautiful-looking movies about beautiful places—she'd shot much of *Marie Antoinette* (2006) at Versailles, the only person ever allowed to film there—and this was a story about a tackier world where the rich were brash and bloated on their wealth . . . But then, that sounded a lot like the Ancien Regime before the French Revolution. And maybe the one percent in America today.

But when I started re-watching some of Sofia's movies in anticipation of meeting her, I realized that the themes in the story

of the "Bling Ring"—the name given to the burglary ring by the *L.A. Times*—were some of the same themes she had been exploring in her films: the obsession with celebrity; the entitlement of rich kids; the emptiness of fame as an aspiration or a way of life. Her first feature, *The Virgin Suicides* (1999), based on the novel by Jeffrey Eugenides, was about a family of rich girls in Gross Pointe, Michigan, who unaccountably all kill themselves, thereby becoming "famous" in their neighborhood. Sofia's Marie Antoinette, played by Kirsten Dunst, was a spoiled teenager and a rock star in her own time (until, of course, she lost her head). *Lost In Translation*—for which Sofia won the Oscar for Best Original Screenplay in 2004—was a portrait of an action star (Bill Murray) drowning in a fishbowl of fame; and in *Somewhere* (2010), Stephen Dorff plays another famous actor living in the legendary Chateau Marmont hotel and finding his existence at the center of Hollywood lonely and meaningless. So, it seemed, the story of a gang of fame-obsessed teens that had robbed the homes of celebrities was to Sofia Coppola sort of like a good horror story was to Hitchcock.

It happened to be right up my alley too. When news of the Bling Ring burglaries first came out, a friend of mine joked that it was like a "Nancy Jo Sales story on speed." I suppose I knew what he meant. I'd been writing about the misadventures of rich kids since 1996, when I did a story for *New York* magazine my editor headlined "Prep School Gangsters." It chronicled the lives of private school students in New York as they acted out underworld fantasies based on gangsta rap and too many viewings of *Goodfellas*. It was entirely by accident that I got on this beat, which has led me to stories on clubkids and kid models and socialites and d.j.'s and rich kids in love. At the same time, I was doing celebrity profiles on some of the very people these fame-conscious kids wanted to be— Puffy and J-Lo and Tyra and Leo and Jay-Z and Angelina, as well as two of the Bling Ring's famous victims, Hilton and Lohan. (I did the first magazine story on Hilton, for *Vanity Fair*, in 2000.)

• • •

I met Sofia for the first time at café in Soho, the Manhattan neigh-borhood where she was then living with her husband, Thomas Mars, the front man for the alternative French rock band Phoenix, and their daughter, Romy, then 3. Sofia was pregnant at the time with her second child (Cosima, who would be born in May 2010), and putting the finishing touches on *Somewhere* in the editing room. It was a warm, bright day, and Sofia, in a light purple cotton dress, looked very lovely, with her slanting brown eyes and creamy skin. She was soft-spoken and calm and had a dreamy quality about her which somehow reminded me of the delicate touch of her films. We sat at a table at the back of the restaurant and had breakfast, coffee for me, tea for her. I asked her what had interested her in the Bling Ring story, which she said she had read on an airplane returning to New York from L.A.

"I thought, somebody should make a movie of this," she said, "and I thought probably someone already was. It never occurred to me that this was something that I would do. Then I kept going back to it—I think because it had in it all of these things that I'm worried about in our culture, or thinking about. I don't know if 'microcosm' is the right word, but somehow it distills all the cultural anxiety of right now. I feel like this story kind of sums it all up.

"To me it's the whole idea of the narcissism and the reality TV and the social media obsession of kids of this generation," she said, "and the entitlement—that they," the Bling Ring kids, "thought it was O.K. to just go into these homes and take whatever they wanted. I think all these themes are in this story and this was what I was connecting to without being aware of it at first. I think it's about what our culture is all about right now—it's just so different from when I was growing up. . . ."

Sofia grew up in the Napa Valley, where her father, *The God-father* (1972) director Francis Ford Coppola, moved her family from New York in the 70s. "I always knew that we got special

attention and the attention was all about him," she said, smiling, when I asked if she had realized as a child that her father was famous. "But we lived in Napa, which doesn't have a lot of showbiz people, so we were like 'the Hollywood people' there. I feel like that must have had some influence on why I'm always drawn to this step-world, this meta-world" of people living with some kind of fame.

She was raised in a household full of celebrities whom to her weren't celebrities—they were just her family. Sofia wouldn't be Sofia if she hadn't grown up around filmmakers. Her mother, Eleanor Coppola, is a documentary filmmaker; her brother Roman is a screenwriter and filmmaker; her aunt Talia Shire and cousins Jason Schwartzman and Nicolas Cage are actors; and her grandfather, Carmine Coppola, was an Oscar-winning film composer. (Her older brother, Gio, a budding director, died in a speedboat accident in 1985.)

Her parents' friends were filmmakers and writers, actors and artists. One of her earliest memories is sitting on Andy Warhol's knee. Marlon Brando, Werner Herzog, Steven Spielberg, and George Lucas were all dinner guests at her family's home. Her Italian father set the tone, which was warm and inclusive, so the kids were always around listening to the adults talking about filmmaking. "I think I was learning all these things sort of without knowing it," Sofia said. And when she and her family would accompany her father on film shoots—they spent months in the Philippines during the filming of *Apocalypse Now* (1979)—she would watch filmmaking firsthand. (Her mother co-directed an unforgettable documentary about that experience, 1991's *Hearts of Darkness: A Filmmaker's Apocalypse,* in which little Sofia appears.) "For me as a kid it was just about getting to take a helicopter ride over the jungle," said Sofia.

In her teens she became fascinated with fashion; at 15, she worked as an intern for Chanel. "When I was a kid nobody had designer handbags," she remembered. "In high school there wasn't

all this label awareness. It wasn't as much of a mainstream culture thing back then. I remember going to fashion shows and you'd never see celebrities sitting in the front row. Now celebrities have clothing lines—and now Alexis [Neiers]," one of the Bling Ring burglars, "wants to be a fashion designer too."

As did several other kids in the burglary ring. As I got to know Sofia, it struck me that as a teenager she had had some of the same aspirations as the Bling Ring kids—the difference being, of course, that she was the genuine article, the sort of It Girl they longed to become. After leaving the California Institute of the Arts, where she had studied photography and costume and fashion design, she started her own clothing line, Milkfed, which is still sold exclusively in Japan.

Over the almost three years between our first meeting and the completion of *The Bling Ring,* which premieres on June 14, 2013, Sofia and I would get together to talk about the movie she was writing and then directing. I always looked forward to seeing her. She was fun to talk to. It seemed we were always gossiping about Hollywood, as if something about the subject matter we were dealing with was turning us into the worst kind of tabloid junkies. We talked about the celebrification of everything, which seemed to have happened overnight, over roughly the last decade. I said I thought the milestone was the ascendance of Paris Hilton. Sofia said she thought it was the explosion of tabloid journalism.

"I think *Us Weekly* changed everything," Sofia said, referring to how *Us* magazine went from a monthly to a weekly in 2000, becoming more gossipy and invasive and igniting a huge boom in the coverage of celebrities. "I remember living in L.A. before *Us Weekly* and you could go out and do things and have privacy," she said. "I mean, I don't feel like I'm really in that [celebrity] world, but suddenly it was different. There weren't paparazzi around all the time before. And another big change was TMZ," which launched

in 2005. "I remember I went and lived in France for a few years and then I came back TMZ was everywhere and it was so weird. It happened fast, too, like TMZ and Twitter and reality TV all of a sudden were everything and it was like our culture just went crazy.

"With Twitter," she said, "it's insane how accessible these stars are"—so accessible that the kids in the Bling Ring "thought that they knew them because they knew what they were eating for breakfast. So they felt comfortable going in their homes."

Sofia seemed to share my amazement for the way the kids in the story spoke about what they had done, as if they were already stars themselves—especially Alexis Neiers. Sofia had read the transcripts of my interviews with Alexis and some of the other Bling Ring defendants, some of the dialogue from which she said she was incorporating into her film. "When people [she was showing her script to] read it," she said, "they're like, oh my God, how did you come up with that? And I tell them that was real, that comes from the transcripts. I used the real stuff because I couldn't make it up, it's so absurd."

In my *Vanity Fair* piece, for example, Alexis tells me how she thinks she might "lead a country" some day. Her comment wasn't directly related to the burglaries—but perhaps it was. At 18, she was already convinced of the power of her pseudo-fame.

"It's so weird to me today," Sofia said, "this whole idea of being famous for nothing. I guess that started with the reality TV thing and then it became normal. The [Bling Ring] kids all wanted to be famous for no reason. When I was a kid people were famous because they accomplished something, they did something.

"I feel like such an old fogie complaining about all this," she said, smiling self-consciously.

By February 2012, Sofia had cast Emma Watson in the role of Nicki, based on Alexis Neiers (who had now become a consultant on the film, which was becoming like an Escher woodcut about

celebrity). "I met with [Emma] and she was so interested in playing the part," Sofia said, "and I felt like she had a really smart take on it. She understood the themes because of her popularity." As a co-star of eight Harry Potter films, Watson had an almost cult-like celebrity status. "She was very interested in the whole subject matter of celebrity," said Sofia. "And she could relate to it, she knew exactly how things are for a celebrity today—she could see it both from the kids' perspective, who were like, her fans, and from the people on the other side, the ones who were robbed.

"I forgot how famous she was," Sofia said. "I had the kids" who had been cast in the movie, "all go out to lunch together one day, to bond, and they got swarmed with paparazzi." Throughout *The Bling Ring* shoot, which took place in Calabasas, California, and L.A. in March and April of 2012, the set would be dogged by paparazzi and videorazzi and gossiped about on celebrity blogs such as TMZ, mirroring the very themes in the film.

In preparation for their roles, Sofia had also had the young cast—which includes Israel Broussard, Katie Chang, Claire Julien and Taissa Farmiga—"rob" a house in the Hollywood Hills. "It was an improv," Sofia said. "Before we started filming we had them actually sneak into a friend of mine's house" (not someone famous). "We set it up so that no one would be home and we had them break into the house while my friend was away for a few hours. We left a window open and we gave them things that they had to take from the house. We gave them a list." The Bling Ring kids often went "shopping," as they called their burglaries, armed with lists of articles of clothing owned by their famous victims, items which they had selected from research they did on the Internet. "They did great," Sofia of her cast. "They were very good burglars."

Why did the Bling Ring do what they did? Why steal celebrities' stuff? This was something Sofia and I talked about a lot. She said, "I love the quote" from the transcripts "in which Nick [Prugo] says," of his co-defendant Rachel Lee, " 'she wanted to be part of

xvi Preface

the lifestyle, the lifestyle that we all sort of want.' I thought it was so important to put that in the film, that he assumed that that we all want that lifestyle."

Finally, Sofia and I talked about raising daughters in a culture gone mad for fame. She told me of how her daughter Romy, now 6, had recently informed a lady in the park that her mother was "famous in France."

"I don't even know how she knows that or why she thinks that's important," Sofia said, laughing. "I hope there's going to be a reaction against all this," that is, our cultural obsession with fame. "There has to be right?" she asked. "I'm hoping that when our kids are teenagers and young women it's on the reaction side."

THE BLING RING

THE FAME MONSTER

In 2007, Paris Hilton bought a house in the Mulholland Estates, a gated community in what is technically Sherman Oaks, California. The developer was able to secure the more coveted Beverly Hills, 90210, zip code for the address, which over the years has attracted many celebrity residents, including Charlie Sheen, Paula Abdul, and Tom Arnold. The development boasts panoramic views of the San Fernando Valley and some of the area's most extravagant homes, most of them built in the 1990s, when residential architecture was continuing to reflect the mass celebration of conspicuous consumption as seen on popular television shows like *Dallas* and *Lifestyles of the Rich and Famous*.

Two thousand seven was a difficult year for Hilton, from a legal perspective. Her driver's license had been suspended on a DUI charge the year before, and, after she was caught speeding down Sunset Boulevard in her blue Bentley Continental GTC, she spent 23 days of a 45-day sentence for probation violation in jail. Meanwhile, she continued to do very well financially. Even footage that surfaced of her using a number of racial and homophobic slurs did not interfere with her growing success. The "lifestyle brand" she launched in 2004 now encompassed television, movies, music, clothing, books, jewelry, fragrances, handbags, pet apparel, and her Dreamcatcher hair extensions. Her latest reality show, *Paris Hilton's My New BFF*, was in the works (contestants in the first season were asked, "Would you die for Paris?" as Hilton looked on, giggling). Hilton, still just 26, was "hot," as she liked to say. And so she bought herself a 7,493-square-foot, five-bedroom, Mediterranean-style mansion for $5.9 million.

About a year later, on a balmy night in October 2008, two teenagers drove along Mulholland Drive toward Hilton's home with the intention of robbing it. They were a girl and a boy, 18 and 17, who lived not far away in Calabasas, an affluent suburb in the

Valley. The boy, Nick Prugo, was slight of build, with sharp, fox-like features and an anxious, flashing smile. With his prematurely thinning hair, he looked like some former Nickelodeon star who had outgrown his childhood appeal. He had a pencil-thin mustache and a sparse goatee, which complemented his trendy hipster look (hoodie, jeans, sneakers, wallet chain). The girl he said was with him in the car that night, Rachel Lee, was dark-haired and slender with a baby face that belied her steely core. As always, Rachel, who had been voted "Best Dressed" in their high school, twice, was styled to perfection in casual burglar chic (hoodie, scarf, designer T-shirt, jeans). Rachel was obsessed with fashion, Nick said, she was obsessed with clothes; that was why they were going to Paris's house that night, because Rachel wanted Paris's clothes.

The friends didn't say much as they traveled along the curving mountain road toward their target's home. The planning stages had "felt very *Mission: Impossible*," Nick said, and they had taken to calling the job they were about to perform "the mission." They'd been intense and talkative then, figuring out how they were going to gain access to a gated community with a guard. Nick had scoped out the property on Google Earth, having found Hilton's address on Celebrity Address Aerial. (It was a website dedicated to the divulging of celebrity addresses and photographs of their residences for $99.99 a year. Its web masters took a dim view of Hilton, opining on their promotional page, "The reason so many people hate America is, quite simply, Paris Hilton.")

When Nick checked out the aerial shots of the Mulholland Estates, he noticed an area in the back that looked accessible via a steep hill. Rachel was pleased with this finding, he said, and that pleased him; Nick liked to please Rachel. He felt a thrill as they hurtled toward this strange adventure together. He was nervous, he said, but Rachel was calm, and that calmed him down. He tried to keep his mind on the music playing in the car as they zoomed along through the dark. He liked club hits by Pharrell and Lil Wayne and

songs by Atmosphere, the melancholy white rap group from Minnesota. There was one song of theirs in particular that always made him think of Rachel—called "She's Enough." It's about a man who will do anything for the woman he loves:

"If she want it/I'm gonna give it up . . . If she needed the money/I would stick you up . . . She wanna do the damn thing and I'm on her side . . ."

Around midnight, Nick said, they arrived at the Mulholland Estates and he parked his white Toyota at the back of the development. They found the hill they were looking for easily and climbed it, making use of the smooth firebreaks—man-made clearings in its side—to help them scale it. They could hear each other panting with the effort. They weren't athletic kids—they smoked cigarettes and weed. They both had medical marijuana cards issued by the state of California; they weren't hard to get.

Once inside the gated community, they strolled past the cavernous castle-like mansions and gleaming luxury cars, as if in a dream. They were confident, Nick said, that if anyone spotted them, they wouldn't be thought out of place. They looked like "normal kids"; he might be some neighbor's boy; Rachel might be his girlfriend.

"That's the thing that really made everything flow when me and Rachel would go out and do these things," Nick said. "We wouldn't be masked, we wouldn't be in gloves. We wouldn't be conspicuous—we'd be just natural looking so if anything ever happened we'd just be like, what? We're normal kids. It wasn't that we were criminals."

He said he could never remember the exact moment when he and Rachel decided to start burglarizing the homes of celebrities; but once they did, they knew right away that Paris would be the first. "Rachel's idea," he said, "and, I guess, my idea, was that she was dumb. Like, who would leave a door unlocked? Who would have a lot of money lying around? Logically out of anyone in America

could probably figure out that if you were gonna do something to a celebrity it would be someone that wasn't, you know, that bright...."

And then suddenly there was Paris' house, rising before them like the villa of some Spanish contessa, all glowing yellow stone and Mediterranean tile. Nick tried to stay calm as he followed Rachel across the driveway to the front door. Their plan—well, not really a plan, it was more of an impulse, for as often as they had imagined this night, they had actually decided to just go and do it spontaneously, after having a few drinks—their plan was just to ring the bell and see if anybody answered. And if somebody did, well, then, they might get to see Paris. And that would be awesome, in a funny kind of way. They would pretend they were just a couple of ditzy kids with the wrong address, kids out looking for a party.

Rachel rang the bell, Nick said, putting on the innocent face he had seen her wear so many times before. Rachel was good at playing the pretty girl whenever adults were around asking questions. "She knew she was a good-looking girl and she knew there were certain things she could get away with. She knew how the system worked. She knew how you could play it."

She rang and rang again ... but still there was no answer. Was Paris in, or out? Promoting her handbag line at some Tokyo department store? Attending a Russian billionaire's birthday party

in Moscow (for a fee, of course)? Nick had been tracking Hilton's whereabouts through her Twitter account and celebrity news outlets like TMZ, but he wasn't actually sure where she was that night....

Ding-dong.

Paris Hilton's booking photo following her arrest for reckless driving, September 2006.

Were they really going to do this thing? Or were they just going to go home with a funny story to tell their friends?

And then, Nick said, the thought occurred to him just to look under the mat. It was like finding Willy Wonka's Golden Ticket when the glinting metal of the key appeared. Dumb was right.

"Wow."

Inside it was like a Barbie Dreamhouse. There were images of Paris everywhere, framed photographs of Paris on the walls; framed magazine covers of Paris cover stories; framed pictures on tables of Paris with all her famous friends—there was Mariah Carey, Jessica Simpson, Fergie, Nicky Hilton (Paris' sister), Nicole Richie (were they still close?). There were pictures of Paris in the bathrooms. Her face was silkscreened on couch pillows.

There was a lot of pink, and there were crystal chandeliers in almost every room. Even the kitchen. It was like stepping into the girliest Hilton hotel you've ever seen. Nick said they walked around slowly, marveling that they were really there. "There was that percentage of wow, this is Paris Hilton's house, but as soon as I put my foot in the door, I was just wanting to run out.... It was horrifying."

He wanted to leave, he said, but now Rachel was running up the stairs. Upstairs were the bedrooms, and the bedrooms had the closets, and the closets had the clothes. Nick said he followed Rachel to the master bedroom—it was chilly in there and smelled like the perfume counter in a department store. The room led out on to a balcony overlooking the pool and, beyond that, the rolling hills of the Valley, shimmering with lights. As they gazed in the direction of their own homes from the vantage point of one of the most Googled people on the planet, they couldn't help but laugh.

The little dogs—Chihuahuas and a Pomeranian, Tinkerbell, Marilyn Monroe, Prince Baby Bear, Harajuku Bitch, Dolce and Prada—scurried around, regarding them curiously, but they didn't bark. They must have been used to having strangers in the house.

(About a year later, Hilton would build the dogs a 300-square-foot, $325,000 miniature of her home in the backyard. Philippe Starck would provide the furniture.)

"Oh my God!"

Nick said that Rachel squealed with delight when she found the closets. One was the size of a small room and the other the size of a small clothing store. It was like that scene where the dwarves discover the dragon's treasure-laden lair in *The Hobbit*. One closet had a chandelier, and the other had furniture, as if Paris might want to just sit in there and look at all her stuff. The smaller closet had floor-to-ceiling shelves with hundreds of pairs of shoes, all lined up like trophies—Manolos, Louboutins, Jimmy Choos, a pair of YSLs shaped like the Eiffel Tower. There were shoes of every color— satiny, shiny, pointy shoes. Huge shoes. Size 11.

The bigger closet was full of racks and racks of clothes. Nick had to smile. "Rachel, do your thing," he said. And "she was rummaging through everything, very, very into it, very focused, very 'This is my mission.'" She was plowing through the racks of the wild, sparkly, feathery clothing, exclaiming over all the designers— this was Ungaro, that was Chanel! There were dresses, gowns, blouses, and coats by Roberto Cavalli and Dolce & Gabbana and Versace and Diane von Furstenberg and Prada. . . . Nick said Rachel recognized some of the pieces from Paris' public appearances; she followed these things; she knew which one Paris had worn to the VMAs and the Teen Choice Awards.

He said she said it was like "going shopping."

Now he was starting to get nervous again. He decided to go and be the lookout from the top of the stairs; from there, you could see through the big windows to the front of the house. So Nick stationed himself there. He was "sweating unnaturally," he said. "Every five minutes I was yelling down the hall, 'Let's get the fuck out of here! I want to leave! Fuck this, I don't care anymore!' And she was like, it's fine, it's fine, it's fine, let's keep going. . . ."

He resented the way that Rachel was always in charge, no matter what they did—he "hated that," he said—but what could he do? This was "the girl [he] loved," and he didn't want to lose her. And although he'd never tested it, there was something about Rachel that said that if you didn't do what Rachel wanted, she would walk. It wasn't that he minded Rachel taking a few of Paris's things— look at Paris's house; she "had everything." And she "didn't really to contribute to society," she wasn't "some great actor like Anthony Hopkins or Johnny Depp, someone that's really good at their craft." She was an "heir head," like the tabloids said, a "celebutard."

"It wasn't like a malicious thing for me," Nick said. "I wasn't out to get, like, a working-class American."

But Nick did not want to get caught. He yelled again for Rachel to "hurry up and let's get out of here!" But he said she just answered, "This is fine, this is okay, why are you tripping out?"

And then he saw on the wall of the stairwell the portrait of Paris scowling down at him. She was wearing a little black cocktail dress and sitting on a settee with her legs folded underneath her. She looked like a Park Avenue princess who has become very displeased about something. She was staring, glaring, as if to say, "How dare you come in my house and touch my stuff, bitch? I'm gonna get you. . . ."

Nick bolted back down the hall to Rachel. She had selected a designer dress, he said—he couldn't remember which, "there would be so many"—and a couple of Paris' bras. He insisted that now it was time to leave—but not before they checked inside Paris' purses. They knew from experience—for yes, they'd done this kind of thing before—that people with money tend to leave money lying around the house. And, sure enough, in the closet with the shoes and the sunglasses where Paris also kept her many bags—Fendi, Hermes, Balenciaga, Gucci, Louis Vuitton and on and on—they found "crumpled up cash, fifties, hundreds," "which looked to us like she went shopping that day, and this was just her spare change." Nick

would remember the smell of the expensive leather, Rachel ooh-ing and aahing over the labels, and the crinkling sound of the bills. They came away with about $1,800 each—a good haul.

And now it really was time to go. But first they couldn't resist checking out the rest of the house. They wandered around—it was spooky, as if Paris were there somewhere, watching them. Paris could walk in at any time. They discovered the nightclub room with the disco ball and the padded bar. They thought about all the famous people who had been in there—Britney, Lindsay, Nicole, Nicky, Benji Madden (the Good Charlotte guitarist and then Paris's boyfriend), Avril Lavigne. . . . They couldn't help but imagine themselves there again someday, chilling, dancing, with Paris.

Nick took a bottle of Grey Goose vodka for himself, and they left.

2

About a year later, in October 2009, I found myself driving along the 101 North from L.A., on my way to Calabasas. It was a fine, clear day. I had a cup of coffee in the cup holder beside me, traffic was humming, and the craggy Santa Monica Mountains lay before me like giant scoops of butter pecan ice cream. They were kind of pretty, and that was not what I was expecting. I'd never been to the Valley before. All I knew was its reputation, that it was the West Coast's bookend to New Jersey, a place full of shopping malls and spoiled teens speaking Valley Girl. Bob Hope, a Valley resident for more than sixty years, had called it "Cleveland with palm trees."

Vanity Fair had put me on the story of "the Bling Ring"—that was what the *Los Angeles Times* was calling a band of teenaged thieves that had been caught burglarizing the homes of Young Hollywood. Between October 2008 and August 2009, the bandits had allegedly stolen close to $3 million in clothes, cash, jewelry,

handbags, luggage, and art from a number of young celebrities including Paris Hilton, Lindsay Lohan, and *Pirates of the Caribbean* star Orlando Bloom. They'd stolen a Sig Sauer .380 semi-automatic handgun that belonged to former *Beverly Hills, 90210* cast member Brian Austin Green. They'd taken intimate things: makeup and underwear. It seemed they just wanted to own them, wear them.

The Bling Ring kids were from Calabasas, a ritzy suburb about thirty minutes from L.A., and that's why I was headed there. There'd never been a successful burglary ring in Hollywood before, and somehow it made sense that it would be a bunch of Valley kids. I wasn't sure why it did, but I thought if I went to Calabasas I might find out.

Up until the 1940s, I'd read, the Valley was "out there," ranchland where settlers went to grow oranges and raise chickens and families. Then Hollywood discovered it as an appealing hideaway with bigger houses—Clark Gable and Carole Lombard made a love nest there, and so did Lucille Ball and Desi Arnaz. Jimmy Cagney moved out to play gentleman farmer, Barbara Stanwyck to run a thoroughbred ranch, but somehow the place never became glamorous. Something was always off. After the war, the population exploded, and the Valley became the defining American suburb, a sunny Eden of split-level homes, electric blue swimming pools, and kids living seemingly perfect childhoods. The Brady Bunch were tacitly Valley folk.

Frank Zappa's song "Valley Girl" (1982) introduced the world to a young white Southern California female whose main interests were shopping, pedicures, and social status: *"On Ventura, there she goes/She just bought some bitchen clothes/Tosses her head 'n flips her hair/ She got a whole bunch of nothin' in there. . . ."* Zappa learned about Valley Girls from his then 14-year-old daughter Moon Unit, who encountered them at parties, bar mitzvahs, and the Galleria mall in Sherman Oaks. The film *Valley Girl*, released in 1983—adding "space cadet" and "gag me with a spoon" permanently to the

lexicon—explored Valley kids' longing to be part of the supposedly cooler, star-studded world of Hollywood, so close but so far away.

Calabasas (population 23,058) was said to be a typical Valley hamlet, but with more celebrity residents, including (then) Britney Spears, Will Smith and Jada Pinkett and their already famous kids, country singer LeAnn Rimes, Nikki Sixx of Mötley Crüe and Richie Sambora of Bon Jovi, former Nickleodeon star Amanda Bynes. . . . Weirdly, Calabasas was also a Fertile Crescent for reality television. One of the first big reality shows featuring a (sort of) famous person, Jessica Simpson, and her then husband Nick Lachey, was shot there: *Newlyweds: Nick and Jessica* (2003–2005). So was Spears' burps-and-all look at life with her then husband Kevin "K-Fed" Federline: *Britney and Kevin: Chaotic* (2005). And so is the Queen Mary of all reality television: *Keeping Up with the Kardashians* (2007–). In each of these shows, Calabasas looks like Xanadu with SUVs, a place of SoCal-style easy living, where everybody's wealthy.

And Calabasas is rich, relatively speaking; the median income is about $116,000, more than twice the national average. According to the online *Urban Dictionary* (albeit an opinionated source), "The typical Calabasas resident is young, rude, rich. . . . You'll see . . . 10-year-old girls with their Louis Vuitton purses and Seven jeans giggling to their friends on their iPhones."

It was interesting to see how media coverage of the Bling Ring was playing up the burglars as "rich." Said the *New York Post*: "A celebrity-obsessed group of rich reform-school girls allegedly waged a year-long, A-list crime spree through the Hollywood Hills, ripping off millions in cash and jewels from the mansions of such stars as Paris Hilton and Lindsay Lohan. . . ." People always seemed fascinated by stories about rich kids. I should know, I'd done a few myself. Editors seemed to like such stories, especially if the kids were behaving badly. Readers seemed to love to hate these kids. I once received a letter, in response to one of my stories about bad

rich kids in Manhattan, from a World War II veteran demanding, "Can the prep school gangsters fly a B-29?" That was a very good question.

But it was clear the appeal of the Bling Ring story wasn't just the wealthy kids; it was one of those stranger-than-fiction tales that hits the Zeitgeist at its sweet spot, with its themes of crime, youth, celebrity, the Internet, social networking (the kids had been advertising their criminal doings on Facebook), reality television, and the media itself, all wrapped up in one made-for-TV movie (which didn't exist yet, but would). The wall between "celebrity" and "reality" was blurring faster than you could say "Kim Kardashian." Celebrities were now acting like real people—making themselves accessible nearly all the time; even Elizabeth Taylor tweeted ("Life without earrings is empty!")—and real people were acting like celebrities, with multiple Facebook and Twitter accounts and sometimes even television shows documenting their—real and scripted—lives. It was all happening at warp speed, affecting American culture on a cellular level and, if you wanted to get fancy about it, begging the age-old question of "What is a self?" (And, "If I post something on Facebook and no one 'likes' it, do I exist?") The Bling Ring had crossed a final Rubicon, entering famous people's homes, and their boldness felt both disturbing and somehow inevitable.

News of the kids, so far, didn't offer many details, and no interviews with the suspects themselves. The six who had been arrested in connection with the burglaries were Rachel Lee, 19—"the gang's alleged mastermind," according to the *Post*; Diana Tamayo, 19; Courtney Ames, 18; Alexis Neiers, 18; Nicholas Prugo, 18; and Roy Lopez, 27, who had been identified as a bouncer. Lee, Prugo, and Tamayo all reportedly knew each other from Indian Hills, an alternative high school in Agoura Hills (it was "a couple of exits away" from Calabasas, a Southern Californian had told me). The only one who had been formally charged was Prugo, with two counts

of residential burglary of Lohan and reality star Audrina Patridge (she was one of the girls on *The Hills*, a sort of real-life *Melrose Place* about vacuous twentysomethings in L.A.). Prugo was facing up to twelve years in prison. Another suspect in the case, Jonathan Ajar—a.k.a. "Johnny Dangerous," 27—who had been identified as a nightclub promoter, was wanted for questioning. TMZ was saying he was "on the run."

The kids' mug shots didn't tell much, either, except that they all looked very young and bedraggled in the way people do when they get hauled into jail. Prugo looked rather cunning (later, he would admit that the black-and-white striped T-shirt he was wearing in his mug shot belonged to Orlando Bloom). Lee and Ames—a brown-haired, light-eyed girl, neither pretty nor plain—looked scared. Tamayo wore a defiant expression. Lopez looked thuggish and resigned.

And then there was this wild picture of two of the other girls— it was like a poster for *Bling Ring: The Hollywood Movie* (which didn't exist yet, but would as well). It was of Alexis Neiers and her "sister"—actually her friend—Tess Taylor, 19, a Playboy model and "person of interest" in the case. They were coming out of the Van Nuys Area Jail in the wee hours of October 23, after Neiers had been released on a $50,000 bond. It looked like a paparazzi shot— in fact, it was. You had to wonder who had alerted the paparazzi to Neiers' arrest.

In the picture, Taylor has her arm protectively slung around Neiers' shoulder as she hustles her past photographers blasting away. Both girls have lots of lustrous dark hair and perfectly shaped eyebrows and perfectly toned, exposed midriffs. Taylor has on a black tracksuit and Ray-Ban sunglasses, although it's night. Neiers is wearing what appear to be ice blue Juicy sweatpants and a pair of Uggs. She's holding the end of a black scarf up around her face, dramatically concealing everything but an expertly made-up eye. The girls look like celebrities. It appears as if they think they are.

What had not yet been reported was that they were the stars of an upcoming reality show, *Pretty Wild*, which was being filmed for E!.

"I didn't do jack shit, it's a joke," Neiers told reporters outside the jail.

3

"You are going to hear about five targets in this case: Rachel Lee, Nick Prugo, Diana Tamayo, Roy Lopez, and Courtney Ames. You are going to hear that these five targets know each other through school, through the neighborhood, with the exception of Roy Lopez, who the other targets know from having frequented a local [Calabasas] restaurant, Sagebrush, where he was working.

"You are going to see photographs of the targets hanging out. You are going to see that they celebrate birthdays together ... that they hung out on the computer together, that they eat lunch together.

"They go to hotels together. They party together.

"But you are also going to hear that they commit crimes together, and over the course of the year between the end of 2008 and for about ten months in 2009, they committed burglaries."

—Opening Statement, L.A. Deputy District Attorney Sarika Kim, Grand Jury proceedings in the People of the State of California vs. Nicholas Frank Prugo, Rachel Lee, Diana Tamayo, Courtney Leigh Ames, and Roy Lopez, Jr., June 18, 2010

4

Some of the views around the edges of Calabasas are almost rural. You can see fields with horses grazing, swishing their tails in the sun, echoes of the days when the residents wore desert boots in-

stead of Louboutins. It makes you feel, suddenly, very far away from
Hollywood. The approach to town turns suburban; the inevitable
car dealerships, fast food chains, and shopping malls appear. The
mountains as they draw closer grow greener and still prettier. Cala-
basas, meanwhile, is beige. Everything is overcast with a wash of
sameness—a clean and shiny sameness, a corporate sameness. It's as
if Calabasas should have a logo.

Once I got to town, I pulled into the parking lot of a Gelson's
market in order to do a Google Maps search on Nick Prugo, ironi-
cally enough. Prugo was said to be the Bling Ring's surveillance-
meister, the one who found the celebrities' addresses and pictures
of their homes on the Internet. TMZ, which was all over this story
(they were calling the gang "the Burglar Bunch"), had posted a
Google Maps search of Orlando Bloom's home that Prugo had al-
legedly done on a stolen computer; they were calling the image a
"smoking gun." (It was a bit of a mystery how TMZ was getting its
hands on all these interesting things, but more on that later.)

I'd located Prugo's address using a garden variety people-
finding website. More than a decade before, an editor had asked
me to do a story on how easy it was to track down the world's most
elusive literary recluse, Thomas Pynchon, with the click of a mouse.
Nothing much had changed since then, except that privacy had all
but disappeared. Everybody was spying on everybody. Prugo's data
mining was nothing compared to Facebook's. "It was information
anyone in America could get," he would tell me later.

As I was sitting there trying to get directions, I looked up and
saw two funky-looking, middle-aged people hurrying past my car.
A couple of photographers were chasing them, shouting, "Sharon!"
"Ozzy!" It was the Osbournes. They'd moved to the Valley in 2007
after the success of their reality show, *The Osbournes* (2002–2005).
I'd never seen paparazzi working in quite so mundane a setting
before. The other people in the parking lot just strolled along with
their carts as if nothing out of the ordinary were happening. Ozzy,
wearing his signature-tinted granny glasses, looked a little rattled.

It got me thinking about the Lady Gaga song "Paparazzi" (2008), which was still all over the radio at that time. It seemed like an anthem for our celebrity-obsessed age, or at least for this story I was working on. Gaga equates modern love with a love of fame—to be in love is to be a celebrity stalker, a paparazzi: *"I'm your biggest fan/I'll follow you until you love me/Papa-paparazzi. . . ."* Now it was as if everybody had become their own fan. Everybody was broadcasting themselves on social media. Everyone was their own paparazzi.

And I thought of Lady Gaga—born Stefani Joanne Angelina Germanotta, four to five years before the Bling Ring kids, in New York. She'd dropped out of college and hustled her way to super-stardom. She often talked about how bad she'd wanted it. "In the book of Gaga," she said in an interview, "fame is in your heart, fame is there to comfort you, to bring you self-confidence and worth whenever you need it." In Gaga's world, she was a prophet of fame and fame was a kind of god.

I drove up into the hilly streets of Calabasas, which were lined with lavish homes, some so big they looked like hotels, resort ho-tels, with enormous driveways and burbling fountains. I gave myself a tour. There were faux Colonial McMansions and Tuscan McMan-sions, each one like a different theme park attraction. "Living out here is sort of like living at Disneyland," said a kid in the teenager-produced video, *Calabasas: Behind the Glamour*, which I'd watched on YouTube. "It's not like real life." (In the same video, the kids try and trick Calabasas residents into being mean to a fake homeless person, but they only catch one trying to shove money at him.)

And then there were streets with smaller homes—modest ranch-style ones and Spanish-style ones that looked like the hum-bler, distant cousins of the opulent spreads. I remembered a line from *Double Indemnity* (1944), one of my favorite films, where Fred MacMurray says in voice-over, "It was one of those California Spanish houses everyone was nuts about ten or fifteen years ago." Prugo's house, on a narrow canyon road, had a wistful look. The

lawn was in need of attention. I parked across the street and stared at it awhile, waiting to see if anyone would come out of it. The Bling Ring kids had apparently done the same thing—sat and observed their targets' homes, scoping for Intel on how to get in and rob, and maybe hoping to catch a glimpse of a star.

On September 17, the LAPD had swarmed Prugo's house and searched for items belonging to celebrities. They found "several pairs of designer sunglasses, luggage, and articles of clothing." Prugo denied any involvement in the burglaries at that time. His mother, Melva-Lynn, watched as police led him away in handcuffs. Melva-Lynn ran a dogwalking service. She was from Idaho. Prugo's father, Frank (or like his son, Nicholas Frank), who was originally from the East Coast, was a senior vice president at IM Global, a film and television sales and distribution company. Founded in 2007, IM Global had handled the international rights for *Paranormal Activity*—a "supernatural shockumentary" about a couple being haunted in their bedroom at night by a menacing presence. The film would go on to become the most profitable movie of all time, based on return on investment. With a budget of $15,000, it grossed nearly $108,000,000 in the United States and close to $200,000,000 worldwide. It was released on September 25, eight days after Prugo's arrest. Prugo's lawyer, Sean Erenstoft, told me Prugo's father seemed upset that his son's legal troubles were overshadowing his success.

"He's having the best year of his life," said Erenstoft. "Mr. Prugo is completely distraught. He is concerned about his son, but he said, look, my name is Nicholas Frank Prugo and that's my son's name too."

The younger Prugo had been in trouble before. In February 2009, he'd been arrested for possession of cocaine. He'd pleaded guilty and entered an 18-month Deferred Entry of Judgment program, a kind of drug treatment program that allows the offender to avoid a criminal record. TMZ had posted a video, taken off that

same allegedly stolen computer, of Prugo sitting at his desk in front of the computer smoking weed and singing along to the Ester Dean dance hit "Drop It Low" ("*Drop it, drop it low, girl*"). The bedroom behind him is Everyboy's room, sneakers strewn across the floor. Prugo gazes at his image onscreen, cocking his head this way and that, making "sexy" faces, checking himself out. Inspired, he gets up and lifts up his shirt, showing off his bare midriff. Then he turns around and does a booty dance for the camera. It was like an updated, computer literate version of Tom Cruise's underwear dance scene in *Risky Business* (1983).

Then the phone starts to ring and Prugo answers it, demanding in a jocular tone, "Why are you ruining my life? I don't really want to. . . ." Watching it, I wondered if he were talking to Rachel Lee and she was inviting him out to a burglary.

After a while I drove on to Rachel's house. She lived on the west side of Calabasas, not far from Agoura Hills, in a development bounded by a couple of two-lane highways. The house was large and boxy, like the cookie-cutter homes on *Weeds*. (In fact, the satellite picture from the show's opener for seasons 1 through 3 was a shot of Calabasas Hills, a gated community in Calabasas.) On September 17, the LAPD had served a warrant here, too, but Rachel's mother told police that Rachel had moved to live with her father in Las Vegas. You had to wonder if she was running.

Rachel's mother, Vickie Kwon, was reportedly a North Korean immigrant—an unusual thing to be, since North Korea has strict emigration laws—and the owner of a couple franchises of the tutoring company Kumon. It was "the world's largest after-school math and reading academic enrichment program," according to its website. Kwon sounded like an immigrant success story, which no doubt made it awkward for her that, while she was helping other people's children excel academically, her daughter had been kicked out of Calabasas High School for disciplinary problems and transferred to Indian Hills. In July 2009, Rachel had been arrested for

shoplifting makeup at a Sephora in Calabasas and sentenced to a year's probation. On October 22, she was arrested at the Vegas home of her father, David Lee, a businessman.

I drove on to Diana Tamayo's residence, an unremarkable-looking apartment building near a freeway in Newbury Park, about fifteen minutes west of Calabasas. Tamayo shared a two-bedroom rental unit with her parents and two younger brothers. Her parents had been described to me by a cop on the case as "hardworking illegals" from Mexico. Her mother, Aracely Martinez, was a swap meet vendor. Tamayo drove an expensive car, a Navigator.

In her bedroom, police said they found "several items allegedly belonging to celebrities," including Hermes, Chanel and Louis Vuitton bags, Paris Hilton brand perfume, and four pairs of designer heels. After being arrested on October 22, Tamayo spent four days in jail until her family could raise her $50,000 bail. The LAPD discovered her to be an undocumented immigrant, exposing the illegal status of other members of her family. (She'd come to the United States when she was six; her brothers were born here.)

She'd been class president at Indian Hills and earned a $1,500 "Future Teacher" scholarship after graduating in 2008. A teacher had called her a "spectacular student." She'd been named "Best Smile" in the 2007 yearbook and voted, along with her boyfriend Bobby Sanchez, "Cutest Couple." According to my cop source she was "best buddies with Rachel." They were arrested shoplifting together at Sephora in July, and Tamayo had also been sentenced to a year's probation.

Courtney Ames lived in a small but centrally located Calabasas home on a climbing mountain road. There was a lone rocking chair on the bare white front porch, which seemed like a failed attempt at coziness. I'd heard her stepfather was Randy Shields, a former U.S. Amateur Light Welterweight boxer who beat Sugar Ray Leonard for the National AAU title in 1973. I'd watched a YouTube video of Shields going 12 rounds with a powerhouse named Thomas Hearns, another former welterweight champion, in 1981. Howard

Cosell, who'd announced the fight, said, "As you look at that kid you have to give him all the credit in the world," watching a bloodied Shields being led away after the fight. Now Shields sometimes worked as a bodyguard. In 1994, he'd told the *Los Angeles Times* he wrote screenplays in his spare time.

Ames had graduated from Calabasas High in 2008. That same year, she was arrested for allegedly fighting with a co-worker. She pleaded guilty to the lesser charge of disturbing the peace and was sentenced to 24 months probation. "She was always looking for trouble and always looking to fall into the wrong crowd," one of her neighbors had told the *Post*. "People would make fun of her. She alienated herself on purpose." She drove an Eclipse, a gift from her stepfather, who "bought her everything," a source told The Daily Beast.

In 2009, Ames was arrested for D.U.I. and sentenced to community service. Making light of paying her debt to society, she'd posted on her Facebook page: "Cal trans"—the state agency responsible for road maintenance—"at 5 am you can all look for me on the side of the road ill be in that hot orange vest picking up [after] all you dirty motherfuckers." She was arrested at home on October 22 in connection with the Bling Ring burglaries.

It wasn't clear yet how she knew the other suspects, but she knew Roy Lopez from a former job. In 2008, Ames worked as a waitress at a local Calabasas bar and restaurant, Sagebrush Cantina—a rowdy pizza-margaritas-and-burgers joint with live music and Harley-Davidsons parked out front. Lopez was a bouncer there. He was essentially homeless, my cop source said: "He lives on people's couches. He's the only person who 'needed' to steal." He had a minor juvenile arrest record, but had never been convicted of a crime. "A review of Lopez's criminal history reveals that he is a Pinnoy Boys gang member who uses the street name of 'Bugsy,'" said the LAPD's report on the Bling Ring case. (Lopez's lawyer, David Diamond, denied his client had any gang affiliation.)

"While this activity started as a twisted adventure for Prugo

and his small group of friends fueled by celebrity worship," the LAPD's report said, "it quickly mushroomed into an organized criminal enterprise and—inevitably—the introduction of hard-core criminals, such as Jonathan Ajar and Roy Lopez." (Diamond called this characterization of his client "wrong.")

Lopez was arrested on October 22, along with all the others in the Bling Ring sting, after being located sitting in a car at a stoplight by a police surveillance team. "Is this about the Paris Hilton thing?" he spontaneously inquired, according to LAPD Officer Brett Goodkin.

Finally, I drove by the home of Alexis Neiers in Thousand Oaks, about 20 minutes west of Calabasas. Thousand Oaks is another prosperous bedroom community that has basked in the light of many local stars, including Heather Locklear, Sophia Loren, and Wayne Gretzky. Neiers' home was on a rolling road with a cul-de-sac, flanked by camouflage-colored hills. It was a two-story, yellow stucco house with a tile roof and a lot of foliage around the front porch. Andrea Arlington Dunn, Neiers' mother, was a former *Playboy* model, sometime masseuse and holistic health care practitioner. She was married to Jerry Dunn, a television production designer who had worked on Disney shows, including *Hannah Montana* and *The Suite Life of Zack and Cody*.

Neiers had been homeschooled. She had a little sister, Gabrielle, then 15. Neiers' connection to the other burglary suspects was still unclear. On her MySpace page, she had described herself this way: "I am currently working as a full-time model and actress but in my spare time (when I have any haha) I am a Pilates, pole dance and hip-hop instructor." Her father, Mikel Neiers, a director of photography on *Friends* between 1995 and 2000, told *People*, "[Alexis] was in the wrong place at the wrong time, associating with the wrong people. She got sucked into this. We're standing by her. I'm sure [the case against her] is going to be thrown out of court."

She had no criminal record except for a misdemeanor warrant for "Driver in Possession of Marijuana." On October 22, she was arrested at home after police found a black and white Chanel necklace allegedly belonging to Lindsay Lohan and a Marc Jacobs purse allegedly owned by former star of *The O.C.* Rachel Bilson in her little sister's bedroom.

5

I headed over to the Commons, the snazzy local mall, hoping to run in to some teenagers who knew the Bling Ring kids or could offer some speculation about why they did it—which is what everybody wanted to know. Why would a bunch of kids who had everything risk everything to steal a bunch of famous people's clothes?

But it was clear from driving by their homes that the kids weren't as rich as everyone seemed to want to believe. Everybody wanted them to be the like kids on *Gossip Girl*, but it seemed they lived more like typical teenagers. They were better off than many kids, at the dawning of the Great Recession; but they didn't appear to be wealthy in the way of the new elite class that had been engaging in the deregulated accumulation of capital for the better part of three decades. They weren't as rich as other people in Calabasas, or their victims, either. Which made them wannabes.

The first person I ran into at the Commons wasn't a teenager, however, but Kourtney Kardashian, sister of Kim. "Looking good, Kourtney," said a paparazzo in tow. Being in Calabasas was like having a strange dream where celebrities popped out from every corner, like funhouse clowns. Kardashian was very pregnant (with her first child with her boyfriend, former teen model Scott Disick) and wearing what appeared to be a small fortune in tight-fitting maternity wear. She was carrying a bag that cost about the same as many Americans' monthly salaries. She was coming out of the mall

entrance laden down with shopping bags. Her lip gloss glimmered in the sunlight.

Later, I would learn that Kardashian's Calabasas home had been robbed on October 18, 2009, and that the burglary bore all the marks of a Bling Ring job. Except for Prugo, none of the kids in the gang had been arrested at the time of the heist. One-hundred-eight-thousand dollars in diamond jewelry, Rolex and Cartier watches had been stolen. Cops were never able to put any of the Bling Ring kids at the scene, but they suspected a connection (and still do; the culprits in that burglary have never been apprehended).

"It's boring here," said the girl in Starbucks. "There's nothing to do. A lot of people drink." Now I was sipping sugary coffee drinks with three teenagers, two girls and a boy. They asked me not to use their real names; they said they could speak more freely that way. I'll call them Jenny, Justin, and Jill. They were recent graduates of Calabasas High School, all attractive and fit and sporting bright, sporty gear. They were enrolled in a local two-year college, Pierce, in nearby Woodland Hills.

"A lot of people around here get D.U.I.s," Justin said.

They talked about knowing Courtney Ames and hearing about her recent D.U.I. "I heard her blood alcohol level was point-thirty," said Jenny. "You can die from that—or at least go unconscious."

Ames' Facebook page was full of partying bravado and references to drinking and getting high: "Beer pong, keg, the normal". . . . "Wanna smoke a bluuunt."

"I heard she was, like, a white supremacist," said Jill. "People called her 'White Power.' She had tattoos all over her and was always listening to hip-hop and acting like she was some big gangsta chick."

One of the arresting officers at Ames' home on October 22 told me that in her bedroom he found notebook papers filled with numerous "generic white power kinda stuff. And the 'n' word." When he asked her what this was doing there, he said she told him, "I

was into that in high school but I'm not into it anymore." (Robert Schwartz, Ames' lawyer, had no comment.)

"She was always talking about going into Hollywood to party," said Jenny.

"Most people don't *want* to go into Hollywood," said Jill. "We're like in a bubble out here. We're in a bubble."

"People hang out at the mall," said Jenny. "Hang out at Starbucks."

"Go to Malibu or Zuma Beach in the summer. Go to the Promenade in Westlake," said Jill.

"Make bonfires," Jenny said.

I asked them if it was strange growing up in a community surrounded by so many celebrities.

"It is strange," Justin said. "There's a lot of people with money who think they're better than everyone else. It's the haves and have-nots."

"They act like they're, like, the people on *The Hills*," said Jill. "They wear, like, three-hundred-dollar jeans."

I asked them what they thought motivated the Bling Ring kids.

"Kids are very influenced by the media," said Justin, looking thoughtful. "They're constantly seeing movies and TV shows telling them a certain lifestyle is better, and if you don't live that lifestyle you can't be happy. You're like a loser. So people want what they don't have."

"Everybody wants to be famous," said Jenny.

"No," said Jill. "Everybody thinks they *are* famous. I call it 'FOF'—Famous on Facebook. It's like they think they can just put themselves out there and don't even have to work for it."

I told them I'd just seen Kourtney Kardashian.

"We see them all the time," said Jill. "They have really big butts."

"I saw Britney at the gas station," Jenny said. "Even though she's gained some weight I still think she's really cute."

6

When I got back to my hotel in L.A. that night I thought about what it must be like growing up in an America where everybody wanted to be famous. An awards show was on, the American Music Awards. I watched the stars gliding up the red carpet, and thought of Nick Prugo and Rachel Lee watching it, somewhere, transfixed. Then Jennifer Lopez was singing her song "Louboutins" (2009): *"I'm throwing on my Louboutins . . . Watch this Benz/Exit that driveway. . . ."* I turned it off.

If the kids at the Calabasas Commons were right, then everybody not only wanted to be famous, but thought it was within their reach. It's telling that the most popular show on television between 2003 and 2011—in fact, the only show ever to be number one in the Nielsen ratings for eight consecutive seasons—was *American Idol*, a competition program celebrating the attainment of instant notoriety. "This is America," said *Idol* co-host Ryan Seacrest in 2010, "where everyone has the right to life, love, and the pursuit of fame." As proof of this, Seacrest is also the executive producer of *Keeping Up with the Kardashians*.

The narrative of fame runs deep in American culture, dating back to *A Star Is Born* (1937) and beyond (arguably to the spread of photography in the 1850s and 1868's *Little Women*—Jo wants to be a famous writer—which isn't quite the same as wanting to be on *The Real Housewives of Atlanta*). But it's safe to say there's never been more of an emphasis on the glory of fame in the history of American popular culture. There are the countless competition shows (*The X Factor, America's Got Talent, The Voice, America's Next Top Model, Project Runway*); awards shows; reality television, on which even "hoarders" and "American pickers" can become famous. There are Justin Bieber and Kate Upton, self-made sensations through the wonders of self-broadcasting. Explaining the success of

YouTube in 2007, co-founder Chad Hurley said, "Everyone, in the back of his mind, wants to be a star." There's the new 24/7 celebrity news industry exemplified by TMZ and gossip blogs. There's the way in which even legitimate news venues have become infused with celebrity reporting.

Unsurprisingly, the massive growth of the celebrity industrial complex hasn't failed to affect kids. To put it mildly, kids today are obsessed with fame. There's already a fair amount of research about this—it seems we're obsessed with how obsessed kids are with becoming famous. A 2007 survey by the Pew Research Center found that 51 percent of 18-to-25-year-olds said their most or second-most important life goal—after becoming rich—was becoming famous. In a 2005 survey of American high school students, 31 percent said they "expect" to be famous one day. For his book *Fame Junkies* (2007), author Jake Halpern and a team of academics conducted a survey of 650 teenagers in the Rochester, New York area. Among their findings: Given the choice of becoming stronger, smarter, famous, or more beautiful, boys chose fame almost as often as they chose intelligence, and girls chose it more often. Forty-three percent of girls said they would like to grow up to become a "personal assistant to a very famous singer or movie star"—three times more than as chose "a United States Senator" and four times more than chose "chief of a major company like General Motors." When asked whom they would most like to have dinner with, more kids chose Jennifer Lopez than Jesus. More girls with symptoms of low self-esteem said they would like to have dinner with Paris Hilton.

Interestingly, kids who read tabloids and watch celebrity news shows like *Entertainment Tonight* and *Access Hollywood* are more likely to feel that they, too, will one day become famous. Girls and boys who describe themselves as lonely are more likely to endorse the statement: "My favorite celebrity just helps me feel good and forget about all of my troubles."

The fame bug is more prevalent in industrialized nations than in the developing world. A 2011 survey by the ChildFund Alliance, a network of 12 child development organizations operating in 58 countries, found that a majority of children in developing countries aspire to be doctors and teachers—when asked about their top priorities, they talked about improving their nations' schools and "[providing] more food"—while their counterparts in developed nations want to grow up to have the kind of jobs that will make them rich and famous—professional athlete, actor, singer, fashion designer.

Or for the less hardworking, there is burglar.

It occurred to me, while looking over the careers of the Bling Ring victims, that not only were they rich and famous, but nearly all of them had been in movies or on popular TV shows about people who were rich and famous or *wanted* to be rich and famous. They provided the burglars with an enticing image of fame within fame, imaginary wealth rewarded by actual wealth. There was a double mirroring with all their targets, as deliciously full of things that were bad for you as a double-stuffed Oreo.

There was Paris Hilton, whose "heiress" background was the premise for her reality show *The Simple Life* (2003–2007), in which she and her friend Nicole Richie invaded the lives of working-class people and made fools of themselves and their hosts. There was Lindsay Lohan, famous since the age of eleven, who had appeared in a movie, *Confessions of a Teenage Drama Queen* (2004), about a girl who is consumed with wanting to become a famous actress. And there was Rachel Bilson, who had starred on *The O.C.*, about rich kids in Newport Beach, California. (Josh Schwartz, who created the show, now had another hit with *Gossip Girl*, about rich kids in New York.)

The Bling Ring had also burglarized the home of Brian Austin Green, who had starred in the 1990s teen drama *Beverly Hills, 90210*, about rich kids in Beverly Hills. Their real target in hitting Green was his girlfriend (now wife), actress Megan Fox, who had

co-starred with Lohan in *Confessions of a Teenage Drama Queen*, playing a rich mean girl. Then there was Audrina Patridge of *The Hills*, a reality show about rich girls trying to find themselves in L.A. Spencer Pratt, another regular on the show, was apparently also a target, but the Bling Ring was busted before it had a chance to rob him.

Rachel Lee and Diana Tamayo allegedly fled from the home of *High School Musical* star Ashley Tisdale in July 2009 after encountering her housekeeper at the front door (Tisdale was in Hawaii). The *High School Musical* phenomenon hit when the Bling Ring kids were entering high school. The first installment in the three-part Disney franchise appeared in 2006. Although it was geared more toward tweens, no one could escape the hype, which made stars of newcomers Tisdale, Zac Efron, and Vanessa Hudgens (all three were Bling Ring targets, although none was ever successfully burglarized). The squeaky-clean movies, shot in squeaky-clean Salt Lake City, are about high school kids vying for roles in a high school musical, but their true message is about the thrill of fame. Tisdale's character, Sharpay Evans, a spoiled rich girl seemingly modeled after Paris Hilton (she's a platinum diva who carries a lapdog), announces she will "bop to the top" and have only "fabulous" things in her life. The final number of the first *High School Musical* movie declares, "We're all stars."

And then there was Miley Cyrus, another target on the Bling Ring's list. Her wildly popular tween comedy, *Hannah Montana*, ran on the Disney Channel from 2006 to 2011. It was, famously, about a high school girl who lives a double life as a famous pop star. Miley the regular teen has dark hair, while Hannah the celebrity dons a platinum wig and flashier clothes. *"You get the limo out front,"* Cyrus sang in the show's theme song. *"Yeah, when you're famous it can be kinda fun." Hannah Montana* attracted more 6-to-14-year-old viewers than any other show on cable, and 164 million viewers worldwide.

A study of the effect of celebrity culture on the values held by

kids found that the TV shows most popular with 9-to-11-year-olds have "fame" as their number one value, above "self-acceptance" and "community feeling." "Fame" ranked number 15 in 1997. "Community feeling" was number one in 1967. I searched YouTube for a typical episode of *The Andy Griffith Show* from that year, and found one that showed Aunt Bee fretting over the responsibilities of jury duty (and mind you, this show was a big hit). Meanwhile, a typical episode of *Hannah Montana* from 2009 has Hannah fretting over her overbooked schedule—how will she juggle a concert and a radio show? Or for older kids, there was a 2008 episode of *Entourage* in which Vince the movie star (played by Adrian Grenier) worries over whether he should take a part in a movie, and what it will do for his image.

But it may be too easy to blame pop culture and the media for promoting the "value" of fame. Movies and TV shows and popular music are often more of a reflection than an engine of cultural trends. I think when we talk about the obsession with fame, we're also talking about an obsession with wealth. Rich and famous, famous and rich—they seem connected as aspirations. Interviewing teenagers over the years, I've often heard them talk about wanting to be famous, but almost always in the context of being rich and the "lifestyle" fame ushers in. "Lifestyle" is a word that comes up a lot. "We put them up in the nicest hotels," said *X Factor* judge Demi Lovato of the contestants on the show, "because we want them to get a taste of the lifestyle that fame can bring them." (Sadly for Lovato and also former *X Factor* judge Britney Spears, "the lifestyle" of fame has also included time in rehab, where they both landed in 2010 and 2007, respectively.) When the kids in the Starbucks at the Commons in Calabasas started talking about fame, they immediately started talking about money. It's striking that while there seems to be much consternation about kids wanting to be famous, there seems to be little concern about them wanting to be rich.

America has always offered a dream of wealth; in "the land of opportunity," anyone who is willing to work hard can make a good life for himself and his family. But the idea of what constitutes a good life hasn't always included private planes and 50,000-square-foot homes and $100,000 watches and $20,000 handbags. We are living in a new Gilded Age, with a "totally new stratosphere" of financial success.*

As we've become aware in the national conversation about the one percent, income inequality has increased dramatically since the late 1970s. Then, the top 1 percent of Americans earned only about 10 percent of the national income; now they earn a third. In terms of total wealth, they control about 40 percent. Meanwhile the 99 percent has been going into debt trying to keep up with the newly extravagant lifestyle the one percent inhabits.

"While the top 1 percent have seen their incomes rise 18 percent over the past decade, those in the middle have actually seen their incomes fall," wrote Nobel Prize–winning economist Joseph E. Stiglitz in *Vanity Fair* in 2011. "All the growth in recent decades—and more—has gone to those at the top." At the same time, Stiglitz wrote, "People outside the top 1 percent increasingly live beyond their means. Trickle-down economics may be a chimera, but trickle-down behaviorism is very real."

When rich people started having more money—a lot more money—they started coming up with bigger and fancier ways of spending it. The explosion in demand for high-end consumer goods has been called "the luxury revolution," although it's anything but revolutionary. Tom Wolfe's *The Bonfire of the Vanities* (1987) was a scathing look at the materialistic (and ultimately criminal) culture created by Wall Street players like his main character, Sherman McCoy. But while yuppies might have been portrayed as loathsome

* See Chrystia Freeland, *Plutocrats: The Rise of the New Global Super-Rich and the Fall of Everyone Else* (Penguin 2012).

in movies like *Wall Street*, they had stuff, and their stuff was coveted. A bemused Michael Douglas said in a 2012 interview that young men routinely come up to him and say, "Gordon Gekko! You're my hero! You're the reason I went to Wall Street!"—as if *Wall Street* were an inspirational film rather than a cautionary tale about a financial crook.

Greed was suddenly good, so was shopping. In the wake of 9/11, then President George W. Bush elevated it to a patriotic act. ("Some don't want to go shopping," after the terrorist attack, Bush said. "That should not and that will not stand in America.") Carrie Bradshaw of *Sex and the City* became our lovable over-spender, trolling for Manolos she couldn't afford in between too many cosmopolitans. The show, which ran from 1998 to 2004, and could be credited with mainstreaming a familiarity with designer brands, became very popular among tween and teenage girls, who took to showing off their hauls from shopping expeditions in online "haul vlogs." *Who Wants to Be A Millionaire?* (1999–2013) another popular show asked. Well, who didn't? "Everyone wants to be rich," said David Siegel, the private timeshare mogul profiled in the documentary *The Queen of Versailles* (2012). "If they can't be rich, the next best thing is to feel rich."

By the 1980s, there weren't songs on the radio anymore about loving your fellow human beings. *"Come on, people now, smile on your brother, everybody get together, try to love one another right now,"* sang the Youngbloods in 1967. *"People all over the world, join hands, start a love train,"* crooned the O'Jays in 1973. Now there were songs about loving yourself—and stuff. There was Madonna singing about being "a material girl," "living in the material world." There was Puff Daddy, in the 1990s, rapping, *"It's all about the Benjamins, baby."* In 2008, the R&B group Little Jackie proclaimed, *"The world should revolve around me."* Jay-Z goes by the nickname "Hova"—as in Jehovah—and calls himself "the eighth wonder of the world." The shift in values could be seen on television, too. There weren't shows

about poor families anymore, like *Good Times* (1974–1979) or *The Waltons* (1972–1981)—there were shows about rich people, *Dynasty* (1981–1989) and *Dallas* (1978–1991) and, of course, *Lifestyles of the Rich and Famous*.

Lifestyles had a long run, from 1984 to 1995, and its impact was enormous. Now regular people could see what it was like to be rich from the inside—and they wanted it. "Lifestyles of the Rich and Famous" (1996) by rappers Kool G Rap and DJ Polo, trumpeted the delights of having a "yacht that makes the Love Boat look like a life raft." Quite a change from the Intruders' 1974 anthem, "Be Thankful for What You Got."

When I got a chance to talk to Nick Prugo and asked him why he thought Rachel Lee was so obsessed with their famous victims that she would steal their clothes, he said, "I think she just wanted to be part of the lifestyle. Like, the lifestyle that everybody kind of wants."

7

When you drive up to the address of Indian Hills, the first thing you see is another school, Agoura High; the two schools share a campus. Agoura is a bustling, idyllic sort of American high school, very proud of its Chargers football team. It sits in a large tan brick building with a parking lot full of luxury cars, shiny BMWs, Audis, and SUVs.

Indian Hills, which has less than 100 students, resides at the back, in several prefab buildings, like the ones used as offices at construction sites. It has as its logo the uncomfortable image of an Indianhead, and, hidden at the back of the compound as it is, it has the feeling of being stuck on a reservation.

The two girls I met in the parking lot were seniors at the school. They said they'd rather not use their real names, as they

"didn't want to get involved." They chose the names "Monica" and "Ashley." They were wearing low-slung jeans, tight long-sleeved Ts and a lot of dark eye makeup. Monica was smoking.

We went and sat on the bleachers of the playing field, which was empty except for a couple boys running around the track. Monica said she was sent to Indian Hills for "drugs"; Ashley because "I have trouble learning."

"She was toootally into herself," said Monica.

"Oh, I liked Rachel," said Ashley. "She could be sweet."

Monica raised an eyebrow. "Sweet? You mean *mean*," she said.

They said they knew Rachel Lee, Nick Prugo, and Diana Tamayo, having gone to school with the older kids before they graduated in 2008. "Everybody knew what they were doing"—that is, burglarizing the homes of celebrities, said Monica.

"They bragged about it. At parties and stuff," said Ashley.

"Most people didn't believe it," Monica said. "People thought they were just talking shit."

I asked them why no one ever reported it to the police.

Monica made a face. "You don't do that. They would wear like, Paris Hilton's stuff, and *say* they were wearing it. I would have sold that shit."

TMZ would post a picture of Nick wearing a "P" necklace allegedly belonging to Hilton; across the picture Nick had scrawled, Perez Hilton–style, "Hey Paris, look familiar?"

"Rachel had really nice clothes," said Ashley. "Everyone else would be dressed, like, casually, in jeans and shorts, and she would be wearing like some designer top and heels. She looked like a celebrity. She looked like someone in a magazine."

"Yeah, *Burglars' Magazine*," said Monica.

"Prugo stated that Lee was the driving force of the burglary crew and that her motivation was based in her desire to own the designer wardrobes of the Hollywood celebrities that she admired," said the LAPD's report.

I asked the girls if they knew how Rachel afforded her stylish

wardrobe. "A lot of people in this area have money," Monica said, shrugging.

"She acted kind of spoiled," said Ashley. "I heard she didn't get along with her mom but then she would have all this really nice stuff so I thought maybe her mom was trying to win her daughter by giving her stuff—I don't know. I heard she didn't like her stepfather. She had a really nice car, an Audi A4."

"Rachel's a mean girl," Monica said with a click of her tongue. "She was backstabby. When people say Nick was the ringleader, I don't believe it, 'cause he could never do that by himself. He was too nervous."

I asked them about Diana Tamayo. "Always getting into fights," Monica said. "She used to, like, yell at the Agoura Hills kids 'cause they act like we don't exist."

The boys running around the track ran by.

"It's not all bad here," said Ashley after a moment. "Heather Graham," the actress, "went to Agoura."

"And Brad Delson, the guitarist from Linkin Park," Monica said. They seemed almost proud of it.

"We're a very small group," said Ashley said, "but Rachel and Diana definitely ruled."

"They thought they were The Plastics"—the popular clique in the movie *Mean Girls* (2004), said Monica.

"Once Rachel told me she liked my shoes—they were just some flip-flops but they had a bow—and, I don't know, it made me feel good that someone with that much style liked what I was wearing," said Ashley.

8

It all started, Nick said, when he met Rachel at Indian Hills in the fall of 2006. He'd come back to Calabasas after a year in Idaho, where his family had moved for a while, in part because he was

having difficulties. He'd become "anxious and depressed." He'd been "seeing therapists and psychiatrists." He "had issues," he said. "I was trying to figure out who I was." He'd been diagnosed with ADHD when he was 12, but didn't "think that was a true diagnosis." He didn't think it was "accurate." He could concentrate on schoolwork, he just didn't want to. They put him on Concerta* anyway and he "lost a bunch of weight." He got skinny. He wasn't eating. His parents took him off that when they saw he was "getting weak." Then they put him on Zoloft† for his "anxiety issues," but he didn't think it was helping either.

He said he didn't really know why he got like this—troubled, scared. He wasn't always this way. When he was a kid, he said, he felt good enough about himself to perform in plays. He was in all the plays in school. His parents had seemed proud of him then. His mother seemed excited and happy for him when he got a part in a documentary for the Discovery Channel called *Little Lost Souls: Children Possessed?* (2003). It was about children whose parents think they're possessed by evil spirits. He played a kid named "Kenny" in a re-enactment—it was somewhat corny, but it was a real job, and it was like being a real actor. He thought about becoming an actor one day. Why not? His dad was in the business.

And then something happened around the time he turned 14. It was like somebody pulled out the rug from under him and he was falling through the floor. Suddenly, he couldn't feel comfortable in his own skin, he was so aware of people looking at him, judging him. He became self-conscious about his face, his body, and his clothes. "I genuinely felt that I was ugly," he said. "I never thought I was an A-list looking guy"—not like the models in magazines or the actors on TV, the really truly good-looking people with their perfect skin and perfect bodies and perfect hair and teeth. He felt

* A psychostimulant used for the treatment of ADHD.
† An antidepressant.

"self-loathing things." It was getting harder and harder to do anything. He didn't want to go to school anymore.

His family moved back to Calabasas and he spent ninth grade at Calabasas High. But he didn't like it there—the atmosphere could be very intimidating. All the kids seemed really rich—"everybody else had, like, BMWs and I had a Toyota," he said. They were ambitious and focused on getting into good colleges. The school was ranked one of the top high schools in the state—it had won some "blue ribbon" award from the government, and you never stopped hearing about it. If you did well there, then you were on your way to having this awesome life, they always seemed to be telling you, but if you couldn't cut it. . . . There were kids who seemed to smirk if you couldn't keep up. Meanwhile the most notable person who had ever attended that school was Erik Menendez, who killed his parents.* Oh, and Katie Cassidy, David's daughter; she was on *Gossip Girl.*

Nick stopped going to class. He "couldn't deal with the whole going-to-school thing every day. It didn't fit me. I didn't want to get up. . . . I wouldn't want to go to school—for stupid things, like, oh, I had a pimple." Eventually he was kicked out for excessive absences. Some people wondered if he were doing drugs, but "this is the crazy thing," he said, "I didn't even smoke cigarettes. I didn't smoke weed. I didn't do coke, I didn't do anything, right? I think I was just . . . depressed and had anxiety issues and other stuff."

And then, in tenth grade, he went to Indian Hills. It had a reputation for being a school for burnouts and fuck-ups. He was afraid it was going to be some kind of horrible place, but actually, it was a welcome change, a haven. "Everyone talks about it like it's all these drug addicts," Nick said, "but some of the kids just can't do the school thing every day—they learn different from other kids.

* In 1989, along with his older brother Lyle, in Beverly Hills.

The people I involved myself with, they weren't drug addicts—they were unconventional."

It was at Indian Hills that he first saw Rachel Lee. It was hard not to notice her. She was a "really attractive girl." And she had the most stylish clothes. But it wasn't just her clothes, Nick said, it was the way she wore them, like someone who really knew about fashion and had a sense of what looked good. That was so rare in Calabasas. Rachel wore clothes like she *deserved* to look good. She had this amazing confidence. It fascinated Nick. He noticed Rachel because he was into fashion, too. He "liked clothes," he "liked to think" he "was a stylish guy." But he had never met anyone he could talk with about fashion. He'd never had many friends at all, and fashion wasn't something he felt he could discuss with his family. Imagine, asking his dad what he thought of Charlize Theron's gown at the Oscars.

He and Rachel "bonded over fashion naturally." "She liked fashion, she liked celebrity, she liked clothes." Nick had never thought about designing clothes before, but now he did. Rachel wanted to design clothes; she said that some day she would have her own line. She wanted to go to FIDM, the Fashion Institute of Design and Merchandising, in L.A. Lauren Conrad from *The Hills* went there. "A lot of the *Hills* girls went to FIDM. Rachel loved *The Hills*," Nick said. Before too long he found himself at Rachel's house, hanging out and watching *The Hills*, laughing over the stupid catfights on the show and talking about the clothes. Now Nick and Rachel were going on style websites together and checking out the fashions worn on her favorite shows and finding out where you could "get the look."

"She was the first person I felt was, like, my best friend," Nick said, and it made him so happy, "sometimes I almost felt like I could cry over it."

With Rachel, he could talk about anything. They could talk about clothes and try on clothes. He could even put on eye makeup

with Rachel, if he wanted to, just for fun; Rachel didn't judge. But it wasn't only fashion they were bonding over. They were telling each other about their lives. Nick had never done this with anyone before. He told Rachel about his "turmoil"; how he was feeling estranged from his parents. It seemed his problems in school and emotional struggles had caused a breakdown of communication. "Me and my parents kind of had a falling-out," he said. "It was an awkward time for me and them."

Rachel listened. "She really sympathizes with whatever your situation is," Nick said. "She puts herself in there to understand you, to feel your pain. She builds on that. She really knew where I was at and she knew how to comfort me and be a friend to me, and I think that's why I trusted her so much and why I got involved with her so much. . . .

"I loved her," he said. "I really did, she was the first person I felt was like my best friend. . . . I really thought I loved her—just as a person, not as a girlfriend. I just loved her almost as like a sister and that's what made this situation so hard. . . ."

Now they were in constant contact, talking on the phone, IMing, texting. "People would call Rachel and be, like, oh, you're with Nick. People would, like, know that we were together all the time, every day. Every moment we were together. We were like a one-man-one-woman show. It was me and her till the end, death do us part. We were inseparable."

And Rachel was telling Nick about her problems, too. Her parents had divorced when she was young. Her father moved to Las Vegas, and Rachel and her older sister, Candace, had stayed with their mother in Calabasas. Then Rachel's mother married a man named Phil with whom, Nick said, Rachel didn't get along. "Rachel hates her stepfather," he said. "She just had her issues with him as any stepkid would." He said her stepfather had children of his own, and there was tension in the house. Nick comforted her as she had comforted him. "It was so much more than a friendship."

Through Rachel, Nick was making other friends—"just normal kids, maybe more upper-class, with money, but normal, nothing out of the ordinary." He met Rachel's friend Courtney Ames, who went to Calabasas High. Rachel had known Courtney since seventh grade. Courtney would skip school and come out to smoke weed with them, Nick said. She was kind of a tough girl, not fashionable like Rachel, but Nick "bonded" with her because she was Rachel's friend. It seemed that Rachel and Courtney were close because they had known each other for so long; they were certainly very different. Nick got to know Courtney at the many parties someone was throwing "every other day." For the first time in his life, he knew what it was to be part of a social scene.

He also met Tess Taylor, who went to Oak Park High. "Tess really liked me," Nick said. "I would go hang out with Tess. We would smoke together. . . . She's pretty. She's gorgeous. She's a really good storyteller—she's really good at getting people believing her stories. . . . Basically, if she wants to make it happens she'll make it happen, she's really smart like that." And through Tess, Nick met her friend Alexis Neiers, another pretty girl, one grade younger, who was being homeschooled because her mother believed in all this New Age spiritual stuff.

"This was the social group," Nick said, "This was the Valley group. . . . And this group is sympathizing with me; they're caring for me. I felt like they understood me. It was the first time . . . I felt like I had a support system outside of my family, and someone my own age I felt loved me."

Tenth grade was wonderful. It was Nick and Rachel, a couple of "carefree kids," "smoking weed," "hanging out at Zuma Beach" near lifeguard stand No. 7, "going to parties with a lot of underage kids doing beer pong," Nick said. "It wasn't something devious or ill." He never wanted it to end.

"I guess I was a little naïve about everything," he said, "but I was like, I'm gonna do whatever makes this person happy."

And that's why, he said, when Rachel "sort of let it drop" that

she had gone into someone's house and stolen some money, he didn't make a big deal of it. "She said this one time before I even knew her she had, like, gone into this person's house when they were out of town and taken money from them. In my mind I'm like okaaay, whatever, just wanting to please her."

And then, he said, Rachel asked if he knew of anyone who was out of town. This was the summer after tenth grade, now 2007. "And," Nick said, "I was like, this guy's out of town, why?" The guy's name was Eden. Nick had met him on MySpace. They'd been getting to know each other, "hanging out." Nick told Rachel that Eden and his family had gone to Jamaica for two weeks; and before he knew it, he said, he and Rachel were driving to Eden's house in Woodland Hills, about ten minutes from Calabasas.

It was night. They parked on the street and rang the bell, checking to make sure no one was home. They never had any trouble getting into anyone's house, Nick said, there was always a way in, usually through an unlocked door. And there was always the cover of their youth and presumed cluelessness if anyone noticed them trying door handles or windows. They could say they had forgotten their keys, or they were helping a friend who'd forgotten theirs. Usually they just walked in a door someone had forgotten to lock. Who's that careful in a nice neighborhood? They walked right into Eden's house. Nick said he immediately felt like running back out. . . .

But now, he said, Rachel was strolling through the place, looking at everything, picking stuff up. "I'm in the house, walking back and forth," he said, "freaking out. I mean, it's weird, to go through somebody's things; it's unnatural, it's not something, like, you know how to deal with."

But then "[Rachel's], like, looking under the bed," he said, "and she finds a box full of, like, eight grand in cash. This is the first time I've ever been involved in something like this, so naturally it's like, oh my *God*, you found eight *grand*? . . .

"So we each get four grand," he said. "And it was like, wow.

That was so easy.... We didn't do anything so bad. We didn't kill anybody.... It wasn't murder."

The next day, he said, they went back to the house and took Eden's Infinity out for a spin. Rachel had found the keys in the house.

"We went to Rodeo Drive," Nick said. "We went shopping."

9

"Nick's got some self-esteem issues he's working through and he's seeing a psychiatrist," Sean Erenstoft, Nick's lawyer, told me on the phone. "He's going to drug rehab—he had a drug bust," for cocaine possession, "earlier in the year and so his world collapsed. Inward he's a kid; he's still eighteen and lives with mommy and daddy.

"Rachel's very much the 'A' type," Erenstoft said. "She's the lioness, very much a leader, very influential. Rachel was actually able to lead some other pretty good kids into what seemed like fun—sounds like this Diana Tamayo was the class president and most-likely-to-succeed type girl and the next thing you know she's being arrested for burglary."

It was November 2009 when Erenstoft and I spoke a few times—he still hadn't made up his mind about whether he was going to allow Nick to talk to me. Meanwhile I was travelling back and forth from New York to L.A., meeting with cops and other lawyers in the case. I was beginning to worry about making contact with the defendants—any of the defendants; their attorneys had them all on lockdown. But this story wouldn't be any good without hearing from the kids. They were the only ones who could really say why they did it or what it all meant.

I was starting to suspect from my conversations with Erenstoft that he was the reason for all the media reports on how Rachel was the "ringleader" of the Bling Ring gang; he was getting out in front

of the story, minimizing Nick's role, depicting him as a follower. Nick "will be found to have played a very, very limited role," Erenstoft had said in a phone interview with the *Today* show in October.

Of course, the person I wanted to speak to most of all was Rachel herself. I tried repeatedly to make contact with her, but her lawyer, Peter Korn, would not allow it. What was Rachel's story? I wondered. What was her motivation? Why did she want celebrities' clothes? Was she really the one influencing all the other kids? Or was Nick just selling her out to save himself?

"Even if it Prugo was the ringleader, what was he getting out of all this?" my cop source asked. "Those kids stole *women's* clothes. It's kind of a bizarre thing for a teenage boy to be doing."

But American boys were doing all kinds of troubling things, I was learning, reading up on what was going on with kids. "It's a bad time to be a boy in America," wrote Christina Hoff Sommers in *The War Against Boys* (2000). This now popular notion gained traction in the aftermath of the Columbine shooting on April 20, 1999, when teenagers Eric Harris and Dylan Klebold killed 13 people and wounded 24 others at Columbine High School in Columbine, Colorado, before turning their guns on themselves. The massacre raised concerns about the state of American boys: what was wrong?

By the turn of the 21st century, boys were dropping out of school, being diagnosed with psychiatric conditions, and committing suicide four times more often than girls; they were getting into more fights, were 10 times more likely to commit murder, and 15 times more likely to become the victim of a crime. Boys were less likely than girls to go to college, were more often labeled "slow learners" and assigned to remedial education; and far more boys were being diagnosed (some say misdiagnosed) with ADD and ADHD and placed on prescription drugs like Adderall and Concerta. Boys in 2007 were 30 times more likely to be taking these types of drugs than boys in 1987 were.

But American girls were having a hard time, too. If we're going

to talk about the Bling Ring burglaries as iconic crimes, then we have to begin with the fact that, as my cop source pointed out, they were mostly girls robbing mostly girls. There was Rachel the "mean girl," the arch fashionista; Courtney Ames and her blasé attitude toward getting high; Diana Tamayo, the good student who got into physical altercations; and Alexis Neiers with her pole dancing and exulting over her friend Tess Taylor getting tapped to pose for *Playboy*: "Tess and I woke up to a call from Hugh Hef," Neiers tweeted on April 15, 2009. "Letting her know that she got a 6 pg layout and the cover for playboy! He asked me too but idk [I don't know]."

They were like four faces of the crisis in what is sometimes known as "Girl World."* Meanness, alcohol and drug abuse, aggression, "hypersexuality"—these were all symptoms of a plague of seemingly bubonic proportions that was robbing girls of their childhoods and making them confused and depressed and hard. Once upon a time, the American girl was a shining symbol of something fresh, spirited, and fully self-confident. Mark Twain said, "The average American girl possesses the valuable qualities of naturalness, honesty, and inoffensive straightforwardness; she is nearly barren of troublesome conventions and artificialities." Now, the American girl is often associated with the raunchy style of the girls on *Girls Gone Wild* (1997–). She sometimes seems unhappy and out of control, and nobody seems to know quite what to do about it.

I had a little girl of my own at home. She was lovely, then age nine. Travelling back and forth to L.A. from New York on this story, I would have to leave her for a few days at a time. I didn't like to leave her, even though she was always with someone I trusted to the core. There was something about this story that was making me anxious to be near her, with her, watching over her. This story was

* The phrase appeared in Rosalind Wiseman's *Queen Bees and Wannabes* (Crown, 2002), largely the basis for the movie *Mean Girls*.

making me think about what a tough time it was to be a girl growing up in America.

The statistics are all so dismal. Nearly a quarter of American girls now say they start drinking before age 13. Between 1999 and 2008, the number of females arrested for D.U.I. rose by 35 percent. A 2012 study by the Partnership for a Drug Free America found a 29 percent increase in marijuana use among teenage girls from the year before, with close to 70 percent agreeing that "using drugs helps kids deal with problems at home." The American Academy of Child and Adolescent Psychiatry found that as many as 10 in 100 American girls and young women suffer from an eating disorder. Over the last two decades, the number of arrests of females age 10 to 17 for aggravated assault has nearly doubled. In 2005, *Newsweek* ran a cover story headlined "Bad Girls Go Wild," calling "the significant rise in violent behavior among girls" a "burgeoning national crisis." In 2004, the FBI released data showing an increase in arrests of girls between 1991 and 2000, with arrests of girls now accounting for one in three of all juvenile arrests. Boys commit suicide more often than girls do, but girls attempt it three times more often.

Why were girls being so self-destructive? There's certainly no lack of positive role models for girls in America (Oprah Winfrey, Hillary Clinton, Ellen Ochoa, and Serena Williams come to mind), but there's also no question that there's a disproportionate amount of coverage of women you wouldn't necessarily want your daughter to emulate. When the Bling Ring girls were coming of age, there were four other girls in the public eye with very similar problems— except that they were very, very famous. In roughly the four years before the burglaries began, between 2004 and 2008, there had been a frenzy of news about the misadventures of a group of Young Hollywood personalities known as the "starlets"—Paris Hilton, Lindsay Lohan, Nicole Richie, and Britney Spears, a panties-flashing coterie of paparazzi bait who were BFFs and frenemies in real life.

The starlets seemed just as fame-obsessed as the consumers of the gossip about them, staging catfights for the cameras, calling the paparazzi on themselves. But they also had real problems. Paris, Nicole, and Lindsay had all been arrested for D.U.I. and done brief—sometimes very brief—bids in jail. (In 2007, Nicole did 82 minutes of a four-day sentence for D.U.I. That same year, Lindsay did 84 minutes of a one-day sentence for D.U.I. and misdemeanor cocaine use.) Nicole had admitted to using heroin, while Lindsay had been found with cocaine. In 2010, Paris was arrested for cocaine possession as well. Nicole and Lindsay had struggled with anorexia and bulimia, respectively. A 2006 paparazzi shot of them both looking skeletal, in designer gowns, is still shocking. Britney shaved her head and beat a paparazzo's car with an umbrella in a bizarre public meltdown. Nicole, Lindsay, and Britney had all sought help in rehab. Nicole flashed her breasts for the audience at a fashion show.

The starlets had the misfortune of having shot to fame just as the celebrity news business was exploding like a mushroom cloud. TMZ chased after them as if they were their own personal Furies. They were perfect fodder for the new, mean style of celebrity reporting, being young, "hot," female, and fairly troubled. A picture of Lindsay passed out in the front seat of a car, a photo of Britney strapped to a gurney, on her way to a psych ward, became indelible images of the new celebrity culture. But sometimes the starlets seemed to be milking their misfortunes for attention. Paris and Lindsay made use of their paparazzi-documented walks in and out of courtrooms and jailhouses, working them like runways. The public seemed to revel in their growing disrepute as much as they were outraged by it. The white, skintight Kimberly Ovitz minidress that Lindsay wore in February 2011 when she attended a hearing for grand theft felony sold out across the country almost immediately.

The national preoccupation with the trials and tribulations of these young women—who seemed to spin more out of control the more preoccupied people became—got so bad that former vice

president Al Gore felt moved to weigh in, denouncing our "serial obsession" with "Britney and KFed, and Lindsay and Paris and Nicole" in his bestselling book, *The Assault on Reason* (Penguin, 2007). *Newsweek* decided that the influence of the starlets was becoming a matter of national concern and in 2007 did a cover story, "Girls Gone Bad," which hovered on the edge of parody: "Paris, Britney, Lindsay and Nicole. They seem to be everywhere and they may not be wearing underwear," said the magazine. "Tweens adore them and teens envy them. But are we raising a generation of prosti-tots?" An accompanying poll found that "77 percent of Americans believe that Britney, Paris and Lindsay have too much influence on young girls."

But were the starlets really a source of trouble in Girl World, or just another one of its symptoms? Weren't they just girls themselves, exhibiting in a public arena behaviors that had already become widespread? News of their misadventures was a powerful distraction from some of the more worrisome headlines of the day. How did it feel to be a kid in America? By 2008, the same year Nick Prugo and Rachel Lee began their burglary spree through the Hollywood Hills, we'd just lived through what might be considered some of the darkest eight years in American history. We'd been attacked by terrorists; engaged in two very bloody and unpopular wars. The Bush administration had sanctioned torture. We'd grown accustomed to the drone strike as a form of warfare, and had seen our fellow citizens left to perish on rooftops after Hurricane Katrina. If, as Joseph Stiglitz said, "trickle-down behaviorism is very real," then there was plenty of meanness and aggression to trickle down.

Barack Obama was elected president in November 2008 promising hope and change; but nothing changes overnight. The number of drone strikes has increased. There have been 15 more mass shootings. As of 2013, the United States has less equality of opportunity than almost any other industrialized country. And Lindsay Lohan is still getting arrested.

10

On a bright afternoon in L.A. in November 2009, I went to meet with Alexis Neiers at the offices of her lawyer, Jeffrey Rubenstein. Rubenstein had a suite in an orange-colored high-rise on Wilshire Boulevard. After much back and forth on the phone he'd agreed to let me talk to his client, saying it was an opportunity for her to "protect her interests" in the face of a "prejudicial media storm." In the press release he'd put on his website he maintained her innocence, saying she had been "in the wrong place at the wrong time."

This press release included a picture of Rubenstein and Neiers and Tess Taylor (also then his client) meeting in his office and poring over papers together. Taylor had on a halter-top that revealed some cleavage and some of her seventeen tattoos. Rubenstein had advised me that Taylor was "going to be a Playmate."

"We think it's a fun case," Rubenstein had said on the phone. He'd told me he couldn't discuss the particulars of Neiers' situation, but he would talk about the Bling Ring generally based on information he had learned from the police.

"These kids went on shopping sprees," he said. "It's like they went shopping online. They'd look at a picture on some website of a celebrity holding a Marc Jacobs bag, and they'd say, instead of going to a Marc Jacobs' store and getting a bag like that, I want *that* bag that Lindsay is carrying—I want *Lindsay's* Marc Jacobs bag."

Images taken off the recovered computer allegedly stolen by Nick Prugo showed a gallery of photos of celebrities in designer clothes and bling—Paris Hilton, Lindsay Lohan, Megan Fox, Audrina Patridge, Britney Spears, Hayden Panettiere, Rihanna, Jessica Biel. It had a Google Images search with the heading "Audrina Patridge diamond watch" and photos of Lohan and her then girlfriend, D.J. Samantha Ronson, out shopping for Rolex watches in L.A.

"In some ways they were very unsophisticated," Rubenstein said, "and in some ways they were right out of *Ocean's Eleven*. My understanding is they did really detailed surveillance of these people. They'd drive by their homes and check out the places to see how they would enter. You know when you were a kid and you and your friends would break into your parents' pool house and steal beer? There was some kind of clubhouse thing going on with these celebrities' houses. They were hitting the homes more than once. They weren't into hot prowls; they weren't trying to find these people at home. But there was something very weird going on. This is a Dr. Drew book.*

"What started off as trespassing," he said, "became burglary and then something much scarier. There's elements in this stuff of—well, somebody brought up the Mansons."

I asked him why he thought they did it.

"I wanna feel like they look," said Rubenstein, riffing, "and if I have what they have then I'll be like them. If I can dress like they dress, my problems will go away, my pain will go away. . . ."

When I arrived at his office, Rubenstein got up from behind his desk and came over to greet me. He was a bullet of a man with a shaved head and dark blue eyes, which matched the indigo of his Armani jacket. There was a panoramic view of L.A. behind him and a framed picture of him with Neiers on his desk. "Even if I never get paid, I'm gonna get this little girl off," he told me firmly.

"I wanted to keep her from being charged," he said, "and I'm not happy that she was."

On October 28, 2009, the Los Angeles District Attorney's office had formally charged Neiers with one count of residential burglary for the robbery of Orlando Bloom. (Taylor was never charged.) That same day, Nick Prugo was also charged with six ad-

* See Dr. Drew Pinsky and Dr. S. Mark Young, *The Mirror Effect: How Celebrity Narcissism Is Seducing America* (Harper, 2009).

ditional counts of residential burglary—for Bloom, Hilton, Bilson, Green, as well as an Encino builder and developer named Nick DeLeo and a Hollywood architect, Richard Altuna (whose home Prugo had apparently mistaken for celebrity D.J. Paul Oakenfold's). There were two counts against Diana Tamayo (for Lohan and Ashley Tisdale); one against Courtney Ames (for Hilton); and one against Roy Lopez (for Hilton again). Each count of burglary carried a potential sentence of two to six years in prison.

A warrant had been issued for the arrest of Jonathan Ajar for possession of narcotics and a stolen handgun found in his apartment in a police search on October 22. But so far, curiously enough, Rachel Lee had not been charged. "I was blown away when she wasn't charged," Rubenstein said. "She thinks she's smarter than anybody else, and, guess what, I think she might be.

"This case has been amateur hour," in terms of the justice system, the lawyer complained. "The other lawyers have made every amateur hour move that can be made. Everybody wants publicity. Even the police. And somebody's talking to TMZ." He frowned.

"One of my threats if Alexis was charged was to go on a media blitz," he said. "I believe her story is compelling and I don't think she was a principal."

I asked him what her story was. Why did she have stolen property in her house? Why was she arrested for the Bloom burglary? "I can't talk about that yet," Rubenstein said, "but we *will*. She wants her story known." He further said Neiers "seemed to be a good girl" and had achieved the "highest level in Pilates you can earn." (When I later contacted the Pilates Method Alliance, the governing body of Pilates in the United States, they said no such ranking exists.)

I asked Rubenstein if I could ask Alexis about her upcoming reality show, *Pretty Wild*.

He said, "I have to get clearance." He didn't tell me he was also going to be a character on it.

Now Rubenstein's colleague, Susan Haber, brought Alexis and her mother, Andrea Arlington Dunn, into the room. Dunn was

tall and curvy and wearing a fuzzy bronze-colored Juicy sweat-suit. A pair of headphones dangled from her ears, connected to a cell phone inside her purse. She had highlighted, shoulder-length brown hair and wore a startled expression. There was a flirtatious lilt to her voice, which brought to mind sex kittens of another era.

And then there was Alexis. She was a leggy five-foot-nine, wearing black tights, a long gray sweater, and six-inch heels. She had big hypnotic green eyes and a cascade of chestnut hair. On her wrists there were tattoos of cherry blossoms—"a sign of consciousness," she told me—and on her hand there was an ankh, the Egyptian symbol for life. She was like something out of a Philip Marlowe tale, the beautiful suspect whose story sounds a bit suspect as well.

"I'm an indigo child," Alexis said in her squeaky baby voice, after she'd settled into a chair. "Which means I have a special energy, a spiritual energy."

Her mother nodded, wide-eyed, from Rubenstein's couch. I was trying to remember when I had seen a mother look on her daughter with such devotion—it was Kathy Hilton, mother of Paris.

An "indigo child," I later learned, is a tyke who's said to be blessed with extraordinary and supernatural gifts, according to husband-and-wife New Age self-help gurus Lee Carroll and Jan Tober in *The Indigo Children* (1999).

"I believe that I'm an old soul," Alexis said.

"Yes, she is," Andrea murmured.

They told me that they lived by a spiritual philosophy, which relied heavily on the teachings of *The Secret*, the 2006 self-help best-seller by Australian television writer and producer Rhonda Byrne, which posits that wealth, health, happiness, and weight loss are all achievable through positive thinking.

"It's the law of attraction," Andrea said. "It's the study of man's relationship to the divine. It's not Scientology. It's not Christian Science. . . ."

"My mom is a minister," Alexis offered. "She's been a masseuse. She's an energy healer. She does holistic health care for people with cancer."

"I don't serve at a church currently," Andrea interjected.

She later told me that she'd been ordained through an online course, "the Ernest Holmes* Religious Science Ministerial Program, whose teachings include ancient wisdom principles from spiritual teachings since the beginning of time."

"Our church does a yearly trip to Africa where they build wells and schools for the kids," said Alexis.

I asked her which country; she couldn't remember.

"It was like three years ago," said Andrea. "We participated in that fund-raiser."

"We do bake sales, car washes, and we go to women's shelters during Christmas, feeding the homeless and all that type of stuff," Alexis said.

"Alexis has expressed to me a lot of her humanitarianism," said Haber, the lawyer, an angular woman with angular hair in a conservative brown suit.

I remarked that there seemed to be a bit of disconnect between Alexis' good works and her now being charged with burglary.

Haber interrupted, advising Alexis not to respond.

But Alexis insisted: "I have a good statement to say."

"I'm a firm believer in Karma," Alexis began, "and I think that this situation was attracted in my life because it was supposed to be a huge learning lesson for me to grow and expand as a spiritual human being. I don't think the universe could have really chosen a better person than me because for this—it's not just affecting me, it's affecting the media, it's affecting everyone—and I think that I'm meant to bring truth to all this."

* In the 1920s, Holmes was a founder of the spiritual movement Religious Science, or "Science of Mind," a precursor to New Age thought.

"I think that my journey on this planet is to be a leader," she said; her voice was trembling now. She was welling up. "I see myself being like Angelina Jolie but even stronger, pushing even harder for the universe and for peace and for the health of our planet.

"God didn't give me these talents and what I look like," she said, "to be sitting around and just being a model or be famous or whatever path I want." Her pretty face was screwed up with emotion. "I want to do something that people notice, so that's why I'm studying business"—she had taken some classes at Pierce College—"because eventually I want to be a leader. I want to lead a huge charity organization. I want to lead a country, for all I know. I don't know where I'm going just yet, but eventually I can see myself taking a stand for people."

"And so it is," said Andrea. It was their family motto, a Hindu prayer and the mantra of the movie version of *The Secret*.

11

Christopher Lasch's 1978 best-selling book, *The Culture of Narcissism*, noted a trend of Americans becoming more self-absorbed at a time of diminishing economic expectations. Since then, sociologists and psychologists have been trying to puzzle out the reasons for the precipitous rise in narcissism in America. Over the last three decades, American college students have scored increasingly higher and higher on the Narcissistic Personality Inventory (NPI), a test of narcissistic personality traits developed in the 1980s by psychologists Robert Raskin and Howard Terry at the University of California at Berkeley. (The rising of the scores has actually accelerated over the last decade. The increase between 2002 and 2007 was twice as large as the increase between 1982 and 2006.)

Without being told what the test is about, respondents are asked to rate which statement in a pair describes him or her best.

The first question on a shortened version of the test says, "Choose the one that you MOST AGREE with . . . A) The thought of ruling the world frightens the hell out of me. B) If I ruled the world, it would be a much better place."

The American spirit is about confidence; in "Self-Reliance" (1841), Emerson said to "Trust thyself: every heart vibrates to that iron string." But the kind of spiritual wholeness presupposed by that encouragement is very different from believing, as high scorers on the NPI do, that, "I can live my life any way I want to," or "I will never be happy until I get all that I deserve." The Bridezillas and Real Housewives of reality television, with their outrageous demands and insistence on being treated like queens, are cartoonish symbols of an age in which many people seem to feel so entitled they believe they "deserve" royal treatment. Advertisers happily cultivate the notion. JetBlue assures us that we "deserve a vacation"— and snacks. Time Warner Cable's slogan is "The Power of You." Kohl's department store ran an ad with a 2007 song by the punk band The Dollyrots (also featured on Paris Hilton's reality show *The Simple Life*) entitled "Because I'm Awesome": *"I'm a leader/I'm a winner . . . I don't need you . . . and I beat you/'Cause I'm awesome."*

The self-importance and diva behavior on display in shows like *Keeping Up with the Kardashians* and *Gastineau Girls* (2005–2006)—whose star, Brittny Gastineau, was on the Bling Ring's target list—are extreme reflections of traits that have now become familiar, especially among the young. In a 2008 survey of college students, one-third said they should be able to reschedule an exam if it interfered with their vacation plans. A 2007 survey of 2,500 hiring managers found that 87 percent felt that young workers "feel more entitled in terms of compensation, benefits, and career advancement than older generations." And then there is the "princess phenomenon" in which little girls who believe they *are* princesses insist on dressing in bejeweled plastic tiaras and faux taffeta ball gowns purchased from the $4 billion Disney Princess empire.

One possible reason for the spike in narcissism, according to the authors of *The Narcissism Epidemic* (2009), Jean M. Twenge and W. Keith Campbell, is the value American culture puts on fame. It's a chicken-and-egg proposition—do we want to be famous because we are narcissists? or has fame culture made us narcissistic?—but according to one study, famous people tend to be the biggest narcissists of all. In 2006, Drs. Drew Pinsky and Mark S. Young published the results of administering the NPI to 200 celebrities from all fields of entertainment: "they showed that narcissism is not a byproduct of celebrity, but a primary motivating force that drives people to become celebrities," the authors wrote in *The Mirror Effect*. In other words, many of the leading representatives of our dominant culture may have seriously dysfunctional personalities.

Other possible factors for the rise in narcissism are the self-help and self-esteem movements of the 1970s; the Baby Boomers' premium on "finding yourself"; the skyrocketing divorce rate (which drove families apart and isolated individuals, allegedly turning them inward); the expansion of celebrity-driven media, and the emergence of reality television. You might throw into that pot the fall of the Berlin Wall, which gave Americans an unbridled feeling of national triumph in our hegemony ("USA! USA!").

And another factor is parenting. Listening to Alexis talk about her plans to possibly run a country someday, I was reminded of a child-size T-shirt I'd seen for sale in a store that said, "Future Leader of The Free World." It hung on a rack alongside other shirts saying, "I'm In Charge," "Spoiled Rotten," and another saying, simply, "FAMOUS." I always wondered what kind of parents bought shirts like that for their kids. Apparently parents of budding narcissists do. The reaction of many Baby Boomers to the strict upbringings of their Depression-era parents was to indulge their own children, praising every scribble and softening every blow, giving them an inflated sense of self-worth, leading to a host of ills,

including "failure to launch syndrome," or the inability to figure out how to move out of the house and live as an independent adult.

More troubling, according to child psychologist Dan Kindlon, author of *Too Much of a Good Thing* (2001), overindulgent parenting can lead to character flaws resembling the so-called seven deadly sins: pride, wrath, envy, sloth, gluttony, lust (here, an unhealthy promiscuity), and greed. "The seven deadly sins are, of course, a succinct summary of the symptoms of narcissism," write Campbell and Twenge.

12

It was just a coincidence that I happened to know a family who knew the Arlington-Dunn-Neiers family when they lived in Oak Park, in the Canejo Valley (it's about ten minutes away from Thousand Oaks, where Andrea and Alexis later moved). I met this family while I was doing another story. The mother, who asked to remain anonymous, and I'll call "Susan," had taken a pole dancing class from Alexis at Poleates, a Pilates and pole dancing studio in Westlake Village.

"Andrea was into all this Buddhism stuff," Susan said, "but then she was letting her daughter hang out in nightclubs."

"At five thousand feet from the situation," said Susan's husband, who also asked to remain anonymous, "I could see that Andrea had become her girls' buddy. She had no objection to her daughter teaching a pole dancing class."

Susan's daughter, whom I'll call "Emily," was friends with Alexis, Tess, and Gabrielle Neiers—known as "Gabby"—when they were all Oak Park neighbors. When Emily met the family in 2005, Alexis was 14 and Tess 15. "Tess lived with her parents in Oak Park, but she hung out at Alexis' house all the time," Emily said. "When I first met them they were not wild at all. They wore no makeup. They were just naturally pretty and they were always talking about their

spiritual thing. Guys loved them; all the guys' mouths would, like, drop open when they saw them."

But then, she said, the girls began to change. "They became, like, these manipulative girls. They were good at getting guys to do what they wanted. They said they were older than they were. Their mom, Andrea, would do arts and crafts all the time. Tess was nice. She dated this boy who had inherited a lot of money. He had parties. Everyone would be there. Rick James' son Taz was part of the scene."

And then, "Tess and Alexis started getting into modeling," Emily said.

"They were always doing photo shoots," said Susan. "Andrea let them do those boudoir pictures in Paris."

In 2009, when they were 18 and 19, Alexis and Tess appeared in a video shoot for Issa Lingerie, which showed them in a Paris hotel room wearing fancy Victorian underwear and canoodling with each other. Their youthful allure was made use of, again, in a TV commercial for CamsNetwork.com, "The Hottest Adult Web Cams Site on the Net." In the ad, they can be seen in matching sports bras and "booty shorts," jogging bouncily down the street together, until they come upon a stunned male pedestrian, unaccountably stop, and begin caressing his face.

Emily said, "Alexis showed us all this stuff—she knew it belonged to celebrities. She showed us this dress she said belonged to Miranda Kerr"—the Victoria's Secret model and then girlfriend (now wife) of Orlando Bloom.

13

Rubenstein wouldn't allow me to ask Alexis about the Bloom burglary yet, which I wasn't thrilled about, but I decided to make the best of it and ask Alexis about herself. I did want to know the background of the kids, where they came from and who they were when

they weren't allegedly burglarizing celebrities. I wanted to know about Alexis' friendship with Tess.

"She's been in my life since I was two-and-a-half and she was three years old," Alexis said. She and Tess had met in ballet class as little girls, she said, and "she's stuck ever since. We've shared a bedroom for the last six years. We've legally adopted her," she claimed. "She had a kind of dysfunctional background. We both did."

"And I met her mom," Andrea interjected.

"Can I talk please?!" Alexis snapped, turning around in her chair to glare at her mother.

Andrea stopped talking.

"The reason why we related so well," Alexis went on, turning back around, "is my dad is a recovered drug addict and alcoholic, and Tracie, Tess' mom is—"

Andrea tried to cut in again to say something.

Alexis turned around and shouted, "Please! I told you that if you were going to be here you had to be quiet!"

Andrea shut her mouth.

The lawyers shuffled papers.

Alexis and Tess seemed to have a very close bond, so much so that they would sometimes pretend to be sisters. Their reality show, *Pretty Wild*, which would premiere on the E! network on March 14, 2010, encouraged the idea that Alexis, Tess, and Gabby were all actually sisters—wild sisters. The premise of the show was simply that—wild and pretty girls who lived in the Valley, with Andrea as the harried mom who can't figure out how to stop their out-of-control behavior. The show had been brought to comedian Chelsea Handler by a young comedian and actor, Dan Levy, who was familiar with Tess and Alexis' underage presence on the Hollywood nightclub scene; and then Handler brought it to the E! network.

When the girls appeared together—in short, tight dresses and high heels, beaming and giggling—on *Chelsea Lately* on March 11, 2010, to promote the show, host Handler said, "You're all sisters," to which Alexis, Gabby, and Tess responded, "Yes."

"So one of you was involved in that burglary," said Handler, who during the interview did not disclose that she was the executive producer of *Pretty Wild*.

"Well, I certainly would not say I was *involved*," said Alexis. "I've been accused of many things. The press constantly is hounding me. . . . We definitely use our philosophy of the Secret to get us through this."

"It absolutely works!" said Tess.

"You were in a movie together?" Handler said.

It was called *Frat Party* (straight to DVD, 2009). Dan Levy had also appeared in the film.

"We had a love scene together," said Alexis, coy.

"Alexis and I," Tess said, proud.

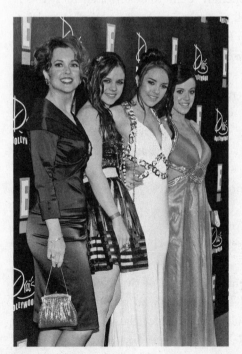

It was a mini-make-out session in which Tess was topless.

"Sisters had a love scene together. So this was shot in the Valley?" Handler joked. The audience laughed, perhaps aware of the Valley's reputation as the capital of the adult film industry.

In real life (as opposed to "reality"), Tess was not abandoned, nor was she ever adopted. Born Tess Amber Adler to Tracie and Franklin Adler, she attended Oak

Andrea Arlington Dunn, Gabrielle Neiers, Alexis Neiers, and Tess Taylor on the red carpet at E!'s Oscar party, March 7, 2010.

Park High School and Oak View High School, another alterna-
tive high school in the area. (She took "Taylor" as her stage name.)
After her parents divorced, she lived with her mother and then her
father, according to sources who know the family.

When I had the opportunity to talk to Tess on the phone, in
December 2009, she told me she had no contact with either of her
parents. "My mom kind of fell off the face of the planet," she said,
"and it just luckily happened" that she was taken in by Andrea some
six or seven years earlier. When I asked if I could talk to her mom,
Tess said she was "unreachable. Honestly I have no idea [where
she is]."

Soon after the premiere of *Pretty Wild*, discussions began to
pop up online about the identity and relationships of the characters
on the show, which was generally found to be unwatchable. "This is
an example of the downfall of our society" was a typical complaint.
(Joel McHale, host of E!'s *The Soup*, would quip, "*Pretty Wild* is like
Keeping Up with the Kardashians without the intellect or the moral
center.") You can only put so much stock in anonymous comments
on blogs, but there was a repetitive nature to some of the stories
told by people online who claimed to know the family. And some
of these claims were borne out in my interviews with Andrea and
Alexis—for example, the fact that Andrea and Tess' mother Tracie
had once been very close.

Alexis said, "My mom and [Tess'] mom became best
friends and—"

Andrea interrupted, "And then—"

Alexis shouted, "Please! That's why I didn't want you in here
because you talk!"

Online comments painted a picture of two New Age friends,
pretty Andrea Neiers and Tracie Adler, who had two pretty little
dark-haired girls they would take to ballet classes and services at
the Westlake Church of Religious Science. Tess, especially, showed
a talent for dancing at an early age; people who knew the family

thought that one day she would go professional. As the little girls grew, their mothers began to have trouble at home. Andrea's husband, Mikel Neiers, left her for another woman. Alexis told me that when she was three, her father left her mother for a production assistant on *Friends*. The breakup was hard on her, Alexis said. Neiers married the woman, but then later, "his wife left him," said Andrea. (Mikel Neiers declined to comment.)

Tracie Adler also got divorced from her husband Frank. Their daughter Tess was becoming "wild," hanging out at nightclubs in Hollywood, and not getting along with her father. "Frank and Tessy's relationship was tough," Alexis said. Tess moved out of her father's house when she was around 18, preferring to stay at Alexis' house, where her unofficial mother now also acted as an unofficial manager, encouraging Tess and Alexis in pursuing careers in modeling and acting.

In July 2009 Tess became a *Playboy* "Cybergirl." Andrea was there for Tess when she began working for the porn empire where Andrea herself once had modeled. "I was in the magazine doing ads all the time," Andrea told me. "I was a centerfold in the international edition. I was a Playmate." Stephen Wayda, the veteran *Playboy* photographer who shot Tess' Cybergirl shoot, also photographed Andrea in the 1980s, Andrea said. "I remember those days," she told me nostalgically.

Cybergirls, who appear on Playboy.com rather than in the print version of *Playboy* magazine, are considered second-string; but Tess was an instantly popular one. She was "Cybergirl of the Week" for the week of July 14, 2009—coincidentally the week after Alexis allegedly participated in the Orlando Bloom burglary. Tess was "Cybergirl of the Month" for November, the month after the Bling Ring suspects were arrested and her face and midriff appeared all over the media. And she would be "Cybergirl of the Year" for 2010.

"Enough about Tess," said Susan Haber curtly.

14

"In my life," Alexis said, dabbing at her eyes, "I've had a lot of struggle, with my dad falling off the face of this earth—he wasn't a father. He wouldn't give any child support for years and he was a drug addict and alcoholic and thank God now he's sober and lot more in my life than he was before." (Mikel Neiers declined to comment.)

"And that's why I want to be doing charity work," Alexis said, "and that's why I want to encourage women to take a stand for themselves. To realize that they don't have to *deal* with this in their lives and through certain steps you can eliminate negativity in your life—"

"Or the possibility of it," murmured Andrea.

"Or the possibility of x, y, and z," Alexis said.

"I dealt with a lot," Alexis went on, "with a lot of women leaving and coming into my life. My dad had a lot of girlfriends, and there was a lot of abuse with my dad. Some physical."

"Um, Alexis—" Andrea cut in.

"I'm being honest!" said Alexis.

"Okay," said Andrea, "but you also have to be considerate of where your dad is now."

"He's raised his hand on me a couple of times." Alexis sniffed. "He's smacked me in the face. Stuff like that. Just a lot of verbal abuse, emotional abuse—just pain, in seeing him in bad positions." (Again Mikel Neiers declined to comment.)

While as a reporter I was interested in knowing these things, I was also curious as to why Alexis was revealing such intimate details about her life just minutes after we'd met. I wondered if it could have anything to do with the confessional culture in which she'd been raised, with celebrity confessors like Oprah—whom her mother told me she idolized—and Dr. Phil, Jerry Springer, and

Maury prompting their guests to spill their guts posthaste, as this made for better TV. Exposing one's pain had become a celebrity rite of passage, and Alexis seemed to think of herself as a celebrity, although her reality show had not yet aired, or even been picked up by a network. Whatever the reason for her confessions, she clearly felt traumatized by something.

"You seem really emotional," I said. "Are you okay?"

"I'm fine," she said, sniffling again. "I'd rather talk about it than not talk about it."

She would have gone on talking about her pain that day, but Rubenstein cut the interview short, saying Alexis would be available another time. I was disappointed that he wouldn't allow her to discuss her case, but he assured me she would do so eventually. On my way out of the office, I stopped by a conference room where Alexis was now meeting with Susan Haber and her mother, Andrea. Alexis was begging Haber to let her fly off to Mexico with a friend on his private jet.

"My friends are telling me, 'you need to chill out,'" Alexis was saying. Her voice had taken on a different tone—it sounded flip.

Haber reminded her that she was not allowed to travel out of the state, much less out of the country, as she was a suspect in a burglary case.

"Nobody will find out," Alexis whined.

"You'd be in Mexico and TMZ would catch you on a beach," Haber said.

It turned out that Alexis actually wanted to go to Mexico for a *Pretty Wild* shoot in Cabo San Lucas, which she eventually did. The episode, "What Happens in Cabo, Stays in Cabo" featured Alexis and Tess doing a photo shoot in bikinis to "raise money for Haiti." "We are successful, strong independent women. I know this is the truth . . . and so it is," they prayed, outfitted in their bikinis.

Alexis started telling me more about her career.

"I started modeling about four years ago," she said, brightening

up. She said she booked her jobs herself; she didn't belong to an agency. "Just print work. I'm not tall enough to do runway unfortunately. I *wish*. Maybe in, like, six-inch pumps.

"I went to Paris in August and stayed at the Crillon [Hotel]"—this was for the Issa Lingerie shoot for FashionTV—"and it was *gorgeous*," she said. "I flew first-class there and back. . . . I took my sister Tess. We got shopping money every day and a personal driver and Ferraris and Mercedes took us around. It was like two weeks of *total luxury*. It was *incredible*."

Andrea said, "It wasn't two weeks, it was—"

"It was almost," Alexis insisted. "It was so cool."

I observed that she seemed to have a fabulous life for one so young.

"Oh, you don't even *know*," Alexis said, laughing. "I've been dating [an Academy Award–winning actor] and Tess is dating Kid Rock." (In March 2009, Tess posted a picture of herself and Kid Rock posing, along with several other girls, on her MySpace page.)

Andrea knitted her brow. "You went on one date," she said. "Unfortunately, she's over 18 and I can't say anything," she told me.

"We were in this house," Alexis said, ignoring her mother, "and [the Academy Award–winning actor] takes my Dior red lipstick out of my purse and rubs it all over his lips and turns around and does this 15-minute monologue as a transvestite. It was *so* funny, *so* amazing."

I said I remembered reading something about how the Academy Award–winning actor had gotten back together with his wife.

"Tabloids lie," Alexis scoffed. "When you read he's back together with her, he's *not*; he's just doing it for the kids."

Later, my cop source, who had had access to Alexis' cell phone at some point, told me, "Alexis had sent some texts asking [the Academy Award–winning actor] to hang out with her, kind of clingy. He was very polite about it."

15

"Alexis is going to jail," my cop source said one day in November 2009. We were sitting in Du-par's, an old-school diner in Studio City with red Naugahyde booths and giant homemade donuts in the display case up front. "She already confessed to being at Orlando Bloom's house the night of the burglary," he said. He gave a small belch. "Did she do the fake crying thing with you where she couldn't quite squeeze the tears out?"

He was a big guy wearing an ill-fitting suit. I'd met him on the phone when I called the Hollywood Community Police Station, which covers Beverly Hills and was the seat of the Bling Ring investigation. (In person, the precinct isn't quite as glamorous as its name; it might as well be the set of *Barney Miller*.) I asked if I could use his real name but he said, "Call me Vince Vaughn." He told me if I "sold him out," he'd "plant drugs" on me; but that was just his sense of humor.

He was eating scrambled eggs and a mountain of turkey hash and drinking continuous cups of black coffee.

"How can Alexis be innocent if she was at the burglary?" I asked.

"Alexis submits that she— Well, I can't tell you that right now. But she did stuff," he said, "believe it."

"What about Tess?" I asked.

"Tess is a Cybergirl, kind of hot. There are a bunch of pictures of her wearing clothing belonging to the victims." One of those pictures was posted on TMZ; it showed Tess wearing a studded, light-blue leather vest allegedly belonging to Rachel Bilson. "Rachel Bilson: Hey, That's My Vest!" said the headline.

"Then why wasn't Tess arrested?" I asked.

"Because her sister"—meaning Alexis—"didn't rat her out," said Vince. This was speculation—Taylor was never charged. "The D.A.'s office only pursues the cases they think they can

prove," he said. "They have to have enough evidence to make it stick."

Nick Prugo didn't rat out Tess, either, although he had told on everyone else allegedly in the burglary ring. On October 6, 2009, three weeks after he was arrested, Nick met with the LAPD in the offices of his lawyer, Sean Erenstoft, and described in detail how he and his friends had been robbing the homes of celebrities. He named names, gave dates, and brought photographic evidence— pictures of his friends wearing items allegedly belonging to the burglarized stars. In one shot, Rachel Lee wears an "R" necklace that had allegedly been stolen from Rachel Bilson; in another, Lee's wrist sports a blue-faced Rolex watch that had allegedly been taken from Lindsay Lohan's house.

Nick told on himself more than anyone else, offering all of this information without first getting a deal. "Which is *weird*," Vince said, shaking his head.

"Why would he do that?" I asked.

Drake Bell, Tess Taylor, and Nick Prugo

"I don't know," said Vince. "You'll have to ask him that."

But Nick didn't implicate Tess—at least, not yet. "They had a date to go clubbing," Vince said with a shrug.

On October 13, 2009—a week after Nick talked to the police—he was seen out clubbing with Tess and former Nickelodeon star Drake Bell, with whom she told the gossip blogs she had been "hang-

ing out." TMZ posted a video of the trio coming out of the Roosevelt Hotel in L.A. and walking down the street to Bell's car. Nick smiles gleefully as the paparazzi cluster around them, calling Bell's name: "Drake! Drake!" "Who's the beautiful young lady?" Bell, formerly the co-star of the tween comedy *Drake & Josh* (2004–2007), is an affable medium-level teen star; but suddenly the paparazzi were acting like he was James Dean. But the Bling Ring suspects were the ones really attracting the attention. Drake Bell-with-alleged-burglars was a story.

"Did you ever think you'd reach this point of fame?" one of the videorazzi asks.

"I didn't know I had," says Bell.

"He's a celebrity," says Tess, who is pouring out of her clothes.

Nick, in the background, giggles excitedly, his white-toothed smile emitting enough wattage to light a room.

"Welcome to Hollywood by the way," Bell tells Tess.

"I don't think Dominick Dunne would write about this," Vince said wryly, in between bites of apple pie.

"Probably not," I said. He liked teasing me—he seemed to enjoy dangling half answers without telling me all he knew. He was holding out on some vital things: What was Alexis' story? What was Tess' explanation for wearing stolen clothes? How did Courtney Ames and Diana Tamayo come into it? How did it all start? How were they caught?

And, "What's the deal with Rachel?" I asked. "Why hasn't she been charged?"

"I totally know why," Vince said in his faux Valley Girl voice. "I know it all, kiddo. But I'm not gonna tell you. I will say she's definitely an interesting client for her lawyer. Do you have the Las Vegas arrest warrant?"

The Las Vegas warrant for Rachel Lee from October 22, 2009, had been sealed by the LAPD, but it was mistakenly released to the media by the court information officer at the Clark County Nevada

Court, who didn't realize he was only supposed to give out the first page. "We seal it to protect cooperating witnesses," Vince explained. "Well, Las Vegas, which is not used to much celebrity attention, got requests for this search warrant from the A.P. and they released the whole warrant." The document included some of the information Nick had given to the police, revealing that he had implicated his alleged partners in crime.

Now Nick's lawyer was demanding that his client be placed in protective custody, as one of his alleged cohorts—Jonathan Ajar— was a convicted felon on the run. Nick reportedly declined police protection, however, but moved from his home to a hotel until Ajar could be apprehended.

"TMZ's acting like Johnny Dangerous is John Dillinger," said Vince, "but he's really just a small-time dealer. He did a two-year bid in Wisconsin."

"Do you think they'll get him?" I asked.

"Ah, yeah," he said. "I don't get the sense that this guy is all that bright. For one thing he was hanging out with the Burglar Bunch."

I asked him why he thought they did it.

"I know why they did it," Vince said. "Here's the deal: these kids were not doing this solely because it was so sexy their nipples got hard 'cause they were in Rachel Bilson's house. At the end of the day, there isn't much more going on here than that the victims they chose happened to be very famous, so it's garnered an inordinate and almost certainly inappropriate amount of media attention. Paris Hilton, clearly, has got shit to steal. With these kids, it wasn't like you with a Sean Cassidy poster in your bedroom. These kids were certainly completely entranced with everything that was celebrity, but more than that, it was about dough."

"But I thought they just wanted to wear the clothes," I said. "They didn't sell much of it, did they?"

"They stole a lot of different stuff," Vince said. "They stole jewelry. They stole cash. And just because somebody's got a lot of cash

doesn't make it any less of a crime when it's stolen." He took out his cell phone and thumbed through it until he found a picture of Paris Hilton. She was sitting at a police officer's desk at Hollywood Station in a short skirt, long legs crossed, looking fetching.

"I met Paris Hilton when she came into the station," Vince said, "and she was a very nice lady. She was a real victim. She clearly lost a lot of things. She's not even certain of all she lost because she just has so much. By all accounts they entered most of these homes multiple times. Prugo's introduction to crime and crime with young kids in general is very similar to drug use. It starts off small, like chasing a high. . . ."

16

It became "like an every night ritual," Nick said. He and Rachel called it "checking cars."* "There was a period of time," between junior and senior year, 2007 and 2008, "when we would, like, drive around looking at cars in Calabasas," he said. "It's a wealthy area; people would leave their cars unlocked. People would leave their purses in their cars. Money. I had no idea this existed. So I'm like, okay, I guess this is fun, scary, exciting. I'm like a young kid. I didn't know what to think of it."

He said he remembered "instances where I would scrounge up enough change to put some gas in my car so we could drive around. We'd drive down a street, like in a wealthy neighborhood." They would look for the Mercedes and the Bentleys, the more expensive rides. They'd park, get out, and stroll up to the car as if they were going to get in it.

* A detective at Malibu/Lost Hills Station, which covers Calabasas, told me that he couldn't discuss the alleged crimes Nick discusses here due to the alleged perpetrators' juvenile status at the time they were committed.

"You'd pull on the door handle to see if the car was unlocked," he said. "Maybe seventy percent of the cars were unlocked, especially in gated communities. And like, maybe ten percent had purses or wallets in them. We would open a car; there'd be a purse in there. You'd take their credit cards, their cash." Sometimes sunglasses, iPods, other things. "We had instances where we'd find, like, at least six hundred dollars in a wallet. So we'd find that, and then we'd go shopping.

"We went shopping with the stolen cards," he said. "We'd go to like, Kitson"—a boutique on Melrose popular with Young Hollywood. "We'd go to Robertson, Rodeo. We'd walk in, stylized and beautiful. We'd use the cards and no one would question. No I.D., nothing. No one would question it."

Now, he said, they were burglarizing other homes in Calabasas. Some of the houses belonged to people Rachel knew, Rachel's "old best friends." "I've actually asked her," Nick said, " 'if I ever became not your friend anymore, would you rob me?' And she said, 'I would never do that to you.'

"When I would enter these houses," he said, "I would want to run out the door. I was always like no, no, no—like, I genuinely hated it . . . but Rachel somehow, she'd be in these houses and it would be an hour and she'd still be comfortable and she'd be sitting there like it's her house. She'd go through everything meticulously, [looking at] clothes, like, try on a jacket.

"I would always be—I guess Rachel would say 'tripping out.' She would say, 'You're tripping out, you're freaking out,' and she would be the one that would calm me down. I'd look at her for guidance and advice and she would be like, 'This is fine, this is okay, why are you tripping out?'

"She had that level of comfort," he said. "She was very comfortable with herself and very, very confident with what she was doing. She pushed that confidence and that comfort level on to me, to where I thought, okay, *she's* comfortable. . . ."

To boost his own confidence, he said, he did cocaine. Rachel

"introduced cocaine to me," Nick said; someone she knew was a dealer, but this dealer, an older girl, wouldn't sell to Rachel, because she didn't want to corrupt her, and so Rachel asked Nick to go and "get a sack." "So I got a gram and I tried it," he said. "I was so scared, but I did it. I snorted it. I would never, never use needles.

"I liked it," he said; and then he loved it, and then he became addicted "for a period of time. . . . And that caused a lot of things to happen. 'Cause then it was like I was stealing for drugs, for cocaine."

17

I wanted to see the celebrity homes that the kids had robbed, so I took a drive up into the Hollywood Hills. I'd always liked the Hills—I didn't want to like it, the way you don't want to like a guy with a smooth line, but I had to admit the neighborhood was beautiful, seductive, with its winding roads and lush, overhanging trees and shrubbery shading the houses. Hollywood stars started moving up into the Hills in the silent era—Rudolf Valentino, Gloria Swanson, and later, in the 1930s, William Powell, Tyrone Power, Marlene Dietrich, Judy Garland. . . . It soon became a movie industry enclave, a fortress of fame and glamour. Many of the homes were built in the 1920s, and the neighborhood had retained that feeling of another era.

The celebrities who'd been burglarized lived in a succession of fancy digs: Orlando Bloom's large ranch-style house looked like a Bat Cave, painted black and surrounded by its own small secluded forest. Lindsay Lohan's modest Mediterranean-style home was surprisingly tasteful for such a flamboyant young woman. Brian Austin Green had the kind of charming Tudor cottage only lots of TV residuals can bring. Audrina Patridge lived in a small, Spanish-style house, the perfect starter home for a young celeb. Rachel Bilson's suburbanish home (it was actually in Los Feliz—I'd driven there

first) looked like it could be the setting for a sitcom about rich kids living in L.A. and running a burglary ring.

It was hard to imagine having the nerve to just walk into these people's homes and steal their stuff. What, I wondered, had made the Bling Ring kids so bold? Was it that they'd been able to find out the location of the houses so easily? Was it just because they could? Were they high, drunk?

It was odd, when you thought about it, that Hollywood had never seen a burglary ring on this scale before.* Hollywood, in the words of Vince the cop, had "shit to steal." And Hollywood has never been shy about showing off its wealth. If all the valuable things up in the Hills weren't enough to attract gangs of thieves, then there was the added attraction of these things belonging to celebrities. In terms of the marketplace, celebrity stuff is sprinkled with magic dust. Look at the boon it affords private dealers and auction houses. Christie's took in nearly $137 million auctioning off Elizabeth Taylor's jewels—a world record for a private collection of baubles, almost three times the record for any other single collection, and that was the Duchess of Windsor's.

So why wasn't Hollywood always getting robbed? (Ironically, the movies specialize in glamorizing thieves—see *The Thomas Crown Affair*, 1968; *How to Steal a Million*, 1966; *The Italian Job*, 1969. . . .) Especially in hard times like the Great Depression, when Hollywood flaunted its wealth as unabashedly as now. Think of all those sumptuous Hurrell photographs of actors and actresses lounging in luxurious settings, looking mystically bored. Or *MTV Cribs*. Or the spreads on celebrities' homes in magazines like *InStyle* and *Ocean Drive*.

And yet, the burglary rate among Hollywood's celebrity population has always been remarkably low. Could it be that criminals

* The "Bel Air Burglars" who robbed dozens of homes between 2005 and 2008 targeted the rich, but not the famous.

assume that famous people have better security, better moats? Maybe, but security never stopped bank robbers. It's not as if some enterprising burglar couldn't figure out where all the celebrities lived, even before the Internet. There have always been maps of the stars' homes and bus tours leaving on the hour. In an episode of *I Love Lucy*, Lucy jumps off a tour bus and does a B&E on Richard Widmark's property, climbing over his wall to steal a grapefruit souvenir. (No doubt the Bling Ring would have made off with some of his wife's dresses.)

More likely, I thought, it was fame itself that had acted as a shield, an invisible fence keeping the non-famous out. Until recently, the fame bubble has always seemed magical, impossible to pierce, like the protective force field thrown out by Violet, the "super" girl in *The Incredibles*. Cary Grant's cufflinks would be a score, sure—but who would want to rob Cary Grant? He was respected and admired. "Everyone wants to be Cary Grant," Grant once said. "Even I want to be Cary Grant."

Criminals have loved their stars, too—they're often wannabe stars themselves, flocking to the same nightclubs and vacation spots. The Mob loved Sinatra not just because he was Italian-American, but because he had crossed over into a nether world in which they could never belong. And he got there because he could do something few people in the world could do as well, and no one in the same way: he could sing.

The history of celebrity has been a history of excellence. Sir Joshua Reynolds could paint; he was an Annie Leibovitz for the Age of Reason, both famous and able to make someone famous with his idealized portraits. Lord Byron, the original bad boy, could write; Sarah Bernhardt could act (and knew how to drive her public wild with stunts that would make Lindsay Lohan blush). Louis Armstrong could play the trumpet like Gabriel himself. Fred Astaire could dance. And while there have always been flash-in-the-pan personalities sensationalized by tabloid media, opportun-

ists who took their fifteen minutes and ran, only to disappear, the real stars—the ones who made it all the way up to that peak where they've been granted by adoring fans an almost godlike status—have always been special in some way, blessed with dazzling gifts and/or beauty, both talented and given to hard work.

"Stars—they're just like us," *Us Weekly* tells us. Well, now they are. Reality television leveled Mount Olympus like a nuclear bomb. On reality TV, even truly gifted and talented celebrities can be seen acting "real"—sometimes too real, like when the late Whitney Houston was taunted by her husband Bobby Brown on *Being Bobby Brown* (2005) for how he had manually assisted her with a bowel movement. A friend of mine remarked, "That was the end of civilization."

The Internet made stars of us all—even the reluctant ones, like the "*Star Wars* Kid" (the unwilling subject of one of the most famous viral videos of all time).* "Why is she famous anyway?" President Obama joked at the 2012 White House Correspondents' Association dinner; he was talking about Kim Kardashian. As probably even the president knows, Kardashian's fame originated with a sex tape, an unthinkable phenomenon fifty or even fifteen years ago. Kardashian saw her friend Paris Hilton's star rise after the release of a sex tape in 2003, and in 2007, her own semi-nude romp with the singer Ray J suddenly appeared. It was supposed to be for private viewing only, but somehow it was leaked, and voila, Kardashian, who formerly had a job organizing closets for the rich and famous, was famous.

Her mother, Kris Jenner, had been shopping around a reality show tied to the fame of her husband, Olympian Bruce Jenner, but now it sold with the help of Kardashian's sex tape fame. Kardashian, guided by her mother, now also her manager, followed her friend

* In the 2003 video, a Quebec high school student awkwardly brandishes a golf ball retriever as if it were a lightsaber from *Star Wars*. His friends put it on the Internet without his knowledge.

Paris' celebutante business model with just a few variations. After the reality show came endorsements, clothing, fragrances, personal appearances, books, and then spin-off shows for her sisters, Khloe and Kourtney. But, more important, Kardashian had a more sustainable image: she didn't do drugs or get arrested for D.U.I. or go to jail, and she didn't toss around offensive words (as Paris had). She was the nice Paris. In 2010, the Kardashian franchise earned $65 million.

So why was Kim Kardashian famous? Because she was very good at marketing herself, that was all—and today, that was enough. Corporations are now people and people are now products, known as "brands." At a time when the 1 percent was getting richer, the 99 percent was suddenly trying to keep up with the Kardashians.

Maybe, I thought, the Bling Ring kids felt they could just walk into the stars' homes because stars no longer shined. Maybe the Bling Ring, for all its silliness, represented a turning point in America's relationship to celebrity.

18

Nick said they visited Paris' house four times between October and December 2008. Paris never seemed to notice that they'd even been in her house, much less that they'd stolen anything. She never reported anything to the police. Nick was always Googling her, checking the news for any signs of trouble. Paris just put another key under the mat, replacing the one they'd taken. Nick said Rachel put that key on her keychain.

"Paris never really knew anyone was in her house—this was my assumption," Nick said. One reason for this might have been that, in the beginning, they would only take a few items at a time. "Why not take a little bit," he said, "I guess my thought was. You know, take a little bit so they don't notice. Don't take everything and really screw them over."

On those repeated missions to Paris' house, he said, he felt like he got to know her; he "saw her more as a real person. Being in someone's house when they're not there you see all kinds of things." Sometimes Paris' house was a mess, and there were signs that she'd been in a hurry, upset, or possibly in a rage. Once, Nick said, a mirror was cracked, as if something had been thrown against it. Maybe a cell phone, he speculated. Sometimes there would be clothes everywhere, as if Paris had tried on a million different things, unable to choose what to wear. He knew the feeling. He'd read that Paris said she'd been diagnosed with ADHD when she was young and was prescribed Adderall. He'd been diagnosed with ADHD, too, and knew lots of kids who took that drug. When Paris was a teenager she'd reportedly been sent to the exclusive CEDU High School for troubled teens in Running Springs, California. It was sort of like being sent to Indian Hills, but with rehab.

And then there was Paris' cocaine. "We found about, like, five grams of coke in Paris' house, or Rachel did," Nick said. He said they snorted in her house and left. "We drove around Mulholland having the best time of our lives."

"I don't know why anyone would listen to allegations made by a self-confessed thief," said Dawn Miller, a rep for Hilton.

Often after doing a mission, Nick said, they would drive around pumping club hits like Lil Wayne's "Got Money": *"Got money and you know it/Take it out your pocket and show it/Then throw it like/This a way, that a way. . . ."* They would get a high just off having done something so wild—like Lil Wayne in the music video for the song, where he robs a bank and then throws the money to grateful pedestrians. Except Nick and Rachel were the pedestrians.

"You know," Nick said, "unbeknownst to us, mentally we were acting insane, but it felt so glamorous and wonderful."

They went back and back, he said, becoming addicted in a way that mirrored their addiction to cocaine—and to each other. He said that Rachel's boldness grew despite the fact that once they were almost discovered. One night they when were walking up to

Paris' house, "we see these cops and we jump in the bushes," he said. "We're sitting in the bushes for maybe an hour. These cops are just sitting there, looking around with their lights. We're for sure we're getting screwed; we're sitting in the bushes not moving, freaking out. I'm pooping in my pants—like, I'm *scared*. And then they drive away. So we leave. We don't even go into the house."

But then, he said, "We go back on another occasion. We go back in. It didn't seem to faze [Rachel] every time we would go into this house." It was the lure of the things, the intimacy of the things. And the intimacy of the space, and Paris not being there in it.

Sometimes the things they took were intimately mundane, like a pair of sneakers that belonged to Benji Madden, Paris' boyfriend. Nick wore them around. And sometimes the things they took were more personal. Nick said Paris had a "safe room and in her safe—it was completely unlocked—she had a thing of, like, maybe eighteen pictures of herself topless and rubbed with, like, some tanning color all over her body." So they took them. "We thought we might be able to sell them to a tabloid," he said. "We thought it would be profitable at the time, but after looking into it we were told every-one has seen Paris Hilton naked so it didn't really matter. So Rachel just kind of hung on to those." And Nick did as well.

Meanwhile, he said, his anxiety over their new hobby grew. When he'd voice his concerns to Rachel, "she'd say like, 'It's okay, you're freaking out over nothing,' minimizing anything I would worry about. And I would believe that 'cause this was my best friend." It was, " 'I love you. I'd do anything for you.' "

"She was like a family member," Nick said. "I'd bring her over and we'd celebrate my sister's birthday together." His little sister Victoria went to Calabasas High School; he said she was a sweet girl and a good student and knew nothing of his criminal activities.

"Rachel was my family," said Nick. "She was my family, I was her family."

And that's why it felt wrong when she started involving other people in their "secret." "It was, like, our secret," Nick said, "but

Rachel would tell her best friends and I would tell some of my best friends. . . . Rachel kind of recruited Diana [Tamayo] through Indian Hills." After graduating from high school in 2008 Diana had enrolled in Pierce College, where she was taking business classes.

"At first I didn't like Diana," Nick said, "because I didn't know her . . . It's not that I didn't *like* her, it was [supposed to be] me and Rachel—it was our friendship, our thing; and I didn't really agree with bringing other people into it and making it, like, a big thing. I didn't think it should go that far. . . . Rachel asked me is this okay, should I bring Diana into this? I didn't feel that should even be an option; I didn't think it should grow, but it eventually did and Diana came to be involved."

Tamayo's lawyer, Behnam Gharagozli, denies all of Nick Prugo's allegations about his client. "I don't agree with the contention that Rachel started the whole thing," he said. "I don't think she was the ringleader. Nick had heavy involvement in this whole thing."

Once, Nick said, when they went on a "mission" to Hilton's house, Rachel brought along her former boyfriend (he was a minor at the time). He was a good-looking kid who resembled James Franco when he played bad boy Daniel Desario on *Freaks and Geeks* (1999–2000). According to the LAPD's report, this boy was arrested for possession of an unregistered handgun in February 2009. At that arrest, "several items of jewelry" were "recovered . . . and booked into evidence by the arresting deputies." A few months later, in November, after the Bling Ring was busted, the jewelry was shown to Hilton, who recognized it as hers. (Rachel's ex was never charged for the burglary of Hilton's home due to reasons that are still unclear—probably his minor status, which would have complicated the Bling Ring case for the L.A. District Attorney's office; minors are more difficult to prosecute.)

"I just found it odd that [Rachel] would want to involve more people," Nick said. It was becoming a party atmosphere. Now they

would hang out in Paris' nightclub room and smoke cigarettes. They would lie on her bed.

Another person Rachel allegedly brought along with them to Hilton's house was Courtney Ames. Ames' lawyer, Robert Schwartz, denies Ames ever entered Hilton's house or was involved in any burglary there. "She's irresponsible, she's a goofball," Schwartz said. "That's who she is. I'm not here to tell you she had no involvement at all or that she's led an upstanding life. She's had a drinking problem; she has used terrible judgment on many occasions." But, he said, his client was innocent of all the crimes of which Nick Prugo accused her.

Nick said that although he was initially turned off by Courtney's "hard-rock" exterior, he had grown to like her over time. "Like, there's like two different Courtneys," he said. "There's the one that, after getting to know Courtney, I kind of understand; she's really like a little girl. She's not really a hard-ass. She tries to be a hard-ass so much. She hangs out with the worst people. She involves herself with the worst boyfriends, the worst kind of things. But, like, inside, just from knowing her for years, I really see a different part of her. I think that's what attracted me to her. It obviously wasn't her looks or her style."

From Hilton's house, Nick said, they took "jewelry and dresses and leather jackets. Courtney took a leather Diane von Furstenberg jacket." "She was given the jacket by Prugo," said Schwartz. "He wanted to be a big shot, a big man."

19

Nick told police that he, Courtney Ames, and Roy Lopez planned the $2 million heist of Paris Hilton's jewelry in December 2008. (Ames' and Lopez' lawyers, Schwartz and David Diamond, both deny all of Prugo's allegations about their clients. "Roy Lopez was

never in Paris Hilton's home," said Diamond.) Nick knew Lopez
from hanging out at Sagebrush Cantina, just off the Mulholland
Drive exit in Calabasas, where Courtney briefly worked as a wait-
ress in 2008; Nick said she would serve him and his friends free
drinks.

Lopez was the bouncer there; he was barely making ends meet.
"He was staying with friends, at shelters, and on the street," Dia-
mond said. "He could not even afford to get his car, which had no
wheels, fixed." Lopez would see Nick and his friends coming into
the bar wearing expensive designer clothes. "To him it seemed like
they had a lot of bread," Vince, my cop source, said. Lopez saw the
topless photos that Nick said he'd stolen from Hilton's safe; Nick
was showing them around. So when Nick and his friends bragged
about hanging out at Paris Hilton's house and stealing her clothes,
Lopez had reason to believe that they were telling the truth.

Lopez proposed they do a bigger robbery of Hilton's house,
Nick told police. Why settle for these smaller things they were
coming away with when there was a whole closet full of jewels
just sitting there waiting to be taken? Nick had regaled his friends
with how he and Rachel had found Hilton's jewel closet hidden
behind a secret door in the wall of the closet with her shoes. He
said it was "like a jewelry store," lined with shelves crammed with
velvet-covered stands dripping with sparkling necklaces, bracelets,
earrings. "It was like Paris' own personal Tiffany's."

"Roy [Lopez] promised a 'cut' of any proceeds from the up-
coming burglary for Prugo's assistance" in planning it, said the
LAPD's report. "Roy told Prugo that he could expect to receive as
much as one hundred thousand dollars after Roy sold the jewelry
he expected to steal from Hilton's residence. Prugo readily agreed
to . . . Roy's proposition. Prugo stated that he was asked to plan this
burglary because of his knowledge of the residence that he gleaned
through his prior burglaries at Hilton's residence."

In the early weeks of December, "Prugo stated that he met

with Ames and Roy on numerous occasions to plan the . . . burglary," the LAPD's report said. "Prugo drew a map of the interior of the Hilton residence, which included the location of the jewelry as well as the location of the surveillance cameras installed on the perimeter of the residence. Prugo explained to Roy that the only way to access Hilton's property was to . . . walk up a hill to the rear of Hilton's property. Prugo also advised Roy that Hilton kept a key underneath a doormat at the front of the residence."

Hilton said in Grand Jury testimony that on the night of December 18, 2009, she left her house at 10:30 p.m. for three or four hours. (She was meeting friends at Bar Deluxe in Hollywood.) She didn't turn on her alarm, she said, "because, before this, I felt so safe in this gated community, like no one could ever get in, that I sometimes would just go out and not even think to put the alarm on, because I never thought anyone could get in my home." She also said she usually left her key under the doormat, in a flower planter or "up in a light."

When she returned between 2 and 3 a.m., Hilton said, "I just noticed that there was, like, kind of shoe marks with dirt on them that were, like, leading up the stairs. And then when I went into my room, I had black carpet on the floor so you could really see there were prominent footmarks, which led into my closet area where my jewelry was.

"My closet where all my jewelry is kept had been ransacked and, you know, basically two full shelves were, I guess, pushed into a bag," Hilton said in court. Surveillance footage from that night shows a male, about six feet tall and wearing a black hoodie, walking up the stairs to Hilton's bedroom and later coming out with a Louis Vuitton tote bag. Inside the bag was over $2 million worth of jewelry, Hilton said, including heirlooms that had been in her family for generations. Police pictures of the bag (which was later recovered) show a tangled heap of glittering stones, chunky necklaces and bracelets, all wound together, crisscrossed with strings of pearls.

After finding her house had been robbed, Hilton called the police; the next day it was all over the news. "Paris Hilton's Pad Burgled!" said E! Online. "Prugo discovered through the media that Hilton's residence had been burglarized," said the LAPD's report, "Prugo contacted Roy to congratulate him and ask for his portion of the proceeds. [But] Roy advised Prugo that while the burglary was successful, half of the jewelry that he removed from the residence was inexpensive costume jewelry and that [the] remainder were priceless pieces that Roy's 'fence' could not sell. Roy advised Prugo that the jewelry was being stored at a location in the state of Arizona.

"Prugo stated that he never received payment for the planning of this burglary."

"Roy Lopez . . . did not steal anything from Paris Hilton," said David Diamond, Lopez' lawyer.

20

Tess Taylor

"Oh, God, *Nick*," Tess said as she waltzed out of a Starbucks In L.A. "We've known each other since high school."

She was talking to a videorazzo from the gossip website X17 Online. "He got into some in-ter-est-ing business," Tess said dryly, "and we really haven't been speaking much since. But, we go way back."

She was wearing a pair of low-slung jeans and

an off-the-shoulder white T-shirt that showed a lot of skin. She had on her black Ray-Bans. You had to wonder how X17 Online knew she would be there.

"[Nick] was accused of breaking into Lindsay Lohan's house and stealing some of her belongings," the videorazzo said. "Do you know anything about that?"

"Um," Tess said, circumspectly adjusting her sunglasses. "I didn't really know much about that until the other night when, haha, it came out on TMZ."

"Oh. Okay."

"*Yeeeah*," she said.

"Is that when you were out with Drake Bell?" the reporter asked.

"I was," said Tess. "We were out hanging out at the Roosevelt. . . . We were hanging out and um, Nick just so happened to be there as well."

It was October 16, 2009, three days after Tess and Nick had been hanging out with Bell. But Tess seemed to be trying to distance herself from Nick now. In just six days, her "sister" Alexis would be arrested.

"Has [Nick] ever spoken to you about anything that occurred during that time, with the Lindsay thing?" the videorazzo asked. "He's even accused of breaking into Audrina Patridge's."

"I *heard* about that," Tess said. "He didn't tell me too much. He told me he knew about it. . . ."

21

A couple of weeks later, on October 29, 2009, a TMZ reporter caught Paris Hilton going into Philippe, a Chinese restaurant in L.A. She was with her sister Nicky. The cameras were flashing.

"What do you think of the Burglar Bunch?" the videorazzo asked.

"They're scumbags," said Paris.

She looked every bit the star that night: her platinum hair was cascading loosely in an elegant 'do, her lipstick was hot pink. She was wearing a little black cocktail dress with a plunging neckline. She had Old Hollywood glamour to her, although her fame had never been based on anything like Old Hollywood achievements.

In just a couple of years, Paris' star had fallen. She was no longer a staple of the tabloids. Journalists had vowed not to report on her anymore. The Paris backlash was in full swing. By December 2009, CNN was asking, "Why has Paris Hilton disappeared?" "Phase one was the ascension, seemingly out of nowhere," said Samantha Yanks, editor-in-chief of *Hamptons* and *Gotham* magazines. "That came with a media frenzy, the antics, the partying, the music, the babe-like status, and of course the fashion label. Phase two, she disappears." Sort of like former president George W. Bush, whose rise and fall Paris' closely paralleled.

Bush, who once enjoyed a 90 percent approval rating (the highest of any president since the poll originated), was now being called the worst president in U.S. history and was largely absent from view. Paris, who could be said to have symbolized the Bush years in some all-too obvious way, was on her way to becoming the most unpopular celebrity in America, according to a 2011 poll. She bristled at a *Good Morning America* interviewer, Dan Harris, who asked if she thought Kim Kardashian was "overshadowing" her. "Do you ever worry about your moment having passed?" Harris said, interviewing Paris in the lavish living room in her home. Paris got up and walked out.

"How much [time] you think they should do in jail?" TMZ asked Paris of the Burglar Bunch, that night in October 2009, a week after they had all been arrested.

"Ten years," Paris said. "They're a bunch of dirty rotten thieves."

DANCING with the STARS

PART TWO

DANCING
with the
STARS

1

Audrina Patridge was discovered, poolside, at the apartment building where they were set to shoot a new MTV reality show called *The Hills*. It was 2006, and Patridge was then a 20-year-old aspiring model and actress from Yorba Linda, California, about 40 miles southeast of L.A. "The executive producer came up and started talking to me about a new show," Patridge told Sydney's *mX* newspaper. "He said it was kind of like *Sex and the City* and he really liked what I had going on." A Lana Turner for the reality age, Patridge had a brunette sex appeal that would carry her through all six seasons of *The Hills*, in which she wore many bikinis and tank tops.

She was a rich girl who starred in a reality show about rich kids who never seemed to work very hard, but wore lots of designer clothes and drove fancy cars. Yorba Linda, where Patridge is from (also the birthplace of Richard Nixon), is consistently ranked by the U.S. Census Bureau as one of the richest cities in America, with a median income of $115,291. Patridge's father, Mark Patridge, is the CEO of Patridge Motors, "an extremely successful family business producing engine parts," according to his bio page on VH1.com. In 2011, Audrina landed a VH1 reality show—*Audrina*—about herself and her family, produced by Mark Burnett, the reality television mogul behind *Survivor* (2000–) and *The Apprentice* (2004–).

In 2010 Audrina, now a blonde, appeared on *Dancing with the Stars*, but was eliminated due to what the judges felt was her lack of personality and "passion." A day after she was voted off the show, her lookalike mom, Lynn Patridge, emerged from the celebri-centric L.A. bar-restaurant Beso and complained tipsily to the paparazzi:

"I've had it. I've been a celebrity mom eight years through this *Hills* bullshit, but 'Drina's going to the next level, baby. . . . She's got it in her."

"I liked her the best of all the *Hills* girls," offered a cameraman.

"Fucking *Hills* girls," Lynn Patridge scoffed. "*Hills* tramps! My baby's a star! She's the only one that has some class and I don't give a fuck about it.... I'll be on another reality show ... we're gonna kick ass, show you how the *real* American, all-American family lives." (*Audrina* was cancelled after one season.)

As friends pulled her back inside the restaurant, the outraged celebrity mom continued to rant in that expletive-laced patois common among many adults today (dubbed "Fuckspeak" by Michael

Lewis in 1989's *Liar's Poker*, it traces its lineage to Wall Street bond salesmen, rappers, and frat boys alike): "[Audrina] was kick-ass," her mother said. "She fuckin' smoked last night—she's hot!"

Audrina's hotness was a significant factor in her role on *The Hills*, a spin-off of *Laguna Beach* (2004–2006), an MTV reality show about high school students in another affluent California town starring another rich girl, Lauren Conrad.

Audrina Patridge, center, and co-stars shooting a scene from *The Hills*, September 2009.

Laguna Beach proved very popular among teenagers; and by 2007, one in seven teenagers said he or she hoped to become famous by being on a reality show. The *Laguna Beach* producers saw a winning ticket and followed Conrad to fashion school in L.A., setting her up in an apartment in the Hollywood Hills with three hot roommates—Heidi Montag, Whitney Port, and Audrina Patridge.

But *The Hills* wasn't really about fashion school or even the nonstop drama between the girls and their fashionable boyfriends; it was about a lifestyle. There was Lauren, the show's real star, in her amazing clothes, in her amazing apartment, going to amazing parties and having an amazing job where she wears numerous amazing fashions. (Conrad had an internship at *Teen Vogue*, while Patridge was a receptionist at Epic Records.) There was Audrina, looking hot, riding around on the back of the motorcycle of her boyfriend Justin Brescia, known as "Justin-Bobby," who was almost as hot as she (but who was sometimes guilty of fashion faux pas. "Homeboy wore combat boots to the beach," Lauren said. "I know you don't want that for a boyfriend"). He called Audrina "Dude."

Never mind that none of it was "real," that the storylines were often scripted. In an interview with Jo Piazza for her book *Celebrity, INC.* (2011), *Hills* cast member Spencer Pratt spoke frankly of having engineered his romance, marriage to, and even divorce from fellow cast member Heidi Montag in order to profit from the publicity surrounding their union, and disunion—deals with photo agencies, appearances, endorsements. "We were making more money doing that than the television show," Pratt said. "It was instant cash." It was only when Montag admitted to *People*, in January 2010, to being "addicted to plastic surgery," that fans turned against the couple; it was an orchestrated bid for more publicity that, this time, misfired. You could be unreal, it seemed, as long as you didn't cop to it.

But *The Hills* didn't have to be real—it was reality.

And Rachel Lee wanted a piece of it.

"Rachel had a fascination with Audrina's clothes," Nick Prugo said. "She loved Audrina's fashion." On and off the set, Patridge's style epitomized the kind of Southern California girl who goes in for maximum exposure of a toned body and spray-on tan. She wasn't high fashion, like Paris Hilton; she wore "what any rich girl in Calabasas would have. . . . We found her on Google Maps and

Celebrity-address-aerial-dot-com," Nick said. It was becoming a habit.

Nick and Rachel hadn't been on a mission together to rob a celebrity's home since the last time they'd visited Paris' house in November 2008. They had done one other job, in January 2009, Nick told police, at a house on Hayvenhurst Avenue in Encino, a tony suburb of L.A., that they'd noticed was for sale and appeared to be empty, so they went in to check it out. It belonged to the builder and developer Nick DeLeo. Nick Prugo said they were able to get into the guesthouse, where they found two Apple iMac computers, so they took them, one for each. Nick kept his and used it, since its screen was bigger and nicer than the computer he already had. He would use it to video chat with Rachel. (It was from this computer that TMZ would take the images of the Bling Ring kids it later posted on its website. DeLeo himself had made the images available after the computer was returned to him by the police.)

How was it that Nick's parents didn't notice all the expensive new things popping up in his room? "My parents—I don't really want to involve them in the conversation," Nick said; he did allow that, due to his estrangement from them at the time of the burglaries, "it was really easy to keep things secret from them so it wasn't like there were all these signs for them to see. . . ."

By February 2009, it had been eight months since Nick and Rachel had graduated from high school—or since Rachel had. Nick never did. He knew he should be getting his act together and doing something with his life, he said: "I had gotten my GED, I planned to enroll in Pierce [College], but just through my friends and my influences I never ended up going. . . . My parents wanted me in school, and I was like, I *want* to work, I *want* a job. I was just making excuses 'cause we continued to make easy money." Stealing from cars in the Calabasas area, stealing from houses. "It was that accessible," he said. "It was that easy."

On the night of February 22, 2009, Nick and Rachel drove to Patridge's house in the Hollywood Hills. They knew she would be out. It was Oscar night, and anybody who was anybody in that industry town would be outside the Kodak Theatre, joining the yearly procession of gowns up the red carpet. It was an exciting Oscar year, for a change—at least that's what people were saying—Hugh Jackman was the host, and Angelina Jolie, Meryl Streep, Anne Hathaway, Kate Winslet, and Melissa Leo were battling it out for Best Actress in a highly contested race.* It was Hollywood's night, a night of preening and posing and deal-making. If you didn't pay homage to the industry gods at the Oscar ceremony, then you had better be at one of the hotter after-parties around town. "If you go to Google News," Nick said, "and you type in someone's name, it'll kind of tell you the events they're going to. It mentioned something about Audrina's Oscar night plans. . . ."

Around eleven p.m., they made it to the Hills and parked down the street from Patridge's home. It was a cute, Spanish-style house on a leafy, winding street—three levels, three bedrooms, with a tile roof and balcony on the top floor. Patridge had bought the place in 2008, less than six months before, for a reported $1.2 million. Not bad for a 23-year-old who was making just $35,000 an episode on *The Hills*. But then, she "came from a rich family," Nick said, "and had got, like, a deal to do an ad for Carl's Jr." (The ad, which appeared in June 2009, showed Patridge wearing a bikini and eating a hamburger.)

"We walked up to her house, very innocently," Nick said. "Unmasked. We did wear gloves but they were mittens, like something to warm your hands from the cold, so it wasn't conspicuous—it was very natural, you would say. So we went there very innocently, just knocking on the door. We were gonna knock on the door and see if anyone was home and say, 'Can we smoke weed with you?' Just

* Winslet won, for *The Reader*.

pretend like we thought we knew someone who lived there, like a couple of stupid kids.

"There was an instance," he said, "where we actually did this at Paris Hilton's house and Paris actually came on the intercom outside her house pretending to be a maid. She was, like, speaking in a Latin accent and messing with us." (He assumed it was she.) "We were like, 'Do you have a pipe? We live in the neighborhood.'

"I have my club card," or medical marijuana card, Nick said, "so I'm legally able to smoke weed. We said, 'We just want to smoke with you,' 'cause we knew [Paris] smoked, 'cause we found a blunt in her house." (There were also several videos online of Paris smoking what appeared to be marijuana, in one of which she says, "I am smoking pot and eating burgers.")

They entered Patridge's house through an unlocked sliding glass door at the side of the property. The reality star hadn't set her alarm before she went away to visit her family in Yorba Linda, four days earlier. "I never imagined anyone would break into my house," Patridge told the Grand Jury on June 18, 2010, "and I only left for a few days." However, when Nick and Rachel opened the sliding glass door, the alarm system still announced, in a robotic woman's voice, "Door opened." "And it scared them, and they ran off," Patridge said, describing surveillance footage.

But—after a few minutes in which nothing else happened, no cop cars or SWAT teams appeared—the kids came back. Grainy surveillance footage from that night shows them outside the house, ringing the bell. Rachel looks relaxed, her head cocked to one side; she seductively pulls back her long black hair, almost as if she's posing for the security camera poised above her. "Is Audrina looking at me?" it seems she could be wondering. She's dressed in Patridge's style, in tight jeans and a stylish, white long-sleeve T-shirt, oversized and decorated with some design. When no one answers the door, Rachel vamps away, and Nick—wearing a T-shirt, jeans, and a baseball cap (he always wore hats, as he was sensitive about his

thinning hair, but this one was to shield his face from surveillance cameras, too)—follows after her obediently. They go around to the side of the house, and enter.

Once inside, surveillance footage shows, the thieves stroll into Patridge's living room—a large, high-ceilinged room with white walls, a tile floor, and wrought-iron furniture. Rachel slinks around, surveying the place, examining things. She languidly puts up her arm to cover her face when she passes directly under a security camera, but she doesn't seem too concerned about it capturing her image. Nick follows her jumpily, almost comically agitated and looking very much like a nervous teenaged boy. They leave the room to go upstairs, and when they come back, Rachel is wearing a white fedora with a black band. This hat would figure prominently in the L.A. District Attorney's case against her. Rachel had it with her at her father's house in Vegas when she was arrested there.

As they come in and out of the living room—becoming increasingly intense in their movements; at one point, they start to run—they're carrying luggage. They leave and enter the house by the side door repeatedly, hauling luggage. This was the first time they would use their celebrity victims' own bags as a means of carrying their possessions away—a method inspired by Patridge having left packed luggage in her bedroom. She had just gotten back from Australia, where she was to appear at the Australia MTV Music Awards, in March and, she told the Grand Jury, "I still hadn't unpacked."

"There was a suitcase in Audrina's bedroom full of dirty clothes," said Nick. "There were personal things" in the suitcases that "brought home to me they're just normal people, just seeing it firsthand."

When Patridge got home from visiting her family that night, at about 2 a.m. (she wasn't at an Oscar party, after all), she noticed her luggage was gone. "And you know, at first I was like, 'Okay. Did I leave it in my car?'" she said. "So I went downstairs and looked

and it wasn't there. Then I went back upstairs and I said, 'Okay. I'm either losing my mind or someone broke into my house . . . And then I noticed there were two lines in my carpet from my luggage being rolled out of my bedroom. . . . And then when I looked in my jewelry box everything was gone, wiped out. Everything."

Nick and Rachel robbed Patridge's house twice that night. They went into a kind of frenzy they'd never experienced before, stealing more than they ever had. After they left, they decided they wanted more things, so they went back and robbed her again.

<p style="text-align:center">2</p>

When I talked to Patridge on the phone in November 2009, she sounded pissed. "It was almost like they went shopping in my house," she said. "They took whatever they wanted. They took, like, a lot of special things—jewelry I got from my great-grandma, they took my passport, my laptop, sunglasses, purses. Anything that was intimate and that was mine—specific jeans made to fit my body, only to my perfect shape. They took shoes; they took bags and bags of stuff. I don't even know everything they took. I don't even know half of it. Big duffel bags and bags from storage. I was devastated.

"When I saw everything was gone," she said, "I was on the phone with my sister and I was afraid to hang up, because I didn't know if someone was still in my house. . . . I kept noticing more things gone. I felt so scared. I went into my walk-in closet and shut the door and locked the door. I didn't know what to do. What if they're still in my house?

"I had all these things running through my mind. You always thinks burglars are these big scary figures—from watching movies you think criminals are big scary guys. And so my brother-in-law called the police and I threw on my robe and ran downstairs. I literally ran out of my house as fast as I could. I got in my car and drove

to the gas station. I sat there until the police came. They came home with me and checked all the rooms.

"When I watched the surveillance videos, it ended up being two kids, a girl and a guy. I felt so violated, so frustrated. Why did they do this? And they came back again after that! I had gotten home twenty minutes after they left. We could tell from the surveillance video—they came twice in the same night, all in a few hours. They left; they took bags of stuff. They kept coming back and leaving.

"I can't believe it's a group of kids doing this," said Patridge. "Somebody should make a movie about this. You never expect the burglars to be kids. I got my laptop and my luggage back; so far that's it. Half of the stuff I didn't even list—stuff I had in my storage room, bags of clothes, accessories. I don't even know what they took from back there. I think it was about $50,000 worth—that's just the stuff I know for sure they took." The police reported the value of the haul at $43,682.

"They came in here and took stuff in such a rush," she said. "I have one shoe, the left, to a pair, 'cause they forgot to take the right one of the pair. They were just getting luggage, trash bags, anything they could find to carry stuff in.

"After it happened, for like two weeks my brother was staying with me a lot; I didn't want to be alone. I thought, What if they come back? Nowadays I feel like so many people can find celebrities if they want to—they know where you are, what your schedule is. I'm always in the public eye, whether it's from the show [The Hills] or from paparazzi taking my picture or, like, Twitter or MySpace. Now fans are able to stay in close contact with you all the time. They always know what we're doing and I didn't think about it until now, and it makes me conscious of where I go and who's around me.

"I feel like these kids, like Rachel Lee was a big fan of me," Patridge said. "The police said I was her target. She came to my

house and went shopping. They would see us on the red carpet and see things that they liked and they would come in here and try to take it. Now they're caught, and they're gonna have to face the consequences. I'm speechless. I don't know why they would do this—you don't go into someone's house.

"Rachel Lee, she's a little obsessed girl," said Patridge. "I gotta tell you it was definitely her," on the surveillance video. "I have a clear view on my surveillance.

"She's gonna get what she deserves."

3

The day after the robbery, Patridge took the footage from her surveillance camera and put it on her website, AudrinaPatridge.com, in the hopes that someone would recognize the burglars and notify the police. "I had a pretty clear image of their faces," she said. "I did it for my fans. I said, 'Please if you guys recognize these people, please help.' That's how TMZ got it."

On February 24, 2009, TMZ posted the footage with the headline, "Patridge's Pad Pilfered—Caught On Tape." Soon the story was all over the Internet. "The loser duo who broke in didn't do a very good job disguising themselves," said The Hollywood Gossip website. "If you were the type of lowlife miscreant who would go and pull a stunt like this, wouldn't you at least be a little inconspicuous with your appearance?"

The story also made it to the local L.A. news station, KTLA. That's where Nick first saw it. "I was watching KTLA News," he said, "and I saw us on the news and I just broke down. When I saw the video of me and Rachel at Audrina's house it really hit me for the first time," that what they were doing could have consequences.

He said he called Rachel "right away—we were constantly on the phone, trying to figure things out." But "Rachel made it seem

okay. . . . She would be like, this is fine, this is okay, why are you tripping out?"

Still, Nick said, "I was worried, scared, just uneasy all the time, anxious, anxious. I'd been an anxious person even before this happened and now. . . . I saw myself on the news and I was staying up till five a.m., I couldn't sleep at night."

However nothing happened because of the release of the video, miraculously enough. No one ever called; Nick and Rachel were never identified; and "so it was kinda swept under the rug," Nick said. "It was in the news for like a month and nothing happened. It was past history and it was fine. . . .

"We kept doing it."

4

"Why were they so ballsy?" said Vince, my cop source, who always saw things from the most practical perspective. " 'Cause they never got caught."

But I had to think there was more to it than that—particularly from the standpoint of Rachel, who, according to Nick, was the one who kept pushing for them to do more burglaries. Did she want to get caught? It was rudimentary psychology, but I had to wonder. If she couldn't be famous . . . did she want to be infamous?

After all, infamy wasn't what it used to be. Now it was just another kind of fame. There was no shame anymore—people were infamous without shame; they were shame-ous. (Seamus?) There were celebrity sex tapes, reality television. There were YouTube videos in which people, often teenagers, beat up on and bullied each other. There were women who became famous for having had sex with famous men. Some of the women who romped with Tiger Woods offered up their steamy text messages and cell phone pics to the highest bidder.

In December 2012, a pretty blonde 19-year-old Nebraska girl, Hannah Sabata, was arrested for bank robbery a day after posting an eight-minute YouTube video in which she blithely bragged about her crimes. "I just stole a car and robbed a bank," she announced in the video's online description. "Now I'm rich, I can pay off my college financial aid and tomorrow I'm going for a shopping spree. Bite me. I love GREENDAY!" She was wearing the same clothes in the video that she had worn to the bank robbery.

And then there were criminals who planned out media strategies before committing unspeakable acts. Seung-Hui Cho, the Virginia Tech student who murdered 32 people and himself, on April 16, 2007, sent out a media package to NBC News. Eric Harris and Dylan Klebold filmed themselves arguing over who was going to make a movie of their life story—Steven Spielberg or Quentin Tarantino?—before they went on their shooting rampage at Columbine High.

Robbing Paris Hilton and Lindsay Lohan hardly registered on the same horror level as those acts of violence. In fact, I was surprised, as I started talking to people about this story by how many seemed to find what the Bling Ring did amusing or even kind of marvelous. "Good for them," said a young woman I talked to in a hair salon. "Tell them to bring me a Gucci bag." "They have enough"—meaning the celebrities, said a New York taxi driver, sounding a lot like Nick Prugo. "They won't miss it." It made me wonder if there were some kind of growing resentment toward the rich (a precursor to Occupy Wall Street sentiment?). Or was this just a sign of the kind of kick people get out of teenagers doing outrageous things? Is that why Rachel thought she could get away with it? Because she was a teenager, and she knew people expected teenagers to act wild and crazy?

Historically, America has always had a conflicted relationship with the rebellious spirit of teens, which has been seen as both thrilling and threatening. The American Revolution probably never

would have come off without the energy and fight inherent in a population that, in 1776, was roughly 50 percent under the age of 16. "Young people were everywhere in the Revolution," writes Thomas Hine in *The Rise and Fall of the American Teenager* (1999). The middle of the 18th century saw widespread rioting on college campuses about everything from King George to the quality of the food. The Sons and Daughters of Liberty, the patriot protest groups, were full of teenagers stirring up revolutionary fervor. Sixteen of the 116 known participants at the Boston Tea Party were teenagers. The Continental Army was filled with boy soldiers, some as young as 12. Future President James Monroe was just 17 when he became an officer serving under General George Washington, Alexander Hamilton only 19 when he became a famed pamphleteer. Girls were active in the Revolution, too—16-year-old Sybil Ludington, "the female Paul Revere," rode more than 40 miles from her home in Fredericksburg, New York, in an attempt to save Danbury, Connecticut, from a British attack. (It didn't work, but she tried.)

Young Americans helped make America, and America has been forever impressed—and conflicted. Our history is full of alarms over the behavior of teenagers. Apparently we've been asking "What's the matter with kids today?" since the Puritans, who were obsessed with the salvation of children's souls and worried kids were leading us to ruination. "As young people [in colonial America] grew more assertive," writes Steven Mintz in *Huck's Raft: A History of American Childhood* (2004), "adult anxieties rose, provoking the first of many moral panics that would characterize American attitudes toward the young.... Further adding to the fears of moral decline was the emergence of a distinctive youth culture."

In perhaps the first description of "juvenile delinquency" in America, Jonathan Edwards, the formidable preacher and leader of the First Great Awakening, the Christian revival movement of the 1730s and '40s, wrote deploringly in 1730 of how "licentiousness

for some years prevailed upon the youth of the town" of Northamp-
ton, Massachusetts. "There were many of them very much addicted
to night-walking, and frequenting the tavern, and lewd practices,
wherein some, by their example, exceedingly corrupted others."

The fact was that American kids became precocious because
they had to work—on farms, in factories, and in shops—in order
to help their families survive. Teenage labor was enormously im-
portant in the development of the country. But the products of this
early introduction into the adult world of work were often strong-
willed, rambunctious teens, given to an attraction to pleasures
considered beyond their years, and this frightened their parents and
the general population. In the 19th century, reformers—influenced
by the Romantics, who had decided that children were not sinners
but pure, intuitive beings in need of sheltering—worked to save
children from the abuses of the workplace and to make schooling
the responsibility of the state, in a bid also to reign in what was seen
as the problem of out-of-control youth.

A growing influx of beleaguered immigrants gave rise to a pop-
ulation of neglected and unattended teens, street kids, and gangs.
By the early 1800s, New York State had a Society for the Refor-
mation of Juvenile Delinquents, which in 1827 issued a report be-
moaning the difficulty of reforming poor kids who were "returned
destitute from the same haunts of vice from which they had been
taken"—a lament which persists today.

Juvenile delinquency was seen as the result of poverty and
deprivation—a notion which was shockingly overturned in 1924
when two privileged boys, 19-year-old Nathan Leopold and
18-year-old Richard Loeb, brutally murdered 14-year-old Bobby
Franks, believing themselves to be Nietzschean supermen, above
the law. "The killing was an experiment," Leopold later told his de-
fense attorney, Clarence Darrow. Leopold and Loeb were the first
bad rich kids of the American narrative. They were also bad rich
kids who wanted to be famous. "This will be the making of me,"
Loeb said after he was arrested.

"Leopold and Loeb invited all that attention," writes Peter J. Spalding in "The Strange Case of Leopold and Loeb" (2011). "They took to the spotlight like natural celebrities: they read all their own press clippings, they made sure to look good on camera, and they knew just what to say to push reporters' buttons. On June 1 [1924]," a day after they made their confessions, "they showed the police how they'd committed the murder, and they let the press come along on a tour of the crime scenes. Along the way, the boys spouted off plenty of sound bites."

The disturbing case also added to a sense among middle- and upper-middle-class parents that their children were becoming unrecognizable. The 1920s experienced the true "generation gap" that would be identified as such some 40 years later. Parents who had grown up in the rustic 19th century gave birth to the children of modernity. Telephones, cars, and movies changed everything—communication, transportation, entertainment. Now women had the right to vote, and many girls no longer felt like being demure. Flappers with bobbed hair in short skirts smoked, drank, and danced the night away to music created by blacks; jazz was not only a musical but also a cultural movement celebrating social and sexual freedom. Public consternation was severe and often racially charged. In 1921, *Ladies' Home Journal* endorsed campaigns to ban jazz music, declaring, "jazz originally was the accompaniment of the voodoo dancer, stimulating the half-crazed barbarian to the vilest deeds."

Fears of juvenile delinquency plagued the 1940s, too, when anxiety about keeping control over life at home increased due to the outside threats faced during the war. In 1943, more than 1,200 magazine articles appeared on the subject. "Here's to Youth," a popular radio program, ran segments on "Young America in Crisis." Hollywood produced shorts stirring up concern over teenage carousing. "Where is your daughter tonight?" asked a movie advertisement. "In some joint . . . lapping up liquor . . . petting . . . going mad?" "Thanks to the war," writes Grace Palladino in *Teenagers:*

An American History (1996), "younger teenagers were on their own in greater numbers than ever before, and they were getting into trouble. . . . Juvenile court dockets overflowed with complaints of vandalism, auto theft, and teenage petting and drinking parties."

In the 1950s, with the publication of *The Catcher in the Rye* (1951), Holden Caulfield unseated Huckleberry Finn as the quintessential American boy: Huck was an adventurous innocent, vulgar and rough but fundamentally good; Holden was louche, morally flexible, a charming depressive—and a rich kid. But he was essentially cynical on the matter of his privilege. In fact, what seemed to be at the root of his discontent was his sense of coming from an elite class full of "phonies" and "crooks." *Rebel Without a Cause* (1955) continued on the theme, with its well-off suburban teens acting out against their parents' hypocrisy and materialism. "Don't I buy you everything you want? A bicycle? . . . A car?" Jim Backus, as James Dean's father, demands plaintively of his rebellious son, who tries to make his family understand: "You're tearing me apart!"

As the country grew more affluent during the post-war boom, the youth of the 1960s channeled their rebelliousness into a rejection of materialism in favor of making "love, not war." Civil rights, women's rights, and protesting the war in Vietnam were their passions—not shopping. Revisionist historians have liked to minimize the impact of 1960s activism, but Nixon himself admitted after leaving office that student protests had influenced his decision to withdraw troops from Indochina. "Young people were at the cutting edge of cultural and social change," writes Steven Mintz. "Their protests and actions transformed not only their sense of self, but the very character of American culture." In the 1970s, punk rock hardened the 1960s' message, pushing antiestablishmentarianism toward the edge of a nihilism brought on by what was seen as a lack of any real systemic change. The national hysteria over hippies and punks alike fell right in line with Puritan minister Ezekiel Rogers' admonition of 1657: "I find great Trouble and Grief

about the Rising Generation. Young People are stirred here [in the colonies]; but they strengthen one another in Evil, by Example, by Counsel."

And then something different happened. In the 1980s and '90s, more so than at any other time in American history, youth culture wasn't challenging the status quo. Young people didn't want to change the system—they wanted to game the system. They wanted money. The pursuit of the almighty dollar had always been the purview of soulless grown-ups and parents, but now kids—certainly not all kids, but youth culture overall—were promoting the idea that "getting paid" was cool.

The goal wasn't the traditional sort of American success popularized by Horatio Alger's Ragged Dick stories of the 19th century, where a boy would go from rags to riches through hard work and ingenuity. The goal was success that came from the ruthless pursuit of money for its own sake—in fact, often the more ruthless the pursuit, the cooler it was thought to be. I first noticed this trend being expressed in *Risky Business* (1983), in which Tom Cruise plays a cynical rich kid who gets into Princeton after entertaining the school's college admissions officer with the prostitutes Cruise is pimping out of his parents' home while they're away on vacation. This was a big switch from Dustin Hoffman's disaffected college graduate in *The Graduate* (1967) who's repulsed by his society's materialism (in a famous moment a friend of the family encourages him to consider a future in "plastics") and the moral dysfunction of his parents' generation. At a reading in 1997, I met the late Budd Schulberg, author of the classic novel *What Makes Sammy Run?* (1941), about an unprincipled Hollywood hustler named Sammy Glick. Schulberg told me that while his book was once understood to be a dark portrait of a despicable young man and the hollowness of success achieved through dishonest means, young people now approached him saying, "Sammy's my idol! Sammy's my Bible!"

Just as it had once been considered the thing to do to "drop

out," in the 1980s, the thing to do was to join the club. "Wall Street seemed very much like the place to be at the time," wrote Michael Lewis in *Liar's Poker*, of going for a job at Salomon Brothers upon graduating from college in 1984. "I was frightened to miss the express bus on which everyone I knew seemed to have a reserve seat, for fear that there would be no other."

But it wasn't just privileged white boys from Princeton who wanted a seat on the money train. It was kids from the ghetto as well. "I want money like Cosby who wouldn't," Jay-Z rapped in "Dead Presidents, Part 1" (1996). Hip-hop music, which started out socially conscious and politically radical,* became about gangsterism, robbing, drug dealing, and making money by any means necessary ("Gimme the Loot," said the Notorious B.I.G. in 1994). There was necessarily something subversive about young black men from the projects exalting in their wealth—in a country with a history of slavery, segregation, and persistent racism, it was triumphant ("Money, power, respect" said the LOX in 1998). When Puff Daddy appeared on the cover of *Fortune* in 1998, it was a crossover moment of significant proportions. But that was just it—it was about joining the establishment, not fighting it.

In 1998, I did a story for *New York* my editor headlined "Make Moves, Blow Up, Get Paid," after a quote from one of the sources, about New York kids who were eschewing college in favor of going out in the world so they could make money immediately. Their dreams were tied to getting famous—through acting, modeling, rapping, fashion designing, screenwriting—but their ultimate goal was getting rich. And they idolized Puff Daddy for his brand of branding. "Puffy is a genius," Paris Hilton told the *New York Times* in 2005, discussing her inspiration as a businesswoman. "He does

* See Grandmaster Flash "The Message" (1982), Public Enemy's *It Takes a Nation of Millions To Hold Us Back* (1988), KRS-One's Stop The Violence Movement (begun in 1989), and more.

everything. Music. Clothing. I totally look up to him and Donald Trump because he's built this whole empire—hotels, casinos, resorts, a television show."

Bobby Kennedy was gone; and Donald Trump was a new hero. One of the kids I interviewed for another story in the 1990s told me of his admiration for Michael Milken, the "Junk Bond King," who went to prison in 1990 for securities and tax violations. "He basically got off, considering what he really did," the kid said approvingly, referring to how Milken had escaped convictions of racketeering or insider trading. "He's a gangster." The "prep school gangsters" I followed around in those days ran in neighborhood gangs with names that expressed their devotion to self-interest through criminality: Out For Self (OFS), Who's King Now (WKN). "Somehow we became like movie stars," one gang member told me. "We're like gods to kids." They were a legend in their own minds, for sure, but they were also the products of their parents, who included wealthy bankers, a media mogul, a famous actor, and a member of the Mafia.

By the 1980s, kids were looking around at a country where lawbreaking and lawlessness were no longer conditions of poverty and life in the inner city alone. Now these were omnipresent aspects of American business, politics, and the media at the highest levels. "There were no rules governing the pursuit of profit and glory," Michael Lewis wrote of the culture of Salomon Brothers in the 1980s. "The place was governed by the simple understanding that the unbridled pursuit of perceived self-interest was healthy. Eat or be eaten."

"Today," writes Glenn Greenwald in *With Liberty and Justice for Some* (2011), "in a radical and momentous shift, the American political class and its media increasingly repudiate the principle that the law must be equally applied to all." It gives one pause to consider what the Founding Fathers would have thought of the pardoning of Nixon after the Watergate scandal; the overturning of the con-

victions of Lieutenant Colonel Oliver North and former National Security Advisor John Poindexter after the Iran-Contra scandal; or the Bush administration's warrantless wiretapping, politicized prosecutions, torture, and "black sites"—for which no one was ever prosecuted. Every step along the way has been an even bigger departure from the insistence of the framers of the Constitution that in a democracy everyone must be equal before the law. Meanwhile, Greenwald laments, "the media [directs] its hostility almost exclusively toward those who investigated or attempted to hold accountable the most powerful members of our political system."

And then there was the financial meltdown of 2008 that brought the world economy to its knees. While its causes have barely been investigated or made transparent, it has become sufficiently clear that the crisis was largely the outcome of widespread fraud and lawbreaking. Yet there has been virtually no prosecution of those responsible. "There is no fear of individual punishment," *Rolling Stone*'s Matt Taibbi said in an interview in 2012. "That's the problem."

So why did Rachel Lee think she could get away with stealing celebrities' clothes? Maybe Vince was right, after all: 'Cause she hadn't been caught. Yet.

5

In the first two weeks of May 2009, the Bling Ring burglarized Rachel Bilson's house five times. They went back again and again, trying on her clothes, picking out clothes, looking through her things. They put on her makeup and examined her jewelry. They went "shopping" and then decided they wanted to go shopping again. "Ms. Bilson was probably the most emblematic of how this group typically worked," Officer Brett Goodkin told the Grand Jury on June 22, 2010, "where the accomplice," allegedly Lee, "iden-

tified [Bilson] as a target and Mr. Prugo went to work and they committed numerous burglaries all within an approximate two- to three-week period."

By now, they had gotten it down. Rachel picked Bilson as the next victim on her list, Nick said. "She loved her clothes." Like so many young actresses today, Bilson, then 27, was admired as much for her fashion sense as for her work. She appeared at entertainment and fashion industry events in an array of dazzling gowns and around L.A. in unfailingly eye-catching ensembles. She was the object of many a "style crush" among young women and girls. She had a vintage, boho style which she told reporters was inspired by Diane Keaton and Kate Moss. In 2008, she worked with DKNY Jeans to create the junior sportswear line Edie Rose.

Ever since the fashion world success of Paris Hilton, P. Diddy, Jennifer Lopez, and other celebrities, having a clothing line—one of the potentially most lucrative franchise opportunities for a personal brand—has become de rigueur for starlets and reality stars alike. Mary-Kate and Ashley Olsen, Jessica Simpson, Nicole Richie, Britney Spears, Miley Cyrus, Lauren Conrad, Selena Gomez, Mandy Moore, Kelly Osbourne, Hillary Duff, Whitney Port, and Avril Lavigne, all have had lines, to name a few. In 2010, *Women's Wear Daily* reported that The Jessica Simpson Collection had become the first celebrity clothing line to top a billion dollars in retail sales. Simpson's reality and fashion stardom would seem to suggest her as an object of Bling Ring interest; but they never targeted her. "Rachel would never, like, carry a handbag that wasn't made of real leather," said Nick, referring to Simpson's more downscale merchandise.

Rachel Bilson, on the other hand, offered Rachel Lee a whole sleek package of things Lee admired: she was beautiful, stylish, famous, rich, designed for Donna Karan—plus they had the same name. "Rachel-Rachel," Nick said. "Rachel identified with her." Both Rachels were from the Valley. Bilson was raised in Sherman Oaks.

Her mother Janice was a sex therapist, her father Danny Bilson a Hollywood writer, director, and producer. Her great-grandfather ran the trailer department at RKO, and her grandfather was a director on 1960s sitcoms such as *Get Smart* and *Hogan's Heroes*. So if she wasn't quite Hollywood royalty, she was landed gentry.

Nick did the research. He found out the location of Bilson's four-bedroom, 3,662-square-foot home in Los Feliz, an L.A. neighborhood popular with Young Hollywood. Bilson had purchased the white Spanish-style house for $1.88 million in 2006, three years into her role as Summer Roberts, the unashamedly shallow rich girl on *The O.C.* (2003–2007). When the Bling Ring kids were robbing Bilson, they were also robbing Summer—which for them, it seemed, was a form of flattery as much as it was a crime; the character was the embodiment of the sarcastic, slack-mouthed, eye-rolling mode of discourse ("Seriously?") so prevalent now among teenaged girls on television and, consequently, in real life. Summer's catty dialogue included the phrases "Ew," and "Random," "Ew. Random," and these bon mots:

"I suffer from rage blackouts."

"I guess I really will end up bitter and alone."

"I'm gonna study this thing so hard I'm even gonna out-Jew you."

"Way to go, Wonder Whore."

And this exchange:

Summer: "My dad [a plastic surgeon] says chins are the new noses."

Anna [a friend]: "Picasso thought so, too."

Summer: "Really? What hospital does he work at? Kidding! I'm not that dumb. Just shallow!"

Summer sounded a lot like a reality show star named Paris Hilton. The acerbic attitude of *The O.C.* was catnip to teens seeking validation for their desire to appear cynical and rude—just like a spoiled rich girl. And *The O.C.* had romance, nerd-bitch romance.

Bilson's on and off-screen entanglement with Adam Brody, who played the adorable Seth Cohen, had been a big deal for 15-year-olds when Rachel Lee was 15. Summer was a girl who could handle herself, once telling a presumptuous suitor, "I'm not gonna be your sloppy seconds, assface." Not exactly Elizabeth Bennet putting Mr. Darcy in his place in *Pride and Prejudice* but critics hailed the show as "clever" anyway.

But in real life—not the fake reality of *The O.C.*'s simulated reality TV moments—Bilson was a girl who'd had problems of her own. During a self-described "rebellious, self-destructive period" in her teens, when she was "hanging out with people she shouldn't have" and dating a bad boy, she was in a serious car accident, a head-on collision which left her in a coma for days, and from which she still suffered migraines and memory loss. Another passenger in the car

became paralyzed. (Bilson was not driving.) Because of the experience, she told reporters, she "changed" and "[went] in a different direction," becoming an actress. She dropped out of Grossmont College, in El Cajon, California, after a year and made her screen debut in 2003, appearing in an episode of *Buffy the Vampire Slayer* (1997–2003).

Nick and Rachel scoped out Bilson's house, Nick said, doing their usual reconnaissance. Sometimes they just sat and watched with binoculars, and some-

Rachel Bilson, as Summer Roberts, on the set of *The O.C.*

times they did leisurely drive-bys, casually searching for clues about how best to get in and do the job.

For a couple weeks, Nick checked on Bilson's comings and goings around L.A. "This was their operating norm," Officer Goodkin told the Grand Jury. "Mr. Prugo would go to work with doing his kind of back-office research on the Internet, finding out where that victim lives, where is the primary residence, and then culling through Internet source stuff to determine is this a victim that travels a lot, is this a victims that's not at home very often." Nick discovered Bilson was planning a trip to New York for a couple of weeks with her then fiancé, *Shattered Glass* (2003) star Hayden Christensen. As soon as the paparazzi shots of her at LAX appeared, the Bling Ring was on its way.

Nick said he and Rachel and Diana Tamayo burglarized Bilson's home four times in the beginning of May, entering through an unlocked door. (Tamayo's lawyer, Behnam Gharagozli, denies Tamayo had anything to do with the burglaries of Bilson.) Nick said they took Bilson's designer clothes—pieces by Chanel, Roberto Cavalli, Zac Posen—and her vintage shoe collection; she was a size 5, too small for either of the girls, but they wanted the shoes anyway. They took Bilson's handbags and extensive stash of Chanel makeup, her Chanel No. 5 perfume, her jewelry, "underwear, bras. With these celebrities everything's brand-new," Nick said, "they still have the tags on the items. But of course they would take dirty or non-dirty and wash 'em, whatever—anything and everything that would fit, that they liked, they would take, and being that these were all women there wasn't a lot of stuff for me. . . ."

Rachel, he said, had gotten so comfortable with the routine that during one of the burglaries of Bilson's home she took time out to have a bowel movement. "We were in Rachel [Bilson's] bathroom and Rachel just had to go, so she just . . . yeah. I remember the incident so well. I can recall the smell, which is really nasty, disgusting. I know I would never, like . . . When you're in there," robbing someone's house, that is, "you have a rush, like I've had to pee when

I've been in there, but I would never use their bathroom, just in fear of that maybe some type of evidence would be left there. I think that's weird, personally. But yeah, she did."

The fifth time at Bilson's house, Nick said, he went with Tess Taylor and another girl who was a minor at the time. When Nick met Tess in 2007, she was just another pretty girl on the Valley scene; now she was a fixture on the Hollywood nightclub circuit, going out almost nightly, and so Nick thought she might like some fashionable new items to add to her wardrobe. He said they took purses, clothes, and a studded, light-blue leather vest. When I spoke to Taylor in December 2009, she denied going with Nick on any burglaries and said she wasn't even aware that he had been engaged in any criminal activity.

They took so much from Bilson, Nick said, he and Rachel "got a lot of her stuff together and sold maybe thirty purses" on the boardwalk on Venice Beach. "During the day there's these stalls you can rent where you can set up like a shop to sell things to people that walk along," he said. "We came up with maybe a thousand dollars each from Venice, just like selling [purses] for like fifty bucks a piece. We had all these designer things and people would jump at the chance."

6

On June 18, 2010, Rachel Bilson told the Grand Jury:

"I got a phone call from my mother while I was away," in New York, in May 2009, "and she said, 'Are you sitting down?' And I said, 'Yes. Why?' I was really concerned. And she said, 'Your house has been burglarized.' And immediately my reaction was I was crying, and, you know, a little horrified. And then she went on to describe what she came home to [see], what the house was like.... It's really a feeling of violation and invasiveness.

"When I came home," Bilson said, "walking into the house ...

[I got] just a really bad feeling. My whole upstairs, where my bed-room is and my closet and everything, everything was out on the floor, drawers were pulled out, just totally scattered, and everything was in disarray.

"All of my, I guess you would say, higher-end shoes, purses, clothing, those were all taken. My jewelry, some irreplaceable things that were sentimental, in like, my jewelry boxes and things, all of those were stolen. . . . My grandmother's jewelry, and my mom's engagement ring that she had set for me when I turned 16, that was taken; things like that were hard to accept.

"And a TV was taken and a DVD player. Lots of DVDs. Actually, a whole cabinet of movies were—it was emptied . . . downstairs." Bilson estimated the total loss to be around $128,000.

"There was no forced entry anywhere," she said. "I had an alarm system. It wasn't set at the time of the burglary.

"It took me a while to feel comfortable staying there. I wouldn't sleep in my bedroom for about a month. I would stay in . . . a down-stairs room. And I was convinced [for a time] that I needed to sell my house and get out of there, because I was very scared."

7

On November 4, 2009, Jonathan Ajar turned himself in to Holly-wood Station. He was accompanied by his then lawyer, Jeffrey Val-lens, and a *Maxim* magazine writer named Mark Ebner. Ebner had been traveling with Ajar for the past few days, having tracked him down to Las Vegas through Ajar's mother, Elizabeth Gonet. Gonet was afraid her son—who was being called "armed and dangerous" and was the object of an LAPD manhunt that had become national news—was going to perish in a hail of bullets, Dillinger-style, if the cops tracked him down, so she had encouraged him to let the reporter escort him back to safety.

And maybe Ajar also liked the thought of *Maxim* magazine fame. The night before he turned himself in, Ebner made a video of him announcing his intentions, which Ebner posted on his website, Hollywood, Interrupted. It was instantly picked up by TMZ, the gossip website Gawker and news media all over the country.

"What's your name?" Ebner asked Ajar, a lumpy young guy with droopy eyes and a goatee; weighing in at about 250 pounds, he wore an oversized T-shirt and baggy jeans. He looked like a white homeboy as played by *Mall Cop* actor Kevin James.

"Jonathan Ajar. A.k.a. Johnny Dangerous," Ajar said with a sly smile.

"Media reports are calling you armed and dangerous. How would you respond to that?" Ebner asked.

"Not right now," Ajar said offhandedly.

He was a 27-year-old ex-con who had spent a year and a half in a Wyoming state prison for drug trafficking between 2005 and 2006. He had grown up poor and sometimes homeless near Reseda, California, about 30 minutes northwest of L.A. When the LAPD searched his apartment in Winnetka, a small, predominantly Latino town in the Valley, on October 22, 2009, they reportedly found "a large amount of narcotics and paraphernalia," including the prescription drugs Clonazepam, Lexapro, and Oxycodone; some allegedly stolen property, including a diamond-encrusted Cartier Tiger watch, a Montblanc watch, gold and diamond bracelets and rings, purses by Marc Jacobs, Louis Vuitton, and Chanel, Gucci eyeglasses, a Blackberry, True Religion jeans; a bag of loose diamonds totaling 42.94 karats; "two stolen semi-automatic handguns," "one semi-automatic shotgun," a cache of live ammunition, and a ballistic vest. One of the handguns, a Sig Sauer .380, was registered to the actor Brian Austin Green.

"Mr. Ajar did come into possession of a few items, which were apparently stolen by Mr. Prugo and his friends, according to Mr. Prugo," said Ajar's lawyer, Michael Goldstein.

In the parking lot of Hollywood Station that November day, Ajar allowed himself to be handcuffed by Officer Brett Goodkin before he was led inside. A videorazzo from TMZ called out from behind a chain link fence, "Hey Johnny, man, who's the ringleader? How'd you meet these kids? Johnny, where were you hiding out this whole time, bro? Johnny Dangerous!"

Squinting in the sun, Ajar looked a bit stunned by his predicament. It was as if he suddenly couldn't quite believe that he was going back to jail because of these "fucking idiots," as he called the Bling Ring kids. He would be charged with 12 felony counts, including for possession of drugs for sale, possession of a firearm by a convicted felon, possession of ammunition, and receiving stolen property. He was held on $85,000 bail.

How did he get there? According to Ajar, he met Courtney Ames one night in the spring of 2009 at the Green Door, a Hollywood bar-restaurant that was very hot at the time (and since has cooled). Heidi Klum had thrown a Halloween party there, Orlando Bloom liked to have dinner there, and Prince had performed there in 2008. Ajar was a marginal figure on the L.A. nightlife scene, working as a promoter for Les Deux, another Hollywood club that was having a moment (it closed in 2010), with patrons like Leonardo DiCaprio, Paris Hilton, Lindsay Lohan, and the girls on *The Hills*—Lauren Conrad, Whitney Port, and Audrina Patridge.

Ajar was living the high life; that's how he saw it. "I had a good time," he told *Maxim*. "Who else can say they had Playmates at their birthday party?" He'd been photographed with Black Eyed Peas member will.i.am. and partied with former Death Row Records mogul and reputed Bloods gang member Suge Knight.

Coming upon Courtney Ames and her friends at the Green Door the night they met, Ajar said he helped them get in, although they carried fake I.D.s. He seemed to like Courtney's tough girl image, so different from the typical airheads that flocked to the nightclub scene. On another night, at Les Deux, he talked

Courtney and her buddies into getting body-painted in honor of his birthday (another birthday). Soon Courtney and Johnny were spending time together and she was staying overnight at his apartment in Winnetka.

8

By the spring of 2009, the Bling Ring was in full escalation mode and the kids were hitting Hollywood nightlife hard in their newly acquired clothes and jewelry. They had exciting new things to wear, and now they wanted to show them off—and where better to do that than in the same places where the celebrities they were robbing, and planning to rob, liked to go and party?

Dressed in their new celebrity skins, they gravitated to Les Deux. The French-themed club was popular with underage guests, as it had a garden and a dance floor that made it easy to pass from the restaurant to the bar unnoticed. But the Bling Ring kids never had a problem getting served, or getting in, thanks to their friend, now Courtney's boyfriend, "Johnny Dangerous."

Alexis Neiers and Tess Taylor actually knew Johnny before the other kids. "He would get us into clubs," Alexis said when I spoke to her again at her home, after our first meeting in her lawyer's office. She said that she and Tess had been going out since they were 16 and 17, and that's when they started to become a part of "the Hollywood scene. It was *known* that we were out hanging out with Emile Hirsch and Leonardo DiCaprio," Alexis said, "and just, like, typical Young Hollywood. Paris Hilton's birthday—just typical stuff."

In her Grand Jury testimony, Hilton testified she didn't know any of the Bling Ring kids; all the other celebrity victims said the burglars were strangers to them. "Every time we were at a club there'd be celebrities there," Alexis maintained. "That's how I be-

came friends with Mickey Avalon. . . . Mickey's such an awesome guy!" Avalon is a white rapper and former prostitute known for his graphically sexual lyrics.

According to Nick, Alexis and Tess would sometimes exaggerate their closeness to the stars. "They like to make themselves sound like they [know them]," he said, "but they don't. There's a little bit of truth to each of their stories. They might have met someone and hung out with them in a club, but they don't really *know* them. They're really good with embellishing. They sit at these guys' tables, these rich guys and whatever, and then it's over. They're like arm candy. . . . They just get [caught up in] the celebrity, the glamour."

But the glamour was what Nick wanted, too. And he knew that Tess and Alexis could provide him with that by bringing him into nightlife. "They were the first people that brought me out to clubs," he said. "They brought me to Beso," the celebrity hot spot on Hollywood Boulevard. "I started going out with them, started meeting people. Everyone loved me, everyone loved them. We started going out a lot to the hottest nightclubs, celebrity nightclubs—Voyeur, Wonderland, Teddy's at the Roosevelt. They can get in anywhere because they're so hot and gorgeous and young and the celebrity guys love to have them at their table."

Clubkid Nick was a very different Nick from the boy who, just three years earlier, was too anxious to go to school. Cocaine, perhaps, and a successful robbing spree, along with a fabulous new wardrobe, had given him an edgy self-confidence. Now he was a boy who hung out with beautiful half-naked girls in his room. A picture taken in 2009 (published on the gossip website The Dirty in 2011) shows Nick and a topless Tess in Nick's bedroom, Nick looking suavely into his computer screen as Tess bends over him, looking seductive (she's wearing a bra that's pulled down). Gabby Neiers can be seen in pictures from the same photo shoot, smiling and apparently giggling.

"Prugo has this weird relationship with pretty girls where he

falls in love with the girls and lets them boss him around," observed Vince the cop.

"I've liked surrounding myself with beautiful girls," Nick said. "Tess . . . really connected with me, she was really good at manipulating me, with, like, making me feel loved and wanted friendship-wise."

Which made Rachel jealous? "Of course," said Nick. "Rachel felt Tess was a threat. She didn't really like Tess and Tess didn't like her. Tess wanted me to be her little best friend, and Rachel wanted me to be her best friend—it was kind of awkward for a while. I tried to introduce them a couple of times and it was really weird so I didn't do that anymore."

In a purely social sense, the Bling Ring had two wings, Nick being the common denominator to both. It was Nick and Rachel (and Diana and Courtney), and Nick and Tess and Alexis (and Gabby), and they rarely socialized with each other. "I didn't care for Rachel," Alexis said. "She seemed odd—like, I hadn't heard the best things about her. I had heard that she was nasty, not a nice girl. . . . She was haughty . . . and she always dressed really, really nice in extravagant things but she looked like she was just a typical Calabasas rich girl."

So Nick did double duty with both his sets of "girlfriends," hitting the town with Tess and Alexis some nights, and Rachel and Diana on others. They would all be dressed to the nines. "Diana's, like, entire personal wardrobe was made up of clothing she stole," Nick said. ("Patently false," said Tamayo's former lawyer, Howard Levy.)

They were living out the fantasy of the nightclub as seen in countless hip-hop music videos made over the past 20 years. By now it was a copy of a copy of a copy of a nightlife experience that had originated in the club scene in New York in the 1990s, when hip-hop was crossing over into the mainstream—the Cristal Champagne popping, the half-dressed flygirls dancing as slick

boys in wifebeaters ogled them, throwing simulated gang signs. It
was the club scene of Nelly's "Hot in Herre" and 50 Cent's "In Da
Club"—except that it was a bunch of white kids from the Valley.
Celebrity was necessarily a part of it. Celebrities had to be there,
somewhere, in the background, validating the glamour of it all with
their presence. It was the fun being had, somewhere, by Paris and
Puffy and Jay-Z and Leo.

"We had a really good time," Nick said. "The nightclub scene
was there whenever we wanted it. All you needed was money. And,
like, me and Rachel had money so we could get in anywhere, too—
that's all you need, money and looks, and, like, we weren't ugly so it
wasn't that hard." This was a different boy, too, from the one who
said that in high school he had been convinced that he was "ugly."

But in nightlife, it's a much less prestigious thing to be the kind
of patron who gets into the club because he can afford to purchase
a table, versus being the one who gets in because he's with the hot
girls who know the promoters and maybe the stars. Nick went out
"more with Alexis and Tess," he said, because it was more fun. And
it seemed cooler.

"Nick really liked the life we had," Alexis said. "He wanted to
live like us.... He wanted ... to tag along with us to the clubs....
We never introduced him to celebrities—the only one he met was
Drake Bell. In a way he looked up to them. He was into the typical
celebrity gossip. He'd say 'Oh, she's hot, oh, she's not'.... He just
really wanted to seem like he was the cool guy."

Nick was dressing different, acting different; now he always
had a Parliament cigarette in his hand. Whereas he used to be shy
and hesitant to speak, now he was glibly throwing jokes around.
He'd developed a sardonic humor and flippant air like the charac-
ters on Rachel's favorite TV shows.

He was dressing Tess and Alexis, too, for their evenings out on
the town, confident in his opinions and his style. "I was like, this
looks good, this doesn't," he said. "Because I read GQ. I read the
magazines. I know what looks good. I know fashion. So, I would

tell them, you look trampy. You look good. You look classy. I'd be honest, and they valued my opinion because they looked good after I was done with them."

9

Someone else who was changing in the wake of her exposure to Hollywood nightlife was Courtney Ames. Courtney's very appearance had transformed. Once typically seen wearing Converse sneakers, T-shirts, and baggy jeans, she now dressed in designer clothes. "She was transforming from a tomboy to a sexy girl," said her stepfather, Randy Shields, when I spoke to him on the phone. "She had friends for the first time in her life. She went about a year and a half with zero friends. Then Rachel introduced her to Nick and all of a sudden she had friends. Now she was having the time of her life."

"The one time I saw her [at Les Deux] she was wearing a leopard piece of lingerie with zebra shoes," Alexis sneered.

"Alexis and Tess would make fun of [Courtney] a lot," Nick said with a laugh. "There was this song called 'Sexy Can I' by Ray Jay"—about a man with a taste for designer fashions (*"Gucci on the feet, Marc Jacob on the thigh"*) begging a hot girl to have sex with him (*"Sexy can I?"*)—"and basically me, Alexis and Tess made it into a song about Courtney. . . . It was like, 'Courtney can I?' . . . and she would get upset about it. And she'd threaten people: 'I'm going to beat your ass! I'm going to kill you!'" (Ames' lawyer, Robert Schwartz, had no comment.)

Nightlife photos taken of Courtney at Les Deux in 2009 show her looking like a stylish club girl, in short skirts and leather—including that leather Diane Von Furstenberg jacket that belonged to Paris Hilton. "Prugo gave it to her," Shields alleged. "She accepted the coat for one night. She was a stupid kid out partying and she wanted to look good."

Courtney's once frizzy dark hair was now slicked back and styled. A picture she posted on her Facebook page of herself and a female friend in a suggestive pose was captioned "Hwydd," as if announcing her new domain and her new attitude. "This is the end of who I was and the start of a whole new beginning," said another one of her posts. She had become the girlfriend of a Hollywood club promoter, bad boy, and drug dealer, and she seemed proud of it. "Mondays Le Deux [sic]. Johnny D.," she posted.

"Courtney had never been out in Hollywood at all," Nick said. "Courtney was introduced to Johnny and they hit it off and started connecting and got quite close. They were sleeping together and, like, partying, and she was getting more confident." In one nightlife shot, Courtney has Johnny's middle finger all the way in her mouth.

She seemed to find the dark side of her new life quite glamorous. A picture found on the computer stolen from Nick DeLeo's Encino home shows her brandishing a thick wad of cash. "It's kind of like *Alpha Dog* without the killing. Hahh," she posted on her Facebook page. (*Alpha Dog*, a 2006 film starring Emile Hirsch and Justin Timberlake, was based on a true story about a group of suburban drug dealer kids who got caught up in kidnapping and murder.) On October 10, 2009, twelve days before she was arrested, Courtney posted, "What a dangerous road we walk and a tangled web we weave." And on October 15: "Karma is a bitchhh god I love my lifeeeee."

Nick claims it was Courtney who told him that Johnny Ajar was interested in becoming the fence for their stolen goods. (Ames' lawyer, Robert Schwartz, had no comment.) "[Courtney] found out that Johnny had contacts, or connects," Nick said. "And it came to Johnny's attention that me and Rachel were involved in what we were involved in and Johnny made a proposal that if we had anything of value to sell or get rid of he was our man.

"So we tried it out one time," he said, "we brought him the Rolexes"—Rolexes belonging to Orlando Bloom, who had an ex-

tensive collection of the watches, 10 of which disappeared from his house during a burglary on July 13, 2009. Johnny "sold them, he gave us cash," Nick said. "Five thousand. For like ten Rolexes, which is, I guess, a rip-off now that I think of it.

"I wasn't thinking this is what they're *worth*," he added. "I was just like, cash, okay, easy, fast, whatever. Johnny gave us the cash and we just started a business thing."

And perhaps it was also fear of Ajar, an older, more hardened criminal, which kept Nick from pressing for more of a return. "It is with the introduction of Ajar that Prugo's life was first threatened," said the LAPD's report. "Unfortunately, it would not be the last time as Ajar advised Prugo that should he ever speak to the police about Ajar's fencing activity that Ajar would not hesitate to murder him or his family."

"I find it troubling that Mr. Prugo who, according to most of the players, is the mastermind of these burglaries, along with Ms. Lee, is now implicating everybody else, while my client Johnny Ajar who has nothing to do with the Bling Ring burglaries remains incarcerated," said Michael Goldstein, Ajar's attorney.

10

Ajar didn't bother to deny that he was fencing the Bling Ring's goods when he was interviewed for *Maxim*. "I ended up buying [Brian Austin] Green's pistol," he said, "because the stupidest fucking thing to do would be to let them run around with that." He also said that one of Orlando Bloom's Rolexes was still in his apartment and that he would gladly return it. (The LAPD had already found it during their search warrant there and returned it.)

"They did all this research, but I didn't pay much attention," Ajar said of the Bling Ring kids. "I didn't want to be involved. They were spending all their money from the crimes on bottle service at

the clubs. It wasn't just my club; it was every hot club in the city. And they drink horribly. Courtney, I tried to tell her, 'You can't act like that.' Nick would blow chunks all over the place."

Before leaving Las Vegas, Ajar gave Ebner a Sony VAIO laptop he admitted belonged to Audrina Patridge. Ebner didn't want to be traveling with Ajar while he was in possession of stolen property, Ebner told me, so he left the computer at his Vegas hotel for a lawyer to retrieve it.

"I can't fuck with stolen goods," Ebner said on the phone. "I gotta turn that in. I've already got Marty Singer," a high-powered L.A. lawyer, "suing me for a million dollars over that Eric Dane–Rebecca Gayheart video."

He was referring to a sort of sex tape of a threesome between the married actors Eric Dane and Rebecca Gayheart and a former beauty queen, Kari Ann Peniche (the women loll around, topless, while Dane walks around naked), which Ebner had sold to the gossip website Gawker for an undisclosed amount. (How he came into possession of the tape is unclear.) According to Dane and Gayheart's suit, "as a direct consequence of Defendant's despicable misconduct," the tape was "now available on countless other adult sites on the Internet." (In August 2010, Gawker settled with Gayheart and Dane and agreed to take the video off its site.)

After leaving Las Vegas, Ebner—also the author *Six Degrees of Paris Hilton* (2009), about an L.A. kid named Darnell Riley who insinuated himself into the lives of celebrities including Paris Hilton, and then in 2004 videotaped himself robbing and extorting Girls Gone Wild founder Joe Francis at gunpoint—drove Ajar to his own home in Los Angeles, where Ajar proceeded to summon a tattoo artist to Ebner's living room. During the tattoo party, Courtney Ames appeared wearing a rosary necklace that looked just like one Lindsay Lohan had been photographed wearing. TMZ had already posted a picture of Courtney wearing the necklace with the headline: "Burglar Bunch Suspect Up To Her Neck In Trouble,"

suggesting the necklace might be stolen. Courtney told Ebner she had bought it retail. Courtney's lawyer, Robert Schwartz, told me "the necklace was given to her by Prugo." Randy Shields said, "The guy she was dating gave it to her. She didn't know it was Lindsay Lohan's."

"Courtney shows up," Ebner said, "she's obviously high on something." (Schwartz had no comment.) "She's just, like, slouching around the house. And the idea was Johnny and his best friend were gonna get matching tattoos of guns on their torsos and she was gonna get a 'Dangerous' tattoo." This was all happening a little more than a week after Courtney had been charged with one count of residential burglary of Paris Hilton, and Ajar was still technically an outlaw.

When Ebner asked Courtney about her burglary charge, he said she told him casually, "Oh, I'm pleading not guilty to that." She then told Ajar she was pregnant with his child, according to Ajar, which got him in a funk. (Schwartz had no comment.) "As the evening winds down, I find the young lovers a cheap hotel on the edge of Hollywood where they can spend one last night together," Ebner wrote.

"It's like this drama thing with these kids," Ebner said. "This is their fifteen minutes and they're loving it. I can't even find a reference—you wanna say it's like *The Gang That Couldn't Shoot Straight*, but it's more like T*he Gang That Couldn't Pass Their GED*. When we were in high school everybody loved their drama and scandal, but now it's at this absurd level. Everybody's living in their own reality TV show."

11

I met Ajar's mother, Elizabeth Gonet, one afternoon in November 2009 at a Middle Eastern restaurant in Sherman Oaks. She was

disappointed that the place didn't seem as inviting as she remem-
bered it being years before when she lived in California with her
young children, so we ended up just talking in the parking lot.

"That's my grandchild," she kept saying. "That was my first
grandchild." She was sold on the idea that Courtney Ames had
been pregnant and lost the child due to miscarrying, a story she said
Courtney had told her herself. (Randy Shields told me that Court-
ney was never pregnant and didn't believe she had ever said she was.)

"She says she had a miscarriage from partying too hard and
she's not pregnant anymore," said Gonet. "That was my first grand-
child. She's been partying every day since the beginning of the
summer."

She was a small woman with a mane of shock-white hair and
deep-set eyes, dressed in flowing clothes. She was not in the best of
health, she told me. She had taken the bus down from Washing-
ton State, where she lives, to visit her son Johnny now that he was
locked up in the L.A.'s Twin Towers Correctional Facility. She said
she was a cashier at a grocery store, and that she'd raised Johnny
and his sister and brother on her own after she split with Johnny's
father, a truck driver, when Johnny was two.

"I'm not saying it's right," she said, "but I can almost under-
stand someone like my son turning to crime. But why are these kids
doing it? They don't need it. They have everything.

"My son might be doing drugs but he's not a thief," said Gonet.
She blamed Johnny's current legal issues on Courtney. "The cops
found jewelry at Johnny's house that Courtney stole from Paris
Hilton's house," she said with a frown. (Ames' lawyer, Schwartz,
maintained that Ames was never in Hilton's house.)

"It looks like she was living at Johnny's apartment," Gonet said.
"There were flip-flops and Tampons there. They've been together
three months. Known each other six. They think they're madly in
love with each other. They want to get married. She wants to wear a
bloodred dress to her wedding." She grimaced.

She showed me a text she had allegedly received from Court-

ney that day. It said, "I am so sorry you have to go through this. Hopefully it will all be over soon and it will all work out. If you talk to Johnny tell him he's my angel and I love him."

"Her parents won't let her talk to him," said Gonet, "but she's been writing letters to him in jail. She said her stepfather's writing a screenplay about this whole thing and he wants her to help him. He said as soon as they're done with the screenplay he's gonna buy her a car."

When I spoke to Shields, he said that he had written a book and a screenplay about the Bling Ring, but he didn't say whether Courtney had helped him.

"She's blowing me off now," said Gonet. "She defriended me on Facebook. She's plenty nice and sweet when she talks to you, but there's something wrong with a girl who drinks like that. That was my grandchild. That was my first grandchild.

"I blame the parents," she said. "She said her mom didn't want her to smoke cigarettes, but she wouldn't stop, so now her mom just says, 'Don't throw butts on the lawn.' She gave her an ashtray."

12

In the middle of November, three weeks after the Bling Ring kids had all been arrested, Courtney had her 19th birthday party at Les Deux.

"Its my birthdayyy ... round 2 tonightttt!" she posted on her Facebook page. "I want a nos tank," a nitrous oxide tank, she wrote.

Rachel came and celebrated. So did Diana. It was as if nothing had changed. Except Johnny was in jail.

Nick was not invited, of course. He'd told the police of their alleged crimes a month before, in October, launching them all into legal battles about which none of them seemed very concerned. In fact, Courtney sounded almost psyched about all the attention she

was getting: "Gotta love having rolling stone magazine knocking at my door," she'd posted on Facebook.

13

I found Courtney at Art's Delicatessen on Ventura Boulevard one night soon after her birthday. A friend of hers had told me she'd be having dinner there. She was sitting in a booth with two other people. She was a rangy girl with dyed black hair (she was really a redhead, she said), freckles and pale, intelligent eyes. She was dressed kind of funky, like a girl I'd see in my neighborhood in the East Village. She wore a graffitti'd T-shirt and a leather jacket (not Paris Hilton's). Her nails were painted black. She had a studied cool, as if modeled after Kristen Stewart.

"I can't talk to you," she told me with a stare. "I've been approached by the *New York Times, New York Post, Rolling Stones* [sic]. My lawyer told me not to talk to anybody."

I asked her if she would come and sit with me in a booth and just talk about the case in general. She said okay. When we sat down, she offered, "I didn't do any of this. I'm not into the whole crowd that's into fame. If you want to know what happened, go for Tess and Alexis. They want fame. They are so starved for attention and want to be famous."

"What about Rachel?" I asked.

"Rachel's a good person, she has a good heart," Courtney said. She said that they'd been "best friends" since seventh grade and that she met Nick through Rachel in tenth grade. And she said she didn't know anything about any burglaries.

"Are you still friends with Nick?" I asked.

"I *was* friends with Nick," Courtney said. "But then when I found out what he was doing, I stopped being friends with him and that's why he's saying I did this stuff with him."

I wondered why she would drop a friend for being a thief when her own boyfriend, Johnny Ajar, was a convicted drug dealer and in jail.

"Just because you stopped being Nick's friend, you think that's why he said you robbed Paris Hilton's house?" I asked.

"Yes," she said. "The only reason I ever hung out with Nick was because he got us into clubs. That's all I would ever do with him."

However pictures that surfaced on TMZ showed Courtney hanging out in Nick's bedroom, on his bed, dressed in just a pair of pajama pants and a bathing suit top (revealing a large scorpion tattoo on her side). There she was in Nick's bedroom, again, mugging for the camera, throwing faux gang signs, smoking a bong.

A video later posted on TMZ made it clear that, even after Nick was arrested on September 17, 2009, Courtney continued to visit him in his room. "Have you seen or have you talked to Nick," a TMZ videorazzo asked her in January 2010, after catching up with her outside the Obsession Ink tattoo parlor in Studio City, where she was getting a tat. "Has he told you anything about the picture of you laughing at him when he was getting arrested?" The photographer was referring to a picture TMZ had obtained of Courtney seemingly laughing while holding up a copy of a celebrity tabloid published in September 2009; "Suspect In Robberies Arrested!" it said, with a picture of Audrina Patridge, Lindsay Lohan, and Nick Prugo.

"That picture was actually taken with [Nick] sitting on his bed watching me take it [with a computer camera]," Courtney told the cameraman, annoyed.

"So you and Nick are cool?" he asked.

"No," Courtney said. Not after he rolled on her a couple weeks later, in October, that is.

"I didn't do it," Courtney told me flatly when we spoke in the deli. "The cops have been harassing my parents, my mom and stepdad, calling them up and telling them things they shouldn't say."

She said that Officer Brett Goodkin had telephoned her mother and stepfather and told them she was pregnant, after he had allegedly been told this by Mark Ebner. "Goodkin called our house," Randy Shields told me. "He says, 'You know your daughter's pregnant, I'm doing this as a concerned parent.' I can't tell you the contempt I had for him. It was all lies. Courtney was on her period at the time."

"My stepdad wants to sue them," Courtney said, "but my mom says no.

"I don't *need* to steal," she went on. "I have my parents. I go to college. I'm studying psychology," at Pierce College. "I'm not into celebrities. I'm not into that whole crowd that's into fame. I wasn't friends with the whole Tess and Alexis crowd. I didn't hang out at Zuma Beach."

She didn't seem to be willing to say much more, so I tried to find out what she knew about the Bling Ring kids. Her stepfather told me that "Courtney was there for every bit of it, except she wasn't involved in any of it."

"Do you know whether they were taking drugs from the celebrities' homes?" I asked. I'd heard from cops that the kids were taking prescription drugs like Adderall, Ambien, and Zoloft from some of the celebrity victims' medicine cabinets.

Courtney looked around the diner.

"Ehhhh," she said nervously. "I can't say anything about that."

14

On November 12, 2009, Nick was arraigned at the Los Angeles County Court. He walked grimly past a phalanx of media shouting at him from behind a police barricade: "Nick!" "Nick!" "Was it worth it?" "How's it feel to be a rat?"

Nick was looking very Young Hollywood that day, wearing dark sunglasses and a sporty jacket. His lawyer, Sean Erenstoft, who

Courtney Ames, Sean Erenstoft, and Nick Prugo in court on December 2, 2009.

looked like a lawyer on *Law & Order*, was following behind him. Erenstoft's girlfriend, also a lawyer, walked beside Erenstoft, holding his hand; she looked like a soap opera actress. Although she was not instrumental in the case, she would often accompany Erenstoft to Nick's media-saturated court appearances. They could have come around to the back parking lot like everyone else, but instead they came in the front, where the cameras were.

Nick's parents were nowhere in sight.

Once he got inside the big white building on Temple Street, several policemen, including Brett Goodkin—a tall bald guy in his thirties who looked like Mr. Clean—surrounded Nick and hustled him across the lobby to the elevators. It was as if Nick were a defendant akin to Lee Harvey Oswald, in imminent danger of being gunned down. Erenstoft had told TMZ that Nick was under the protection of "multiple law enforcement agencies." (This was untrue. With Johnny Ajar now in custody, the only alleged threat against Nick had been neutralized. Erenstoft later admitted to me

that his "strategy" was to "use the media to create sympathy for Nick," who was being called a "rat," and that he had actually "paid for [Nick] to stay in a private hotel to effect the imagery of him being in 'protective custody' following his decision to rat out the rest of his crew." It was all smoke and mirrors.)

In the hall outside Department 30, where more media was clustered, I introduced myself to Erenstoft and asked if he were going to allow Nick to talk to me, as we'd discussed on the phone. "I don't know," the lawyer said airily. "I haven't decided. NBC and ABC are still fighting over me. Everybody wants a piece of this."

A few minutes later, in the courtroom, Nick was charged with eight counts of residential burglary; he was facing up to 42 years in prison.

Three weeks later, on December 2, Nick pleaded not guilty, even though he had already confessed.

Erenstoft put a picture of himself and Nick in court that day on the home page of his website.

15

On November 16, 2009, Alexis was arraigned. She brought an E! camera crew to court with her; they were filming her reality show, *Pretty Wild*.

"They've been with me since four-thirty a.m.," Alexis whispered to me. She was talking about her five-person crew. It was about 8:30 now.

She was sitting on a bench outside the courtroom, pursing her lips for a makeup woman, Julie, who was applying lip gloss. Two regular guys, who were also in some kind of legal trouble, sat at the other end of the bench, trying to ignore this.

Alexis' mother, Andrea, stood nearby, looking nervous in a snug brown suit. Her father, Mikel Neiers, a dark-haired man in a blazer and jeans, was there too, looking rather shell-shocked.

Andrea introduced Neiers to me as Alexis' "biological father."

"I'm not supposed to talk to you about the case," Alexis whispered to me, "but I'm innocent, and I'm *dying* to tell my story. Why would I do this? I think people need to realize I have a career going. I model. I act. I have a TV show."

Alexis' show was still in the speculative stages, I learned. E! was putting together a pilot, waiting to decide if it was going to pick it up. "It was supposed to be a show about two party girls on the Hollywood scene," a supervising producer, Gennifer Gardiner (yoga pants, earpiece, and walkie-talkie) told me, aside, "but then Alexis got arrested the first morning of filming, and we were like, okay." She smiled.

"Do I need any makeup?" asked Jeffrey Rubenstein, Alexis' lawyer, approaching. "The only way I'll get paid is if the reality show gets picked up," he told me, low.

"How do you think she'll play on *Larry King*?" he asked with a confident twinkle, watching Alexis being powdered.

Alexis was being charged that day with one count of residential burglary of Orlando Bloom. On July 13, 2009, $500,000 in Rolex watches, Louis Vuitton luggage, clothing, and art had been taken from Bloom's residence, and the L.A. District Attorney's office was saying Alexis was there.

"Somebody's lying," Rubenstein said with a snort. "It's a game of Clue, except instead of Colonel Mustard, it's Paris Hilton in the tattoo parlor with the iPhone."

At the other end of the hall, a mob of reporters was clustered at the door to Department 30, arguing with the blonde court public information officer about who was going to be let inside. Too much media had shown up for the number of benches—the *Los Angeles Times* was there, and *Good Morning America, Dateline, Inside Edition*, TMZ, et al. The publicist was blocking the door like a nightclub bouncer. Reporters were pleading with her, flashing their credentials. "Is E! going to get a spot?" one demanded, outraged. The answer was yes, they were.

It was time to go into the courtroom now. Alexis stood up, wobbling a moment on her heels. She wore a fuzzy pink sweater and a short tweed skirt—demure as Rubenstein had suggested. A diamond stud twinkled in her left nostril. The cameraman said "ready," and Alexis began to walk down the hall. It reminded me of the girls learning how to walk the runway on *America's Next Top Model*. The camera followed.

Alexis pleaded not guilty in her baby voice.

Despite Rubenstein's advice against it, she insisted on making a statement for the media on the courthouse steps after her hearing.

"This is a very difficult time for myself and my family right now," she squeaked for the cameras, smiling flirtatiously. "I just want to say thank you for respecting my privacy, and I look forward to my day in court and to getting this all cleared up."

After this, Rubenstein filmed a scene in the parking lot where he was discussing the case, repeating lines for *Pretty Wild*'s supervising producer.

16

About the last thing I ever wanted to do was appear on a reality show; but the producers of *Pretty Wild* had Alexis under contract to work on the day of her arraignment, and said I could only interview her if they could film me doing it. "Go ahead," said my editor on the phone. "That show will never get picked up." At that point it did seem unlikely.

We all drove from the courthouse to Alexis' home in the Valley. I traveled in a van with some of the crew, two girls and a guy, all in their 20s. "Alexis and Tess are in a fight," one of the girls told me as we drove along, the mountains coming into view. "Tess isn't living at the house right now—she's staying somewhere else."

"What are they fighting about?" I asked.

"Maybe 'cause they're both burglars and only one is taking the

rap?" said the guy with a laugh. (When I spoke to her, Tess denied having been involved in any burglaries.)

"No," said the girl. "I heard they're fighting 'cause Tess wants to be in your article and Alexis just wants it to be about her."

"Do you think Alexis is guilty?" I said.

"I don't know," said the girl. "There sure were a lot of cops at their house when she got arrested."

Alexis had described for me the chaotic scene of the morning of her arrest. (At her lawyer's request, this conversation had taken place at the Polo Lounge in the Beverly Hills Hotel.) She said that she had come home late from the first night of filming *Pretty Wild*—the camera crew had followed her and Tess as they partied the night away at Wonderland, one of their favorite clubs—and she was pretty out of it.

"I woke up with my mom and my sisters screaming at me around 9:30 and put on my robe," Alexis said. "They were screaming that the police were here and that we needed to leave the premises and come outside in my driveway. All of my neighbors were outside. The cops were like in full SWAT uniforms; they wanted to make sure there was no one else in the house, no weapons, and that the dogs were under control." The Dunn-Neiers household was home to a yippy Yorkshire terrier. "There were five cop cars and a lot of cops, ten cops probably—"

Andrea was trying to say something.

"I'd like you to stop talking!" Alexis said, raising her voice. "I'm sorry—she talks in every interview! I just don't want her to say anything! So," she went on, "they handcuffed me right away, I was in complete shock. I started crying, my sister [Tess] was crying, Gabby was crying. My biological dad was there. He's just there in the morning; he gets to my house around five a.m., he comes pretty much every day—"

Andrea interjected, "There's more to that story. He doesn't really have a place right now—" (Mikel Neiers declined to comment.)

"I would like you to stop talking!" Alexis shouted. "I did not

want that information to come out and that's why I asked you not to speak in this interview. Now if you'd like to go sit in the other room—"

Andrea closed her mouth.

"Anyways," Alexis said, "he was there that morning. He just comes to the house, he waters the front and the backyard, he takes my sister [Gabby] to school. It's like a morning thing. It's like a big part of my life."

"Did you have any idea why the cops were there?" I asked.

"No, I just had no clue," said Alexis. "I was so scared. They immediately arrested me. I didn't think it had anything to do with me. They didn't tell me why they were there—they said be quiet, don't talk, turn around, face the wall . . . We went into the house and they separated me from my family and put me in another room . . . They started ransacking the house, going through everything—stuff was flying everywhere. They were talking and making some rude comments between each other and he"—Officer Jose Alvarez of the LAPD, one of the arresting officers at the scene—"sat me down and he said do you know why I'm here? He said he had a search warrant; he pulled out a big book and in that book was a photo of me and honestly I was petrified. I had no idea what was going on. It was like a headshot of me off my MySpace or Facebook or something. He started asking me a bunch of questions. I started telling the truth from what I knew; he was asking me questions about the people who were involved, locations, if I had seen anything that was stolen. I told him the truth and he said he was gonna take me down to the station for more questioning."

"What did you tell him?" I asked.

"We're not gonna get into that," said Rubenstein.

"Well they found some [allegedly stolen] stuff at your house," I said.

"We're not gonna get into that," Rubenstein said again.

"It was my grandmother's jewelry," said Alexis. Actually, it

was the black and white Chanel necklace allegedly belonging to Lindsay Lohan and Marc Jacobs bag allegedly belonging to Rachel Bilson. "Everything that was found I have receipts and copies for," Alexis reassured me. But an officer with the LAPD later told me Alexis never provided receipts for anything.

"He [Officer Alvarez] said he was gonna take me down to the station for more questioning," Alexis said. "He told me I was arrested. He read me my rights. I yelled to my mom that I would like my lawyer.... I started crying; they took me outside and put me in the back of the cop car.... I was feeling exhausted from the night prior—so tired, shaky, because I have hypoglycemia. I become really shaky and I get really bad migraines that lead to me vomiting or getting really dizzy or passing out." Coincidentally, these are also the symptoms of a hangover.

"By the time I was in the car I was already a mess," Alexis said. "I got down to the station and they put me in a holding cell, which is like the scariest most terrible place ever. It smelled terrible; it was freezing. Before I left my house the female officer took me up to my room and let me get dressed"—at which point Alexis put on a pair of ice blue Juicy sweatpants. The LAPD would later point out the similar look of these sweatpants and the pants worn by one of the figures in footage from Orlando Bloom's surveillance cameras on the night of the burglary of his home.

"In the holding cell," Alexis said, "they told me what I was arrested for. I was in shock. I was scared. I felt like, why is this happening to me?"

17

The producers of *Pretty Wild* told me they believed Alexis when she said she was innocent; and they didn't seem very worried about her case. Alexis being in the news brought attention to their show and

paparazzi to her house—she wasn't even a celebrity yet, and yet she was being treated like one, with photographers camped out on her lawn, waiting for her to emerge. "This is *so* annoying," Alexis says in an episode of the show as photographers follow her mother's car, snapping away.

Pretty Wild covered Alexis' legal battle with the same light-hearted style as, for example, the scene where Alexis and Tess plan Gabby's birthday party. ("We're doing a pole dancing routine for you," Alexis says. "This is my sixteenth birthday, not some kind of whore party," says Gabby.) As soon as Alexis was in the squad car and on her way to the Van Nuys Community Police Station on the morning she was arrested, the *Pretty Wild* camera crew was filming again.

In the show's pilot Andrea and Gabby can be seen traveling to the station in an SUV driven by Mikel Neiers, after they all had a prayer circle.

"Those two," meaning Tess and Alexis, "think they're invincible," Andrea complains in the car. (Tess had also been taken in for questioning.)

"Untouchable," Gabby chimes in. "Maybe this was just the universe sending a wakeup call."

"Her face is gonna be all over the Internet," Andrea frets.

"Oh. My. Gosh," says Gabby.

"What? . . . That's frickin' ridiculous! . . . She's so stupid!" Andrea says, when Tess informs her by cell phone that Alexis had waived her right to have an attorney present when she spoke to police. (Tess had Jeffrey Rubenstein in the room when the police talked to her.)

Rubenstein told me, that morning at Van Nuys Station, "Andrea arrived with the bondsman. We were talking in the hall. She asked me, 'What's happening with my daughter?' and then she started buzzing, I said, 'What's that?' She was mic'd," meaning wearing a microphone. "I said, 'What? Are you kidding me? I'm a

lawyer. You're asking me confidential information and you're mic'd?' The reality crew was there, recording us. I put a stop to the filming." Rubenstein hadn't yet joined the cast.

In the pilot, Gabby tells the camera, "I cannot believe that Alexis was arrested. I don't understand this at all. It was just like, this whirlwind of like, thoughts was going through my *head* like, what could this *be*?"

18

When we arrived at Alexis' house in Thousand Oaks on the day of her arraignment, November 16, 2009, the reality crew was setting up in the living room. The house was a set, with photographic equipment parked everywhere and lunch for the crew set up in the kitchen.

It was a brightly lit suburban home, cheerfully furnished, with religious talismans and floor-standing statues of Buddhas, which Andrea told me she had purchased at the closing of a Thai restaurant. She said that she and "the girls" prayed in front of the statues every morning.

Alexis went and changed her clothes while the crew prepared to shoot a scene in which Andrea and Mikel Neiers recount for Gabby what happened in court that day. Gabby looked very much like Alexis, with long dark hair and a pretty face. She told me she had recently lost 40 pounds. "My mom has a machine that sucks the fat out of you," she said, "upstairs." In her bedroom upstairs, Andrea had an assortment of New Age beauty equipment including a plastic face mask that resembled the Jason Voorhees mask in the *Friday the 13th* series; but I didn't know which one was the "fat machine," which Alexis had described to me as an "infrared hot dome" that "literally melts your fat."

Gabby told me that she went to Alexandria Academy in Agoura Hills and that "the fat girl on *Weeds* goes there."

Andrea Arlington Dunn (center) with Gabrielle (left) and Alexis Neiers outside their home in Thousand Oaks.

The reality crew was ready to film the scene. "Tell her, 'Everything's go to be okay, Gabby,'" said Gennifer Gardiner, the supervising producer. She was standing to the side of the action, holding a large loose-leaf binder—the script.

"Everything's going to be okay, Gabby," Andrea repeated. She was still dressed in her brown suit from court.

Mikel Neiers looked a bit lost.

Gardiner told him what to say.

19

I'd always heard that reality shows weren't really "real," but it was startling to see evidence of it firsthand. As I stood watching the

Dunn-Neiers family act out the facile script of their lives, I won-
dered what fans of these shows would think if they could see for
themselves that they were fake.

The target audience for most reality TV is young women and
teenage girls. And studies of teenagers have shown they identify
strongly with characters on TV, often replicating their behavior.
What's served up on the scripts of reality TV is, of course, shock-
ing behavior, profanity—and outrageous women. From *My Super
Sweet Sixteen* (2005–) to the *Real Housewives* franchise (2006–)
to *The Bad Girls Club* (2006–) to *Jersey Shore* (2009–2012), reality's
females are ruthless creatures who will stab each other in the back,
if not punch each other out, almost as quickly as they will take off
their clothes.

A 2011 study by the Girl Scouts Research Institute found that
reality television may be having an unhealthy effect on the self-
image of girls—50 percent of whom said they believed reality TV
was "real." The Girl Scout study found that 68 percent of regular
reality TV viewers believe that "it's in girls' nature to be catty and
competitive with one another," while only (only?) 50 percent of
nonviewers do. Seventy-eight percent said that "gossiping is a nor-
mal part of a relationship between girls," and 63 percent said, "it's
hard for me to trust other girls," compared with half of nonviewers.
A higher percentage of reality TV viewers also agreed that "Being
mean earns you more respect than being nice" and "You have to be
mean to others to get what you want."

In a 2010 lecture titled "Project Brainwash: Why Reality TV
Is Bad for Women," media critic Jennifer Pozner railed against
how reality TV "crushes" women for our amusement, calling it a
"pop cultural backlash against women's rights and social progress."
What's disturbing is why the women who appear on these shows
submit themselves to the negative stereotypes they're asked to
fulfill—do they want to be famous that bad? Is fame more impor-
tant than self-respect? Is it really worth the money?

That was always Kate Gosselin's argument: that she needed to

put her kids on *Jon and Kate Plus 8* (2007–2011) in order to keep food on the table (meanwhile the show made her famous and rich). Gosselin was criticized for airing her toddlers' private moments on camera; but this was really nothing compared with the mother on an episode of *Toddlers & Tiaras* (2009–), who dressed up her four-year-old like Julia Roberts as the prostitute in *Pretty Woman*. Or June Shannon, the mom on *Here Comes Honey Boo Boo* (2012–), who plies her six-year-old daughter Alana, a.k.a. "Honey Boo Boo Child"—an inverse Shirley Temple for our age, a little girl with the moves of a stripper and the catch phrase "A dolla make me holla"— with a caffeine cocktail of Red Bull and Mountain Dew (she calls it "go-go juice") to get her energy up to perform. "There are far worse things," Shannon said in an interview. "I could be giving her alcohol."

Pretty Wild fulfilled both trends: that of women and children being exploited in the name of "reality." "I am the mother of three wild and crazy teenage girls," Andrea says in the pilot of the show, announcing to the world that her daughters (one of whom, again, was not actually her daughter) are out of control. Throughout the series (which would last one season), she could be seen giving Tess and Alexis Adderall. "Every morning I give the girls Adderall," Andrea cheerfully informs the camera. "Time for your Adderall!" she calls. (Alexis said she was taking the prescription drug for ADD, but it was never clear why Tess was taking it.)

"Alexis and Tess, it is time for school!" Andrea shouts in *Pretty Wild*. But both Tess and Alexis were done with high school well before the show was filmed (Alexis graduated from her home-schooling program when she was 16). You can only wonder if it was considered more titillating for the audience to think of Tess and Alexis as barely legal, high-school–age girls. In nearly every episode, an excuse was found to show them in bikinis, even top-less (with their breasts fuzzed out for broadcast), disrobing. In one episode they could be seen wearing bikinis and pole dancing in the

living room. In another pole-dancing scene, Andrea joins in, awkwardly spinning around the metal bar. (The pole was installed in their house for the series.)

In an episode entitled "Breast Wishes," Andrea takes Gabby bra shopping at a lingerie store, encouraging the 16-year-old to try on a sexy black lace brassiere. "I'm gonna try it on too because I think maybe we should have matching bras," Andrea tells Gabby. "No!" Gabby shouts. But Andrea does so anyway, appearing alongside her daughter and wearing the same bra as they look in the store mirror together, Gabby scowling.

The girls of *Pretty Wild* were stereotyped; but so was Andrea herself, cast in the role of the jealous mom who's competitive with her beautiful young daughters. She played the anxious MILF, or, pardon the expression, "Mother I'd Like to Fuck"—a designation which didn't exist until being "hot" seemed to become more important, in the gaze of pop culture, than being a mother.

20

The impossible new standards of youthful beauty do seem to have made it harder for some mothers to watch their daughters develop into young women and therefore gracefully accept that this means that they, too, are aging. It's a malaise that seems to be felt particularly hard by the Baby Boomer generation. As Baby Boomers started getting older, they resisted the inevitable—they wanted to look younger. And an America obsessed with the rich and famous wanted to look like the rich and famous could afford to look—which always meant looking younger.

The past decade has seen a huge boom in the anti-aging and plastic surgery industries. Ten years ago we had Oil of Olay; now there is micro-dermabrasion, Retin-A, antioxidants, and peels. "Fillers" like Restylane are becoming so mainstream, women

in Dallas are getting them done in the mall. Americans spent $10.1 billion on plastic surgery in 2011, undergoing nearly 14 million cosmetic procedures, an 87 percent increase since 2000. Between 2000 and 2011, Botox treatments were up 621 percent. More than 230,000 cosmetic plastic surgery procedures were performed on people ages 13 to 19 in 2011. And American girls had 8,892 breast implants.

It's hard not to see Americans' preoccupation with their appearance as anything but another symptom of a culture of narcissism. The Narcissistic Personality Inventory includes the statements, "I like to look at myself in the mirror" and "I like to show off my body." The preoccupation with good looks and fame merged in the MTV reality show *I Want a Famous Face* (2004–), which follows the lives of 12 young people who receive extensive plastic surgery so they can look like their favorite celebrities—among them, Pamela Anderson, Britney Spears, Jessica Simpson, Ricky Martin, and Victoria Beckham.

As never before, Americans seem concerned with looking, as Paris Hilton called it, "hot." Interestingly, the precursor to Facebook was Facemash, a website launched by Facebook founder Mark Zuckerberg while he was an undergraduate at Harvard, on which students could vote on the hotness of their fellow students. Now Facebook has become the central stage on which nearly a billion people worldwide post pictures and other content about themselves, promoting their greatness and hotness. Hot Or Not, a website launched in 2000 with basically the same idea (and no connection to Zuckerberg), has attracted hundreds of millions of users internationally who have voted over eight billion times on each other's hot-or-notness.

After she finished filming that scene with Gabby and her ex-husband, Andrea came into the kitchen fiddling with her mic box. "Dude," she told me (like Audrina Patridge's mom, she often talked in that rough Bro-Speak most commonly associated with

teenagers), "I can never figure out how to put on this thing. Tessie and Alexis and I were at a runway show—and I was looking so hot, this young guy were checking me out—and the mic box slid down my hose. It looked like I took a friggin' dump!"

Alexis was downstairs now. She and Gabby smiled uncomfortably.

21

While they were setting up for me to interview Alexis in the living room, I was starting to get a queasy feeling about all this. Susan Haber had been sent along to sit in on the interview, and now she was telling me I couldn't ask Alexis anything about her case.

"But Jeffrey [Rubenstein] said I could," I reminded her.

"Not now," she said brusquely. "Another time."

"When?"

"Not today," Haber insisted. "If you ask her anything about it we're going to have to cut this short."

I went outside on the lawn to call my editor.

"What do they think I'm doing here?" I complained. "They're acting like this is a celebrity profile. I think they just want publicity for the show."

"Just do what you can," he told me.

Alexis came into the room in full makeup, beaming. She was wearing a sweater and leggings, very Sandra Dee. We were seated on a mahogany couch with white and yellow pillows between us. Alexis sat cross-legged.

One of Andrea's sculptures of Buddha sat in the foreground. Susan Haber stood a few feet away, watching us sternly. A cameraman, a soundman, and Gennifer Gardiner were across the room. The camera started to roll.

"What's it like to be you?" I asked Alexis.

"My life's pretty cool," Alexis said, very cutesy-bubbly. She seemed to be enjoying the *Vanity Fair* interview moment in her life. "I find myself to be a normal teenage girl. I go out a lot. I go to dinners with my friends and shopping. I shop everywhere."

I asked her about her style.

"I'm just into a big new craze of tights and sweaters," she said. "Big into shoes and handbags. I'm *always* in heels—at least five inches or taller. I have a pretty cool shoe collection going on right now. . . . I love fashion; eventually I'll have my own line. That's one of my goals. My shoes are everything from Christian Louboutin to Miu Miu to YSL . . . I have *tons* of bags."

Susan Haber interrupted: "Can you make a statement that all of the shoes and handbags that you have—it's hard to purchase them. Like, 'I can't afford this so that's why I like to go to cheap stores and once in a while I splurge.'"

"Well, I *can't* always afford them," Alexis amended. "I'm saving up plenty of paychecks, of course. I can't afford the high-end stuff all the time. I teach pole dancing, Pilates, hip-hop—that's my main income right now." But since she had started filming the reality show, she'd stopped teaching classes. And how much does a pair of Louboutins cost? $500? $1,500? How much does a part-time pole dancing teacher make? I wondered.

"And of course modeling is great and I wish I could do that all the time," Alexis said. "But with this business, sometimes you're on, sometimes you're off. And it's hard to save once you do get those big paychecks. . . . Saving is difficult. Also I save by not going to the tanning salon all the time or . . . I'll do my own nails."

"What else is important to you?" I asked.

"My connection to the divine, my higher power," Alexis said. "How I choose to connect with that is through my Buddhism and my meditation and chanting and stuff like that. . . . My life has gotten so *hectic* I don't have the time to do it every day, but through

the day I'm constantly reminding myself and telling myself good affirmations. ... I'm a firm believer in Karma and manifesting my own destiny through my thoughts and my actions. Whenever I feel like something's not going my way I just change my thoughts and start saying more positive affirmations and things end up going my way."

"I've never really understood what Karma is and how it works," I said. Like for instance, how was it working when you were charged with burglary? "Tell me."

"Well," Alexis said, "Karma, for me, it gets down to the science of it all; everything we say has a negative or positive charge on it and what you say is positive comes right back to you ... So to me it's like, if you're doing something negative to yourself or someone else you're gonna get that back; and they say that if it's a negative thing it's ten times more likely to come back to you ten times stronger.

"My mom is an energy healer so we work on that all the time," she went on. "Everything from tapping methods* to deep, deep meditation to some of her machines upstairs, which are incredible. She has these infrared machines, stuff to cure cancer."

"Hypothetically," I said, longing to turn the conversation to her legal battle, "if something bad were to happen to someone, how is that explained through Karma?"

Alexis said, "It comes down to choices. My Karmic journey was to bring truth to a situation. If that means for me to have to go through what I am going through—" She was starting to tear up. "My destiny is to bring truth to all of this, and I think that—" She was getting emotional again, like she had in Rubenstein's office when she started to talk about her destiny.

* "Meridian tapping" is a New Age holistic healing technique whereby people tap on their bodies in the hopes of undoing disturbances caused by negative emotions.

"Everything happens for a reason," Alexis said, recovering her composure. "It all comes back to choices."

"Do you see a lot of kids in L.A. making bad choices?" I asked.

She said, "I do. I'm not ever going to be one to say that I'm perfect or that I haven't made a bad choice in my life, but what I will say, with the choices that you make you're setting an example for the future kids. These days I'm looking at these celebrities getting into fights, being in abusive relationships, getting D.U.I.s and stuff like that, and I'm thinking to myself, what kind of example are you setting?

Alexis Neiers, posing for Sales' *Vanity Fair* story "The Suspects Wore Louboutins," March 2010.

The example that it sets for kids in my area is—they think drinking's cool 'cause of celebrities and all the Young Hollywood life and partying and stuff like that, and what we don't realize is our actions truly affect everyone."

It was interesting how she transposed "we" and "they" and "you" when talking about celebrities, as if part of her already considered herself one of them; and yet she wasn't sure.

"In the news today we're so hooked on celebrities and teen culture," she said, "and we're not hearing about the real life situations like kids in Idaho that are being abused." Idaho? "Women that are being abused all over the United States," she said. "All over the world. We're not hearing about that in the news every day; we're hearing about who's wearing what and who got in an argument with who and who's not friends with who anymore. And what

people aren't realizing, 'cause they're getting so caught up in all of this, is that you're setting an example—you're setting an example to those teen mothers everywhere throughout the world."

"A couple of years ago," I said, "in two thousand seven, I remember there were a lot of celebrities getting into car crashes and D.U.I.s and caught with drugs . . . Do you remember that?" Two thousand seven was the year Paris Hilton went to jail for probation violation and Lindsay Lohan went to jail (for one day) for misdemeanor cocaine use and D.U.I. Nicole Richie went to jail (for 82 minutes) for D.U.I. as well. Richie was stopped by police after entering the exit ramp of the Ventura Freeway in her Mercedes-Benz SUV. She admitted to smoking marijuana and taking Vicodin before the incident.

"I do [remember]," Alexis said, "and it's still happening today."

"And do you think that kind of thing has an effect on teenagers, when they see that happening?" I asked.

"Oh," she said, "I definitely do. I think that . . . everyone's actions have consequences. It's everything from smoking or not smoking to drugs and alcohol and stuff like that; people don't realize they're setting an example. What shoes celebrities wear—everyone wants those same shoes. All of a sudden it's a huge craze. I remember when I was in, like, sixth or seventh grade, girls at my school were getting, like, Louis Vuitton bags, because the celebrities had them and it was like this huge craze and my family, we could never afford stuff like that, and so I was noticing, like, the impact it had. That's when I started getting into, like, fashion and that's when girls at my school were, in sixth grade."

I suddenly had an image of a tiny Alexis walking into elementary school with a JanSport backpack while all around her little girls were flashing Louis Vuitton bags. I saw her crestfallen face as she looked around at the sea of shiny brown leather riddled with "LV" logos. Later, Nick Prugo would tell me that during the Bloom burglary, Alexis "grabbed a Louis Vuitton bag, like a laptop-size bag, and she was like, rocking it as like a purse. . . ."

"Like, your clothing or your style of car, or just, like, anything that these celebrities do, kids follow," Alexis said. She seemed to be talking about the very influences that had contributed to her becoming involved in a burglary, while steadfastly maintaining her innocence.

She then told me more about how she had worked hard and scrimped and saved. "I mean I've bought my own car and my own clothes since I was fifteen," she maintained. Because of her struggles, she said, "I grew a lot more and I realized at the end of the day clothes and materialistic things are not what's gonna get me far."

22

The filming went on all afternoon. It was interesting how, even amid the unreality of it all, reality would stubbornly peek through. At one point, Andrea and Gabby were doing a scene in the dining room, now dressed in Juicy sweatsuits. They were supposed to be talking about how to deal with Alexis and Tess' wild behavior. Gabby, 15, had been cast as the voice of reason in the family. Andrea was proposing solutions. (The *Pretty Wild* producers didn't seem to mind me watching these performances, I guess because they were so used to the show being scripted.)

Andrea: "They each have a time out, outside the house."

Gabby: "No! A 'time out outside the house' is them going out!"

Andrea: "If they are not able to live within the boundaries of these household rules then they should move out for a week at a time."

Gabby: "And what happened when we did that?"

Andrea: "A lot . . ."

According to multiple sources, the last time Andrea gave Tess and Alexis a "time out," the Orlando Bloom burglary occurred. But the *Pretty Wild* producers were not aware of this.

Gabby: "A lot of bad things."

Andrea: "A lot of bad things . . ."

They stared at each other a moment.

Gabby: "So, obviously—"

Andrea: "That did not work, so what are you suggesting?"

Gardiner, the supervising producer, cut in, feeding them lines: "So Gabby, this is great! 'You need to be a stronger parent, Mom! I shouldn't be the one telling you what to do with them—these girls are out of control, Mom, do something!'"

Gabby, returning to the scene: "Mom, I don't know what you want me to do. Why should I be the one making the rules? I'm the one who is having to explain to you that the girls are totally wrong in this situation. You're letting them do whatever they want to do, even though every day they mess up like this. Parenting is parenting!"

Andrea: "I'm learning."

Gabby: "I'm parenting more than you right now!"

Andrea: "I understand, but I'm having a really hard time establishing boundaries."

Gabby: "Because you want to *be* them—you want to have fun, you see them and you're like, I wanna be doing the same thing!"

Andrea: "I need an opportunity to go out and network." Network? "It's true I've given them the benefit of the doubt and I actually got to the point where I'm. . . ."

Andrea, at a loss for words, began to laugh.

Gabby, sarcastically: "Oh, finally, Mom, you're parenting. I love you!"

Andrea, sarcastically: "Oh, Gabby."

Gabby: "Oh, Mommy!"

They hugged, laughing at themselves for engaging in this charade.

Gardiner told the cameraman to stop filming.

23

I was stuck there all day, as if on a bad flight I couldn't get off; but Tess never appeared. I wondered about this, so I asked Alexis what was going on with her. Susan Haber was still hovering nearby. "We go through our up and down moments," Alexis said mildly. "Right now it's kind of a down moment."

It would only get more complicated in the months to come. In April 2010, the website The Dirty—which seemed to love tormenting the *Pretty Wild* girls—posted pictures of Tess topless, smoking a bong. After that, *Pretty Wild* reportedly lost at least one advertiser, the dating site eHarmony. By August 2010, TMZ was reporting that "Playboy model Tess Taylor has cut herself off from the family that once took her in . . . which is a problem because the show is based around the family."

"No matter how many times people can tell you that you are a part of 'their' family," Tess was reportedly telling friends, "there is still something that is just different."

But as of that day in Thousand Oaks, Tess and Alexis were still nominally BFFs. "I feel like she's my other half," Alexis gushed, "like we read each other's minds. We are *so* close. Being together and being best friends for so long, we know each other inside and out. We're not competitive—we really support each other. When I got the line'"—meaning the Issa lingerie line, for which several girls actually modeled—"I told them, you have to let my sister model. She's got a great body. She works for Playboy. . . . I'm pretty sure she's gonna be a Playmate."

But Tess never was. The sexy-girl-next-door image of a *Playboy* centerfold has never allowed for being photographed smoking drugs.

"You know, it's kind of like an honor"—that is, being in *Playboy*, Alexis said. "You're the twelve most gorgeous hottest women of the year."

24

I'd encountered this attitude in teenage girls before—the idea that being thought hot enough to pose for *Playboy* was some sort of honor, a mark of distinction and accomplishment. In 2000, I did a story on Playboy mogul Hugh Hefner for which I was able to talk to "The Girlfriends" who were living with him at "The Mansion" in Beverly Hills.

There were seven of them—"One for every day of the week," Hef wisecracked—a few of them teenagers. They told me they'd aspired to be Playmates since they were small, like some little girls dream of becoming doctors or writers.

"I have been dreaming about this since I was six years old," Regina Lauren, one of The Girlfriends told me. "I found my dad's *Playboy*s under his bed when I was six years old and I have been dreaming about it ever since. I always admired all the girls."

"I think I was destined to live this particular lifestyle," said another Girlfriend, Katie Lohmann. "I was always the one in school who was the high fashion, high class, drove a fancy car—and that's just how I wanted to continue my life."

"The lifestyle" was now attainable through simply taking off one's clothes. Posing nude had become a semi-legitimate means of achieving fame and money. Porn stars have become household names. Jenna Jameson took her notoriety as the "Queen of Porn" (she appeared in 161 adult films) and translated it into success as a *New York Times* best-selling author (*How to Make Love Like a Porn Star*, 2004) and favorite talk show guest (the *Howard Stern Show*, *Oprah*). Kendra Wilkinson, another one of Hefner's Girlfriends, became a star of E!'s hugely popular reality series *The Girls Next Door* (2005–2011), about Hefner's Girlfriends, and got her own spinoff reality series, *Kendra* (2009–2011).

The proliferation of porn on the Internet over the last two decades facilitated the mainstreaming of porn stars. The Internet

helped turn porn into a multibillion-dollar industry, almost in the same league as Hollywood and professional sports. (By contrast, in 1975 the retail value of all the pornography in the United States was estimated at $5 to $10 million.) Meanwhile, the content of porn has become vastly more hardcore. "Particularly on the Internet, where much of pornography today is consumed, the type of sexuality depicted often has more to do with violent, extreme fetishes, and mutual degradation than with fun, much less with sexual or emotional connection," wrote journalist Pamela Paul in 2008 in a paper for a conference entitled "The Social Costs of Pornography."

"It's all mainstream now!" exults Seth Rogan's character Zack in *Zack and Mimi Make a Porno* (2008). But not without costs. "There is evidence of a massive rise in Internet porn addictions," *The Guardian* reported in 2013. "Women are reporting more relationship problems caused by their partners' porn habits and the number of indecent images involving children is escalating."

Kids now see porn on a regular basis—each year more than 40 percent of teens and tweens visit sexually explicit sites, either deliberately or accidentally. Among 16- and 17-year-old boys, 38 percent have been found to seek out porn deliberately. Studies have found that boys who view porn have a more degrading view of girls—more often they see girls as sexual "playthings." Exposure to porn has also been linked to the early onset of sexual behavior and the frequency of sexually risky behavior.

Teenage boys I interviewed for a story in *New York* as far back as 1997 ("Sex and the High School Girl") told me they'd been looking at Internet porn as early as fourth grade, around age nine. Their respect for girls didn't seem improved by the exposure. They delighted in recounting sexually charged stories about girls they referred to as "chickenheads" and "hos." Boys who had sex were "players," while girls who had sex were "sluts." They would clandestinely tape record and videotape themselves having sex with girls and play

these recordings for other kids. Today, with YouTube, Facebook, and cell phone cameras, they'd no doubt be putting this stuff on the Internet. The new Scarlet Letter for high school girls is this type of "slut shaming," replete with cruelly mocking comments from their peers.

But many of the girls I interviewed for "Sex and the High School Girl" played right into the boys' negative expectations, often with deep regrets. One spoke mournfully about having had sex with "this one and that one and that one"—"I called myself a whore"—and another one confessed to participating in orgies, at 16. "For a girl to be accepted, she has to be down and dirty," said one girl. Some of these same girls were acting out through stealing; they took me on a shoplifting trip through a pharmacy. Many girls said they felt like the sexual landscape offered them no refuge. "I'm a virgin," one said, "and that still gets me trashed."

Girls wonder why being hypersexual feels so self-undermining when so many famous women are being rewarded for their hyper-sexuality. The line between star and porn star has blurred. Celebrities who appear nude or semi-nude often experience a career boost, rarely a negative reaction. Madonna posed naked for her 1992 coffee table book *Sex*, and, at the time, she was the most famous woman in the world, as well as a successful music mogul who "lived the lifestyle" like a queen. Britney Spears, taking a page out of Madonna's playbook, and dialing down the age of the willing sex object by several years, made a splash with her provocative video for "Hit Me Baby One More Time" (1998), a kind of soft-core-porn schoolgirl fantasy.

The Bling Ring girls were eight and nine years old when that Spears video appeared—just at the age when American children typically begin consuming more adult media. Spears' 1999 *Rolling Stone* cover, shot when she was 18, in bra and polka-dot panties, was a watershed moment in making images of (nearly) naked teenage girls acceptable for mass consumption. Today, it's no longer consid-

ered shocking to see female entertainers posing nude or barely clad. Female pop stars perform in a style previously reserved for the *Solid Gold* dancers.* Lady Gaga, Katy Perry, Rihanna, and Britney herself all bust provocative moves, not to mention The Pussycat Dolls, who actually are burlesque dancers. The blatant sexuality is all the more striking when you compare it with, for example, the more soulful style of popular female recording artists of the 1970s—Aretha Franklin, Joni Mitchell, Gladys Knight, Carole King, Patti Smith. Or when you compare the lyrics of Franklin's "Respect," from 1967 (*"R-E-S-P-E-C-T/Find out what it means to me"*), with Katy Perry's "Last Friday Night (T.G.I.F.)," from 2011 (*"There's a stranger in my bed . . . I smell like a minibar"*).

The spread of Internet porn and hardcore porn also coincided, unsurprisingly, with the ascent of "lad culture"—the British term for a new frat boy–style of male swagger. The unabashed new sexism was exemplified by *FHM* and *Maxim* magazines, raunchy rags with content dedicated to hard drinking and hot girls, with covers of nearly naked and usually oiled-up female celebrities. *Maxim* debuted in the U.K. in 1995, in the U.S. in 1998. It seems significant that all of the female Bling Ring victims—so idolized by the girls in the gang—have appeared on the cover of *Maxim*: Paris Hilton (2004); Rachel Bilson (British edition, 2005); Megan Fox (2007 and 2008); Lindsay Lohan (2007 and 2010); Audrina Patridge (2009); and Miranda Kerr (Australian edition, 2012). All have also appeared on *Maxim*'s "Hot 100," which rates famous women based on their "hotness." While their *Maxim* cover girl status heralded their arrival as hot chicks on the celebrity scene, did it also make them seem more accessible and therefore violable to the burglars? I wondered.

* As the dancing troupe on the variety show, *Solid Gold* (1980–1988), they were once the gold standard for female jiggle—outside of Vegas showgirls or actual strippers—in American entertainment.

The Bling Ring girls came of age at the dawning of so-called "raunch culture" in which self-objectifying women are seen as cool and empowered. "Many young girls and women today," writes Dr. Leonard Sax in *Girls on the Edge* (2010), "do not question the idea that baring their skin is a badge of sexual liberation." Girls post provocative pictures of themselves on the Internet as if they were already porn stars; a 2008 survey found that one in five teenage girls had published a nude or nearly nude picture of herself on social media or sent one via cell phone.

But girls may just be replicating an image of themselves they see virtually everywhere around them today. In its 2010 "Report of the APA Task Force on the Sexualization of Girls," the American Psychological Association found evidence of girls being sexualized in a vast array of mediums—movies, television, advertising, music videos, song lyrics, toys, video games, cartoons and animation, magazines, clothing, beauty pageants, and the Internet. These are images, messages, products that portray girls in a sexual context inappropriate to their age, promoting the idea that they can or should be "hot." The adverse effects on girls' well-being, said the APA report, include anxiety and low self-esteem, "body dissatisfaction and appearance anxiety," and depression, all potentially leading to eating disorders, cutting, drug and alcohol abuse, and smoking.

"Perhaps the most insidious consequence of self-objectification," the APA report said, "is that it fragments consciousness. Chronic attention to physical appearance leaves fewer cognitive resources available for other mental and physical activities."

In Tess' Cybergirl shots, she looks delighted to be there, eager to please—and very young. In her pole-dancing videos on the Internet, in which she wears high heels, a bra, and a thong, you get the sense she might have been an athlete or the ballerina she trained to be if she hadn't decided to pursue a career in modeling.

25

"So you and Tess seem like you have the kind of life a lot of teenagers dream about," I said to Alexis that day in Thousand Oaks.

"It *is* glamorous," Alexis chirped. "It's fun, but we don't take it for granted and at the end of the day we are so wholesome and down to earth and we really just care about people and the environment. Of course living this lifestyle is *incredible*," she said, "hanging out with celebrities and sitting in V.I.P. and traveling and stuff like that. But it's all about giving back. 'Cause I feel blessed—I really do—for the lifestyle that I have. . . . And Tess and I, we started from nothing, barely being able to afford groceries, to this lifestyle."

There was that word again—"lifestyle."

"When was it that you were struggling?" I asked.

"Up until two years ago," Alexis said. "But that's how the entertainment business is—with the [Writer's Guild of America] strike [of 2007–2008] and everything, it's been tough; there's been very rocky tough times in our lives. Two divorces . . . shows not going . . . a lot of stuff factors into it."

"So how do you deal with the rough times?" I said.

She paused a moment, and then she began to cry.

"I know who I am," she squeaked, her face screwing up. "And I'm proud of who I am. And it's taken me, like, a really long time to get to this point; but I've been through a lot of tough, tough stuff and . . . it just made me stronger."

She told me about a former boyfriend she later confided was a drug dealer. "He was a functioning drug addict," she said. "He was twenty years old." She said that they had met through Rachel Lee's ex-boyfriend—the one who allegedly came along to a burglary of Paris Hilton's house in the fall of 2008—and that she had dated him until the spring of 2009.

"Underneath it all he's a good person," Alexis said, "totally into chakras, energy. And we fell in love so deeply and the reason I fell in love with him is I thought that I could fix him. . . . He was completely emotionally abusive to me and verbally he would cuss at me all the time. He started getting heavily into drugs. I didn't have a clue. I didn't know until one day I caught him using it. He was freebasing heroin; he was taking cocaine and smoking weed." She said that when she broke up with him, he threatened her physically. "My parents hated him. It wasn't just the emotional stress on me, it was affecting my whole family."

She said he tried to get her into drugs, but she never succumbed. "I'm never gonna make the same mistake that I've seen since I was young," Alexis said. "I had a dad who used drugs and alcohol and I used to always tell myself that I'm never gonna be that person." (Mikel Neiers had no comment.) "For many years I've been offered *tons* of drugs," she said, "especially partying out in Hollywood; but it's just not my choice, it's not who I am.

"Who is Alexis?" she said, referring to herself in the third person, as celebrities often do. "And how are you being a role model? . . . It's taken me a long time to get to this point, where I can say, 'I'm Alexis. This is who I am, so take it or leave it'. . . . I feel strong. I feel independent. I feel like I have self-worth—"

"Why are you crying?" I asked.

"I've got so many people that are talking crap and getting this view of who they think Alexis is. It really bothers me when people assume and judge."

"Who's doing that to you?" I asked.

"A lot of people," she sobbed. "The press, everyone. And now is the time in my life where . . . I'm ready to say, 'This is Alexis, take it or leave it.'" She took a deep breath. "I'm ready to set a great example. My main goal, my main focus and my main destiny in life is to be a leader. It's *incredible* for a girl my age to be where I'm at right now. Honestly, it's like I'm a thirty-year-old woman in my body.

I'm so confident and so excited for my future. I'm ready to take on whatever comes my way.

"My emotions are really raw and, lately," she said apologetically. "Everyone's been attacking me. I haven't been able to get the truth out . . . I want to tell the truth, but I can't yet. But eventually when I do everyone will see who I really am."

26

After we'd finished our interview, the producers set up Andrea in front of the camera to make a statement about Nick. "He's a con artist," Andrea said with her startled eyes, "and he conned me into believing that he was lending them clothes that were leftover from a season of being a stylist and he was able to lend them for their fashion shoots in order to develop their modeling portfolios. . . ."

Gennifer Gardiner made Andrea say the sound bite again and again. Andrea was rushing her words, not getting it quite right.

This was Tess and Alexis' story: that Nick had told them he was a stylist and that was how he had access to all the fabulous clothes he was giving them to wear. "That was a story they told their mother," Nick told me later. "That's how they explained how they had all this new stuff. These girls want to sound like they're naïve, but they knew" the clothes were stolen.

Later, Alexis went to the back porch to smoke a cigarette. There, away from her parents, her lawyer, and her crew, she started talking about the Bling Ring kids.

"Rachel's a klepto freak," she said, her voice taking on an edgier note. "She was so manipulating, so conniving. Nick always did what she said. Rachel was in charge. She started it all.

"Nick was in love with Rachel. Like, he wanted to be her," Alexis said. "She was the girl part of him. I thought he was a good guy. He was Tess' friend. I got kicked out of the house for two

weeks for a bunch of stuff and went and lived with him. . . ." That's when they went to Orlando Bloom's house together.

27

Their target, according to Nick, wasn't Bloom at all, but his girlfriend, Miranda Kerr. Kerr, then 26, was a Victoria's Secret model whose wardrobe Rachel admired. Born in Sydney and raised in Gunnedah, a small rural town, Kerr became a nationality celebrity at 13 after winning the *Dolly* Magazine/Impulse Model Competition. When she appeared in bathing suits in a *Dolly* shoot not long after her 14th birthday, some members of the local media complained that the shoot was "pornographic" and might attract the attention of pedophiles. A national debate ensued over the increasingly young age at which models begin working.

Once upon a time, models were women in their 20s with hourglass figures. Up until the 1960s, it wasn't uncommon for a model to be a mother. The "youthquake" of the 1960s saw the introduction of younger models like Twiggy and Jean Shrimpton, but 18 was considered an unofficial cutoff point, the age below which a girl was still vulnerable enough to warrant protection from the pitfalls of the industry. In the 1970s, Calvin Klein broke the age barrier by casting 15-year-old Brooke Shields in a controversial ad for jeans ("You know what comes between me and my Calvins? Nothing," she cooed). In the 1980s, the age of models started to creep ever downward. Canadian model Monika Schnarre, who was discovered in 1984 at 14, appeared a year later on the cover of the *Sports Illustrated* Swimsuit Issue. Schnarre has recalled how she was once asked by a photographer encouraging her to mimic sexiness, "Listen, I know you're a virgin, but could you just pretend?"

In the last 10 to 15 years, the fashion industry's use of very young models has soared—which can't have gone unnoticed by

the girls in the audience. And one wonders if that's not the point. Fashion designers explain the youthfulness of models on the fact that samples sizes have shrunk to "0" and only 13- and 14-year-olds can fit into them anymore (another issue on its own); or on the popularity of Kate Moss, who throughout her influential career has retained an adolescent look; or on the novelty of fresh faces. But that's only part of the story. The last 10 to 15 years have also seen an increasing push for marketing to teenage, tween, and even elementary school-age girls fashions, which were once considered appropriate for adults only. Major fashion brands have been developing teen lines for decades; what is more recent, however, is the marketing of "sexy" clothing to girls of all ages—belly shirts, low-slung pants, cleavage-baring tops, "booty shorts," etc.

The thong—an item once found almost exclusively in the wardrobes of strippers, which then found its way into the lingerie drawers of young women in the age of raunch culture—is now marketed to girls, sold on the tween and children's market, often decorated with pictures and slogans designed to appeal to children. "I [Heart] Boys," says one; "Look Out Boys Daddy Is Coming Home"—from being deployed in the military—says another; and most cynical of all, from Kmart Australia: "I [Heart] Rich Boys." (The latter was removed from stores after a Twitter campaign.) Clothing chains such as the Limited Too that cater to tween shoppers now carry "sexy" lingerie such as teddies and scanty panties. In 2011, the website Jezebel posted a story on a store in a Colorado mall called Kids N Teen which was selling crotchless thong underwear. When confronted by an outraged shopper, the owner of the store reportedly defended herself by saying that 25 percent of her merchandise was for teenagers—as if that made it okay. (The store later removed the offending thongs.)

One of the biggest marketers of lingerie for girls is Victoria's Secret. In 2012, its $12 million annual Fashion Show made no secret of who its target audience was, with performances by Justin Bieber, Bruno Mars, and Rihanna. Sales of the company's

youth line, Pink, have skyrocketed since its launch in 2002. While Victoria's Secret says Pink is targeted to 15- to 22-year-olds, a performance by Justin Bieber at its biggest marketing event of the year would seem to say something else; Bieber's fan base is tweens. As the singer performed his hit, "As Long As You Love Me," models walked the runway in Pink merchandise. One of them was Miranda Kerr.

Pink features lingerie, sleepwear, and clothing designed to look sexy. Its 2012 Christmas stocking stuffers included lace panties that said "Unwrap Me" and "Ho Ho Ho." Pink also has a "Bling Lace Trim Thong Panty," a strip of nylon encrusted with fake diamonds. In addition to Pink, other major clothing brands such as Abercrombie & Fitch and American Eagle have rushed to put out teen lingerie, an increasingly large chunk of the multi-billion-dollar lingerie market.

So when Rachel Lee wanted Miranda Kerr's clothes, we can guess she wanted to look sexy. To steal the lingerie of a lingerie model—and the Bling Ring stole Kerr's underwear as well—is on some level an attempt to steal her sexual mojo. When I asked Nick Prugo what he thought Rachel's motivation in the burglaries was, he said, "I know it sounds dumb, but, like, she wanted the clothes. She wanted to look pretty."

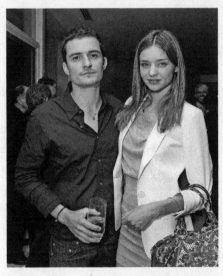

But it wasn't only Kerr's wardrobe that might have appealed; it was her lifestyle as well. She was dating a star—

Orlando Bloom and Miranda Kerr, the month Bloom's home was burglarized, July 2009.

a particularly hot star, one of *Teen People*'s "25 Hottest Stars Under 25" of 2002 and *People*'s "Hottest Hollywood Bachelor" of 2004. Orlando Bloom, then 32, had starred in three of the *Pirates of the Caribbean* films (2003, 2006, and 2007), in which he played the blacksmith Will Turner, a sensitive and gifted swordsman. He had starred in all three of the *Lords of the Rings* films (2001, 2002, and 2003), in which he played the elf prince Legolas, a sensitive and gifted archer. His image had been made into 22 different plastic action figures (10 for Legolas, 12 for Will Turner). He'd appeared in four of the 20 highest grossing films of all time (all three *Pirates of the Caribbean* movies and *The Lord of the Rings: The Return of the King*). Which meant that he and his girlfriend were living very well. They were also Buddhists.

"I see myself as a genuine person who wants the best for everyone," Kerr told the *Daily Telegraph* in 2007. "I believe we're all equal and we all have our purpose in life. We all have our karma that we need to fulfill and I'm here fulfilling mine."

She sounded a lot like Alexis Neiers. Or maybe vice-versa.

28

Alexis told cops that she and Nick were drinking at Beso in Hollywood on the night of July 13, 2009, when Nick got a call from Rachel telling him to come and meet her somewhere. She said she knew that Nick, Rachel, and Diana Tamayo had been burglarizing the homes of celebrities, including those of Paris Hilton, Lindsay Lohan, Rachel Bilson, Audrina Patridge, and others she "was not sure about." Alexis said she was drunk and "not sure what was going on" as Nick parked his white Toyota on the road up the street from a house in the Hollywood Hills. Later, she said, she would find out that it was the home of actor Orlando Bloom.

Alexis said that she and Nick met Rachel and Diana on the

road down the hill from Bloom's home. (Tamayo's lawyer, Behnam Gharagozli, denies his client was involved in the Bloom burglary.) It was a 3,248-square-foot house the actor had purchased in 2007 for $2.75 million. It was looming, black, and surrounded by lush landscaping. Alexis told cops she didn't want to go inside. Surveillance footage of Bloom's home from the night of July 13 shows four figures walking, four abreast, uphill toward the house. One of the lights on the street is out, so you can't see their faces; but you can see that two of them are taller; two are shorter. One of the taller ones is wearing what appear to be light blue pants. They all appear to be wearing hooded sweatshirts, with the hoods pulled around their faces.

As they get closer to the house, it becomes clear that they're walking backwards—backwards up a hill—as if they're aware that they're being filmed by a camera mounted above them, and they're trying to conceal their identities. As they get closer to the house, they suddenly dash toward it—again, seemingly trying to avoid having their faces caught on camera. When they get to the call box at the front of the house (the entire compound is surrounded by a large fence), they ring the bell several times. The postman always rings twice, but the Bling Ring rang three, four. . . .

Apparently satisfied that no one is home, one of the smaller figures attempts to hop the fence, but she can't make it over. She then kneels down and starts working on the fence from the bottom. Alexis and Nick both said this was Rachel, unbraiding the links of the fence, forming an opening. They said she made a hole in the fence and then slipped through, accidentally knocking over a large planter on the other side. The broken planter was found by police when they came to the house two days later, after the burglary was reported.

Surveillance footage shows the lights of a car going on in the courtyard in front of the house (the key was left in the ignition). It was Rachel checking the car for valuables, Nick and Alexis both

said, but she didn't find any. The lights of the car are left on briefly as the burglars make their way up to the house. They walk around the perimeter, checking doors and windows, until they find an unlocked door by the pool area. Bloom's master bedroom.

The lights in the house flicker on successively as the burglars make their way from room to room. Once they were inside, Alexis said that Nick, Rachel, and Diana began to "ransack the home and remove property," "taking numerous items and putting them in bags." She said she saw they were wearing gloves.

"What are you doing?" Alexis said she screamed. "Get me the fuck out of here!" Then, she said, she went outside and threw up and peed in the bushes.

Alexis also said she "specifically observed Prugo walk out with a leather bag filled with items." She said she "told Prugo that she wanted to leave," and that "they all walked back to the cars with Bloom's property." She said she "did not take anything," "but assisted Prugo with the leather bag through the fence." "Lee and Tamayo [then] stated they were going back into Bloom's home to recover more property," Alexis said, while she and Nick "left the area and drove home." Rachel called Nick "as they were driving home," she said, "and told him they had taken numerous watches, jewelry, clothing, and paintings."

Surveillance footage shows the burglars were at Bloom's house for about three hours, and that three or four times during their visit they came out of the house carrying bags to their cars—bags so large and so heavy with stolen goods that, at one point, the one in the light blue pants stumbles, walking up the hill, dropping a bag in the road.

29

Nick scoffed at Alexis's version of events. "We didn't even go to Beso that night," he said. "We've *been* to Beso—we've gotten

wasted at Beso—but this had nothing to do with that night. Alexis just said that as a cover, I think, to make herself sound like" she was drunk and unsure about what was happening.

"Alexis was staying at my house" that night, Nick said. "My parents went out of town and I had the house to myself. Alexis' mom had kicked her out of the house for, like, a learning lesson, so Alexis moved in with me. Alexis' boyfriend was a drug dealer. Her family didn't like him 'cause Alexis had had problems for smoking heroin for a while, and Oxycontin—'O.C.' I've seen [her] smoke it."

"Obviously, it's not true," Alexis said when I later asked her about her alleged drug use. "I would never want something like that said about me."

"Oh God, Alexis and Tess got into the hugest fight over me," Nick said. "Tess was originally supposed to stay with me for those two weeks and Alexis stayed with me instead, and I guess Tess got upset about it. Tess felt threatened that Alexis was taking her friend. . . . And I felt like Alexis was trying to do that to Tess just to make her jealous.

"So Alexis was staying with me," Nick said, "and this was the time when Alexis was into the whole 'I want to rob,' thing. Easy money and whatever." (Neiers' current lawyer, Lesli Masoner, declined to comment.)

Nick said it was Rachel's idea to burglarize Bloom. "Miranda Kerr, the Victoria's Secret model, was dating Orlando Bloom," he said, "and Rachel wanted Victoria's Secret model clothes. So we mapped out Orlando Bloom's house. We knew he was out of town through the Internet—you'd Google his name, see 'Orlando Bloom is shooting a movie, he's with Miranda Kerr in New York.' We planned to meet there, me and Alexis met Rachel and Diana, and we just kind of went from there. We went up to the house—in the video you can see Alexis is walking backwards up the hill. How would a drunk person, so sick, throwing up, be walking backwards up a hill?" he asked.

"That's her Juicy sweatsuit," Nick went on, "those blue pants are her Juicy sweatsuit, guaranteed they're at her house right now." He sounded a bit upset. "I'm more than happy to get on the [witness] stand and give them whatever they need," he said. (Masoner declined to comment.)

Aside from the big robbery of Paris Hilton's jewels—the proceeds of which Nick never saw, as Roy Lopez was never able to sell them—the theft of Bloom's Rolexes was their most valuable haul to date. Bloom's watch collection included over 40 timepieces, some of them quite rare. He had an anti-magnetic Rolex Milgauss from the 1950s and a Rolex Submariner—special items known to collectors.

"Rachel found them," Nick said. "She was in the bedroom . . . and there was like a wall, and Rachel pushed on the wall and it opened up. It was like a bookcase in the wall. . . . I looked in and at the bottom there was a case full of Rolexes and, like, fifteen hundred dollars. So I picked it up and put it on the bed, opened it and we all saw the cash and the Rolexes."

"Alexis was, like, in the house running around," Nick said, "rocking" that Louis Vuitton laptop bag she'd found "like a purse." "Miranda Kerr also had a dress there by Alex Perry, who's an Australian designer," he said, "like a one-of-a kind dress, a fashion runway dress. [Alexis] took that. . . . She had that dress; she had the bag. . . . Everyone just went into the house—you grabbed a suitcase and filled it up with whatever you wanted. Just throw everything in, go back to your house and look through it, and whatever you don't want, just throw it out."

Then "we all left," he said. "We went to the cars and Rachel came up to me and she said, 'I want to go back in. I want artwork 'cause I'm moving to Vegas. I want stuff to decorate my house,' and I'm like, okay. . . ."

It was the first time Nick had heard that Rachel was leaving town.

30

Orlando Bloom told the Grand Jury that he was in New York on July 15, 2009, when he got a call from a woman named Maria Skara, a friend of his girlfriend Miranda Kerr. Skara said that when she went to Bloom's house to pick up some things for Kerr, she found the place had been robbed.

"I called my cousin, Sebastian Copeland," Bloom told the court on June 21, 2010, "and asked him to go up to my house and see what happened. He went to my house, and he called me and said, 'Dude, you have been burglarized. You have been broken into. Yeah, dude.'...He said it was a mess."

In testimony, Bloom, the suave-looking action star, detailed the psychological effects of the burglary on him and his girlfriend. He seemed still shaken from having seen his house trashed, and pained about the way in which the crime had caused him to suspect those close to him.

"There were things everywhere," Bloom said. "It's an awful, awful violation. [My girlfriend's] property, my property, my underwear—you know, everything [was taken]. Personal items, things that I cherish and treasure. It was very hard—it's very invasive, obviously. You don't know until it happens, but it's an awful thing to go through.

"It was immediately apparent that there were painting and photographs [missing]," Bloom said. "It was immediately apparent that everything of any sort of real value had been sort of lifted.... There was a painting in the dining room...a picture in the hallway. There [were] photographs in numerous rooms around the house. There was a painting taken from the guest bedroom.

"[They took] jackets, T-shirts, underpants. There was a bag full of clothes that was stolen. And I think my girlfriend had a lot of her clothes [taken]...."

"I collect watches," Bloom said, "and I had a collection of watches stolen, and a ring. . . . I had a box with [ten] watches and some stuff in it, and that was all gone. . . . There was a ring, and there was some of my girlfriend's jewelry, and some cash that I had in the house for emergencies and stuff . . . Of course I kick myself now because I don't have a safe. But I had [the watches and jewelry] in a box that I thought [I had hidden] quite carefully.

"There's a wall that has . . . a secret [cupboard] in it," he said. "If you look carefully, you can tell that there's a cupboard there, but then there was bookshelves [in front of it]. And at the bottom [of the cupboard], I hid a box, like a briefcase box with my collection of watches and some other personal items in it at the back. I sat books around it, [so] it just would have looked, like a bookshelf— somebody would have to have *known*.

"I mean, that was one of the things that was really freaky about the robbery," Bloom said. "I thought, because they had found those [watches], that somebody who I knew personally must have broken into my house. To know that I even *had* the watches, because it's not something that I talk about particularly. . . . The books were stacked so that it made it not obvious for anyone to look. Everything had been pulled out and dislodged in order to find them. . . . Not a single person in the world knew where I put those."

Also stolen, Bloom said, was "a rug. It's a very odd thing, because things sort of hit you later." The total amount of his loss, he said, was "in the region of five hundred thousand dollars. The watches were of particular value.

"I was really, really freaked out that somebody, and somebody who I knew, who was close to me, who I work with, had somehow been connected to this," he said. "And that for me was the worst thing about it. My housekeeper, [I] was pretty set on [her] . . . as my idea. And so she sort of declined to work." In other words, she quit. "And I have since sent her flowers and stuff, you know."

"You are suddenly second-guessing everything," said Bloom.

"You are like, 'Who has been in my house?' The value of things kind of fades away. It's really about who is it? Who am I starting to question? You wind up looking around at people who are [your] friends [and asking] . . . who it is that could have been involved in this?"

31

In late July 2009, Rachel moved to Las Vegas to live with her father. Nick said she told him she had to get away from her mom, with whom she wasn't getting along. "She was living with her mother in Calabasas, and she and her mother had a falling out," Nick said. "It wasn't about a certain thing. They were just always kind of on edge, and she decided to make the decision to move in with her dad for a change of pace."

It never occurred to Nick that Rachel's decision to move could have anything to do with the burglaries they'd been doing; or the release of the Audrina Patridge surveillance video in February 2009; or the fact that Rachel had just been arrested with Diana Tamayo for stealing makeup at Sephora, and was now "in the system"—that is, the judicial system (her previous offenses were allegedly committed when she was a juvenile and therefore sealed). He never considered that she might be skipping town, distancing herself from him and the robberies. "Not to my knowledge," he said when I asked him about this. To him they were still Nick and Rachel, closer than ever.

He threw her going-away party at Les Deux. It was the last time that they all hung out together—Nick and Rachel, Tess and Alexis, Diana and Courtney and Johnny. "There's actually pictures of it," Nick said. "I bought a table. I wanted to celebrate that Rachel was leaving in a good way. We all had drinks and I got really sick, of course. We had a really good time."

He helped Rachel move to Vegas. They drove across the desert

together, he said, his white Toyota crammed with her stolen goods: bags full of Paris Hilton and Audrina Patridge and Rachel Bilson and Miranda Kerr's clothing and shoes and handbags and hats and underwear and makeup and jewelry and watches and Orlando Bloom's paintings and rug. It didn't occur to Nick that he was assisting Rachel in taken stolen property across state lines. He said, "I really didn't think about that."

He said he stayed with Rachel at her father's place for a week before coming home. "We were going to all the hotels and casinos and hanging out. Partying, I guess you could say." He helped Rachel decorate her father's house with Orlando Bloom's belongings, hanging one of Bloom's paintings in her bathroom. "She was, like, decorating her house [with stuff] from these celebrity homes," Nick said.

He said that Rachel assured him they would stay close, that there wouldn't be any change in their relationship, even though she'd moved away. She said she wouldn't be gone forever, she would probably come back when things with her mom cooled down.

That week in Vegas, Nick said, they didn't talk about all that they had done. He said they never really talked about it—why they did it, or what it meant. "It was, like, a weekend thing," he said. "It was never that serious. In our minds, in the way we were—it didn't mean anything."

But his friendship with Rachel did mean something to him. There were so many things he wanted to tell her now; but he couldn't bring himself to say any of them He just said good bye. "Then I went back to L.A.," he said.

32

By 2009, it had begun to dawn on people that the life of Lindsay Lohan wasn't getting any saner, and that she might be on a trajec-

tory from which her career might never fully recover. Lindsay's career, so far, consisted of a string of successful Disney films (notably the 1998 remake of *Parent Trap*, which made her a star) and a bona-fide hit with *Mean Girls* (2004), the Tina Fey–scripted comedy about a girl who attains popularity by becoming a member of a vicious high school clique.

It was a relatively thin resume for someone as famous as Lindsay, who by now was on a first-name basis with the world. She had stayed in the public eye over the last couple years mainly through the disastrous *Georgia Rule* (2007)—during the shoot she was publicly reprimanded in a letter from her producer, James G. Robinson, CEO of Morgan Creek Productions, for her "unprofessional" behavior and "ongoing all night heavy partying"—and her repeated run-ins with the law, her multiple car accidents and D.U.I.s, trips to rehab, and habit of falling down in front of paparazzi (once outside club Les Deux). There was also the sideshow of her made-for-reality television family, her stage mother Dina (who had actually had a reality show of her own, *Living Lohan*, 2008) and her ex-con father Michael, a pugnacious fame-seeker who acted the part of his daughter's nemesis, calling the tabloids on her, once selling her plaintive voicemail message to the gossip mill.

By 2009, Lindsay was already beginning to embody what is known as the celebrity "trainwreck." The Internet was full of merciless chatter about everything from her latest legal battles to her breast size to her weight. She'd become a lightning rod for a new wave of misogyny as evidenced by the language with which it had now become acceptable to discuss a woman, particularly a young woman, at least online—that is, with the liberal use of the words such as "whore," "slut," and "bitch."

A Google search of "Lindsay Lohan is a bitch" turns up over 13 million links; "Lindsay Lohan is a slut" comes up with over six million, and "Lindsay Lohan is a whore" over four million. Which says a lot more about the meanness of Internet culture than it does

about Lindsay Lohan. In 2009, there was a popular drink among
college kids, a "Redheaded Slut," also known as a "Lindsay Lohan."
"It's a Red-Headed Slut with some Coke in it!" said a drink web-
site. Which I guess is supposed to be hilarious. By 2009, abusing
Lindsay had become a national pastime. Her famous frenemy, Paris
Hilton, kicked off the game in 2006, when she was videotaped
shaking with laughter as oleaginous oil heir Brandon "Greasy Bear"
Davis dubbed Lindsay "Firecrotch," a reference to Lindsay's fiery
natural coloring. When Lindsay entered the Century Regional
Detention Facility in Lynwood, California, in July 2010 for proba-
tion violation, her fellow inmates reportedly taunted her with the
moniker, chanting it.

By 2009, Lindsay was already wearing the scarlet "S," for Star-
let. While the others in her once infamous crew had settled down
and begun to repair their images, Lindsay's continued to unravel.
Paris hadn't been in a courtroom in almost two years. Nicole Richie,
meanwhile, had washed her perceived sins away by becoming a

mother, having had two chil-
dren in quick succession with
Good Charlotte lead singer
Joel Madden in 2008 and
2009. And, in the most
stunning turnaround of all,
Spears, who had been com-
mitted to the psych ward of
Ronald Reagan UCLA Med-
ical Center in January 2008
for involuntary psychiatric

Lindsay Lohan, wearing a $575
Kimberly Ovitz minidress, arrives
at Los Angeles Superior Court for
a hearing on charges of felony grand
theft on February 9, 2011.

observation, released her fifth Number One album, *Circus*, that same December, and then went on a wildly successful tour.

But in 2009, Lindsay seemed at her lowest point. In an emotional interview in *Us Weekly*, in the wake of her breakup with girlfriend Samantha Ronson, Lindsay cried—evincing a seemingly chronic inability to take responsibility for her actions—"Everyone's turned on me. . . ." Ronson's family had reportedly spoken to police about taking a restraining order out against her.

It pained her fans—and she did have fans—to see her fall, because Lindsay was talented. Meryl Streep said so, and so did Jane Fonda. Legendary director Robert Altman had cast Lindsay in a film (*A Prairie Home Companion*, 2006), in which she sang and acted nicely. Plus she was beautiful—"hot"—not yet transformed by the plastic surgery that would bury her fresh-faced looks a couple years later. In 2007, she was voted Number One on *Maxim*'s "Hot 100" list. And that was the same year she was arrested for, outrageously, hijacking an SUV with two men inside and engaging in a high-speed chase through the streets of Santa Monica (she was allegedly pursuing her former assistant's mother, with whom she had been seen arguing earlier).

"It is clear to me that my life has become completely unmanageable because I am addicted to alcohol and drugs," Lindsay said in court in 2007 upon being sentenced to a day in jail and three years probation for misdemeanor cocaine use and D.U.I. But shortly thereafter, she was in the tabloids again, fighting in nightclubs and tweeting angrily at Ronson.

What was wrong with Lindsay? Of all the Bling Ring victims, she bore an uncanny resemblance to the alleged members of the gang. She was the closest to them in age, only about four years older. And there seemed to be a powerful mirroring going on. To begin with, Lindsay seemed as caught up in her own celebrity as the burglars who came to rob her.

As part of research for a *Vanity Fair* profile of Lindsay I did in

2010, I had a long conversation with one of her friends, a former boyfriend who had met her in 2003 when she was 17 and having her first moment of white-hot fame. "She became infatuated with just being a celebrity and being in the press like a Paris Hilton or a Kim Kardashian," said the friend. "At the time she was blowing up, there was this whole celebrity gossip craze that became so big so she concentrated more on that than on her work. She thought it was about being in the gossip magazines. She would plant stories about herself."

When I interviewed Lindsay for the same story, she seemed to concur with this assessment of how she was sucked into the fame machine. "Tabloids were becoming, like the main source of news in the world," she said, "which is really scary and sad, and I would look up to those girls in the tabloids. The Britneys and whatever. And I would be like, I want to be like that. This was around *Freaky Friday* [2003], before *Mean Girls*."

"It's so ironic that Lindsay was in that movie *Mean Girls*," another one of her friends told me, "because that's exactly what it was like. *Mean Girls* with coke and paparazzi."

"She was young and she had no real guidance," said Lindsay's former boyfriend. "Her mom"—Dina, who was then her manager—"had never managed celebrities before. Lindsay was her mother's boss. She was bringing home the bread. If Lindsay threw a tantrum, her mom wouldn't reprimand her." Or worse, Dina was seen out partying with Lindsay; she was called an "enabler" in the media.

Without any discipline or guidance, Lindsay's former boyfriend said, "She developed this sense of entitlement. Since she was a little kid, people were giving her whatever she wanted. She just became rebellious and spoiled and thought that everything was hers and she had the right to everything. She didn't think anything could happen to her." Which was strangely similar to how people had described Rachel Lee to me.

In 2008, Lindsay was accused of stealing an $11,000 mink coat from a 22-year-old Columbia University student, Masha Markova, at the New York nightclub 1 OAK. She eventually returned the coat after Markova saw pictures of her wearing it in paparazzi shots and reportedly had her lawyer call Lindsay's lawyer.

When I interviewed Lindsay in 2010, she said, "I'm a completely different person now. . . . I think self-control is something I've learned over the past few years."

In 2011, surveillance cameras caught her walking out of a Venice, California, jewelry store wearing a $2,500 necklace she was accused of stealing. "Lindsay Lohan is a thief" turns up over four million links on Google.

33

On August 20, 2009, Rachel Lee was back in L.A. for a hearing in her shoplifting case. It was her first offense, and she and Diana Tamayo were sentenced to a year's probation and fined an undisclosed sum. It had been almost a month since Rachel had been in L.A., and in the time she was gone, her friends had been involved in some high drama. There had been an accident. Courtney Ames was driving her car with Nick Prugo in the seat beside her when they wiped out in Hollywood early one morning.

"I was in the front seat of her car," Nick said. "Courtney was driving at seven a.m. We left a bar," Miyagi's on Sunset. "She was drinking from midnight to seven a.m." (Courtney's lawyer, Robert Schwartz, had no comment.) "She got behind the wheel on Sunset and Crescent Heights," Nick said. "She makes a left-hand turn into a car, crashes into this van. Airbags go off. . . . I didn't even have a scratch, thank God, maybe a little whiplash. There were four people in the backseat of her car. Courtney got taken to the hospital." She had broken her collarbone. She was charged with D.U.I.

With Rachel gone, Nick had been hanging out with Courtney, Tess, and Alexis more often. He missed Rachel. But he said he didn't miss the risk of doing the burglaries, or the anxiety it had caused him. He was surprised and reluctant, he said, when, upon her return, Rachel said she wanted to "go on a mission" to Lindsay Lohan's house. He said that he told her he thought it was too risky, that they were pushing their luck; but Rachel couldn't resist pulling off one last heist. "Rachel's like, biggest conquest was Lindsay Lohan," Nick said. "It was her ultimate fashion icon."

Despite all her highly publicized personal problems, Lindsay was still considered something of a fashion goddess at the time, particularly among a young, celebrity-obsessed subset of the fashion-buying public. She'd been the face of a number of labels, including Jill Stuart, Miu Miu, and Dooney & Burke. She'd been on the cover of *Harper's Bazaar, Elle, Marie Claire, Allure,* and scores of other fashion magazines. She was a model before she was an actress, landing a contract with Ford when she was only 3 and appearing in over 60 commercials before the age of 11 (she had supported her family while her father was in jail). A self-confessed "fashion junkie," she once told a reporter she'd dropped $100,000 clothes shopping in one day. She had her own line (of course), 6126, named for the birthday of her idol, Marilyn Monroe (it started with leggings). In August 2009, the month that she was robbed, she was a guest judge on *Project Runway.* She had a sexy, rock star style that reflected her rebellious behavior.

On the night of August 23, Nick said, he and Rachel drove with Diana Tamayo to Lindsay's house in the Hollywood Hills. They went in Diana's car this time and parked down the street, he said, down a hill from the residence. It was a three-bedroom rental Lindsay had moved into in February, after moving out of Samantha Ronson's house, nearby. It was surrounded by tall hedges. The street was quiet, empty like neighborhoods in L.A. always seem empty, except for the sound of traffic somewhere off in the distance.

Surveillance footage from that night shows three people, a boy and what appears to be two girls, approaching the entrance to the house, an arched doorway inside a gated entryway paved with tile. The visitors appear to be trying to conceal their faces. The girls wear hoodies over their heads. One wears a hoodie and a scarf, while the boy wears a hat and a scarf as well. The boy's long-brimmed baseball hat looks a lot like the one worn by the boy in the Audrina Patridge surveillance video. It's Nick. He's smoking a cigarette.

"I didn't even want to go into Lindsay's that night," Nick said. " 'Cause our thing was always, when we'd walk up to the door, we wouldn't be masked. We'd be really inconspicuous, like teenager kids. We wouldn't be looking like we were doing anything wrong. . . . I thought, when we were, like, casing the house, that if people were driving by, I didn't want to look like we were suspicious and so I wouldn't cover myself. I was just, like, innocently there."

But now they felt like they couldn't go anywhere without concealing themselves; not after Rachel and Diana had had mug shots snapped. "And I knew if my face was on camera," Nick said, "and anything was taken, I knew that video would be released, just like Audrina's. But Rachel was like, We're here, Lindsay's gone. I wanna do it, this is our opportunity.

"She said, let's just go in—no one's here. You're on camera, but it doesn't matter. You'll be fine. Audrina was fine, you'll be fine with this one. And so we went in," Nick said. "Obviously it wasn't fine 'cause someone said something to the police and the police came to my house."

In the surveillance footage, you can see the burglars ring the bell several times; and then, when no one answers, they walk around to the side of the house. They were looking for unlocked doors and windows, Nick said, "but the house was completely locked." He said they found a window in the kitchen at the side of the house, which Rachel proposed forcing open. "We had a screwdriver in the car,"

he said. "Rachel took the screwdriver, jimmied open the window. Diana crawled through the window into the house, unlocked the door," and then let them in. Tamayo would later claim that it was Rachel who crawled in the window.

There was "no alarm," Nick said, "no nothing."

The house was "messy," he said, "just clothes everywhere"— bags and bags from shopping trips and freebies delivered from clothing stores and fashion lines. It looked to Nick like the home of a "compulsive shopper. . . . There was so much stuff that hadn't even been worn, with the tags still on. . . . It was obviously heaven for [Rachel and Diana]. They were freaking out, like, 'These are the clothes! This is my dream!' This was the wardrobe [Rachel] wanted." Clothing and shoes and handbags and gowns by Alexander Wang, Chloe, Gucci, Chanel, Donna Karan, Christian Louboutin, Fendi, and Givenchy. . . .

"They started filling up suitcases and bags," Nick said. "And I'm kinda like, standing there like I don't know what to take. After the first ten minutes passed I wanted to go. But they wanted the clothes, they wanted the purses, they wanted the shoes. . . ." He said Rachel told him, "You're already here. You might as well get something for yourself."

"I took, like, a Juicy men's T-shirt," Nick said. "I took one shirt. I took, like, a little picture of some Ed Hardy skull." Actually, he also took some Louis Vuitton luggage and jewelry. That same weekend, he was arrested for driving under the influence.

34

Lindsay told the Grand Jury that on the night of August 23, 2009, she left her house around 9 p.m. to go visit friends in Malibu. When she returned home about 3:15 a.m., she said, she noticed "my front door wasn't locked, and it usually always was. My alarm

didn't sound, and usually I had to turn it off. . . . I noticed that the side door" leading upstairs into her kitchen "wasn't locked at all."

Inside the house, she said in court on June 21, 2010, she saw that "everything was all over the place. . . . Everything that I had was kind of thrown [around], and everything was pretty much disheveled." She said she started looking to see if any property was gone, and right away she found two watches were missing. "One was a gift," she said, "so it was pretty sentimental." The other missing watch was a Rolex watch with a blue face—the same type shown on the wrist of someone in a photo that Nick had given to the LAPD; he said it was Rachel's wrist.

Also missing, Lindsay said, were "a lot of shoes . . . bags were taken . . . It was a lot of stuff that I had accumulated over a long amount of time and that I have worked for. . . . Hundreds of thousands of dollars" worth of stuff—an estimated $128,000 in all. A Hermes bag was gone, a Louis Vuitton bag, a custom-made black mink coat, and two paintings—one depicting a skull—and a beaded rosary Chrome Hearts necklace. Assistant District Attorney Sarika Kim showed Lindsay a picture of a rosary necklace by Chrome Hearts. "And do you recognize it as property that belongs to you?" she asked. "Yes," Lindsay said. It was the same type of necklace that had been spotted by an LAPD detective and taken off the neck of Courtney Ames at her arraignment on December 2, 2009.

On the lower level of her house there was a closet in which there was a safe. When she went to look at it, Lindsay said, "It was as if someone was trying to move it. And there was like a black lacquer on it, so I could see the fingerprints in trying to move it on the white walls.

"I had just gotten back that day from a trip," she said. "So I had things still packed in my suitcase," which was also gone. "That night that I went back to the house, I just felt, to be honest, so violated and uncomfortable that I literally packed as much stuff as I could [and left]. Because it wasn't about the things that were taken, it was

just the fact that someone came into the only private space that I have in my life at this point. And my sister," Ali Lohan, "was with me and she was really upset and scared. So I literally packed as much as I could and left that night and still have not gone back to that house since that night. I left that house. I stayed in a hotel, and then I moved into an apartment building.

"And I don't ever plan on going back to that house," Lindsay said. "It was, like, such an invasion of privacy, and it's just eerie."

35

The next morning, Nick drove Rachel to the Bob Hope Airport in Burbank to catch a Southwest flight back to Vegas. He said he would never forget the image of her walking away, strolling into the airport. "I don't know if there's some airport video," he said, "but she was, like, rolling Lindsay's suitcase, wearing Lindsay Lohan's purse and Lindsay Lohan's clothes—she was just, like, fully Lindsay Lohan."

He said it was the first time he had ever felt a pang of doubt about Rachel. "It was just so crazy," he said, "to be walking into a place like that, with so much security, so many surveillance cameras, with all that stolen stuff. It was like Rachel really didn't believe anything could happen to her."

Since she'd come back to L.A. and said she wanted to "go shopping" at Lindsay's house, Nick said that he had a feeling this was how they were going to be caught. He'd already taken most of his stolen belongings and moved them to his grandmother's house, which, he said, "I feel really bad about." He didn't want to get rid of them completely—he wanted to keep them, all "the beautiful, gorgeous things"—but "I put it all out there 'cause I thought something might happen and . . . it was kind of a precaution." (His grandmother didn't know that the boxes her grandson put in her basement were full of stolen property.)

Two days later after Rachel left, on August 26, the LAPD, with Lohan's permission, released the surveillance footage of her home to TMZ. Now there were two videos circulating, Lohan's and Patridge's, making it all but plain to see that they had captured images of the same people, and that there was a connection between the Hollywood Hills burglaries.

36

In the last week of August 2009, Brian Austin Green's home was robbed. Nick couldn't really account for why he decided to do the job without Rachel there. It was just a week after he and Rachel, and Diana had burglarized Lindsay Lohan's house. Nick knew his image would once again appear on surveillance footage that would be posted on TMZ—"I just had a feeling," he said. The Green burglary happened a week after Rachel had gone back to Vegas, so Rachel wasn't pushing him to do it.

Green, Nick said, had been on their hit list, and they'd already done the surveillance of his home; he said Rachel had been interested in the wardrobe of Green's girlfriend, Megan Fox. But Nick didn't want Megan Fox's clothes.

Fox, then 23 years old, was an actress from Oak Ridge, Tennessee, who'd appeared in a succession of roles highlighting her smoking hotness—she was on a 2004 episode of *Two and a Half Men* in which she played an underage girl lusted after by Charlie Sheen and Jon Cryer; she was the hot pants-wearing love interest of Shia LaBeouf in *Transformers* (2007) and *Transformers: Revenge of the Fallen* (2009). She also played an aspiring actress in *Whore* (2008), about a group of teenagers who come to Hollywood with hopes of becoming famous, but wind up becoming "whores."

Why would Nick risk doing another burglary at this time? Was it because his anxiety about being identified was now so excruciating that he was unconsciously trying to speed up the inevitable?

Was it because, for once, now, with Rachel gone, he wanted to be in charge of a burglary—to finally rob someone who might have clothes he wanted? "I feel stupid now," he said, "but I used to get into fights with her 'cause it was like, this is all for *you*, this is all women's fashion, what's in it for me? This is all women you're picking, and like she'd be like, No they have boyfriends, you'll get something, and I'd be like, okay, just trying to make her happy. I didn't want confrontation and so I just went along with it."

Was it because part of him missed Rachel, and this was a way of making her jealous . . . maybe making her want to come back? Or was it just because he wanted the money? "I guess it became like an addiction," Nick said.

In the last week of August, he said, he went to Green's four-bedroom Tudor home in the Hollywood Hills with Courtney Ames and another friend, a girl I'll call "Sherry." (Ames' lawyer, Robert Schwartz denied Ames participated in the burglary of Green.) Sherry was a graduate of Calabasas High—"a really cute, pretty blond girl," Nick said, who was petite enough to reach up through the doggy door in a side entrance of Brian Austin Green's house and unlock the door. "She had problems with Xanax and, like, pills," Nick said. "She would take pills and want to do these things with me, burglary things."

Nick said that Ames stayed in the car, acting as a lookout, while Sherry reached through the flap and opened the door. "And then we walked in," he said. "The alarm was off. There was a bunch of nice TVs, gamer systems. We didn't take any of that. We just went to the [bedroom] closet, took some clothes, kind of with the idea that if we take a little, no one will notice. And they didn't notice. They had no idea until I talked to the LAPD and the LAPD contacted them and they were like, 'Oh yeah, that makes sense now.'"

Brian Austin Green told the Grand Jury on July 18, 2010, that it wasn't until almost two and half weeks after the burglary that "I went to look for jewelry that I normally wore and it was missing." Among the missing jewelry was a Rolex watch.

It was Nick's style to be stealthy. And maybe also this burglary was Nick's way of proving to himself, and to Rachel, that his way had been right. Be safe, be careful, be like mice. Take only a little. They have so much, they'll never notice it's gone. Green hadn't even noticed the theft of his Sig Sauer .380 until the police called him and told him they had it.

"There was a lock box under the bed," Nick said, "and I thought there was maybe cash or jewelry or something in it." So he took it. He said when Courtney later saw the box, "She was like, 'That's a gun, that's a gun.' So I'm like, 'I don't believe you.' Then we go to Johnny's house. Open the box. There's a gun in there. I hate guns. I didn't even touch it, I didn't want to touch it. Courtney picks up the gun. Wipes it off. Gives it to Johnny. We sell it to him for three hundred bucks and the gun's gone. You know, because I hate guns. They freak me out. So, I got rid of that. Kept some clothes, and, you know, that was really it. . . .

"That wasn't really a big robbery."

Days later, Nick returned to Green's house with Diana and another accomplice, he said, and raided it a second time. Tamayo's lawyer, Behnam Gharagozli, denies his client burglarized Green.

ALMOST FAMOUS

1

On September 1, 2009, the Hollywood Area Commanding Officer of the LAPD, Captain Beatrice Girmala, received a call from a man named Paul Wolcott, a retired cop who was the Security Manager of CNN's West Coast offices. Wolcott had some startling information about a couple of high-profile burglaries that had taken place in the Hollywood Hills. It seemed the robberies had allegedly been committed by two teenagers, Nick Prugo and Rachel Lee. Wolcott had heard this from a CNN employee who didn't want to be named—the LAPD would refer to her as "Protected Witness #1." She was a young woman who had a friend, another young woman, who hung out in Nick and Rachel's social scene. The LAPD would refer to this second source as "Protected Witness #2."

Protected Witness #2 had contacted her friend at CNN and told her that "while attending a party, she overheard both suspects boasting that they had committed both . . . burglaries together"— that is, the Patridge and Lohan burglaries. "During their boasting, the suspects mentioned the names of both celebrity victims," according to the LAPD's report. Protected Witness #2 emailed links to Lee and Prugo's Facebook pages to Protected Witness #1, who then forwarded them to Wolcott, who sent them to Captain Girmala. Girmala notified LAPD Detectives Steven Ramirez and John Hankins, who had been working on finding out the identities of the people seen in the Patridge and Lohan surveillance videos.

Up until this time, the detectives at Hollywood Station didn't have any firm leads about the string of celebrity burglaries that had been taking place over the last eight months. They hadn't even connected them to one another. "Initially, investigators had no evidence that suggested that these crimes were related," said the LAPD's report. Cops had interviewed some of the victims; checked out the crime scenes; taken fingerprints and DNA samples—for example, off cigarette butts found in an ashtray on Lindsay Lohan's balcony

(which they later found to be covered with Nick Prugo's DNA). But they didn't necessarily think that there was an organized crew behind any of this, and certainly not that it was a band of teenagers. "They were a very successful crime ring," Vince, my cop source, said. "They were just really bad at not getting caught."

Booking photos of Nick and Rachel from previous arrests (hers for petty theft at Sephora; his for D.U.I.) showed them to resemble the people in the Lohan and Patridge videos—especially Patridge's, in which you can see both of their faces in the bright light shining from above the front door. When investigators checked out Nick and Rachel's Facebook pages, it became evident that they were indeed "friends" with each other. From Facebook, they also learned that the two had attended Indian Hills High School in Calabasas, California, together. They saw that they liked to post pictures of themselves wearing designer clothes and jewelry; that they liked to party; and they seemed very interested in celebrities.

In addition to the call from the source at CNN, cops were now also receiving tips from random citizens. "Who does this sound like to you?" Vince asked me, playing a voicemail message that had been left for detectives at Hollywood Station. The voice on the phone sounded a lot like one of the Bling Ring suspects, anonymously identifying other defendants.

"Armed with the above information, search and arrest warrants were penned and executed at the homes of Lee and Prugo," said the LAPD's report.

2

On September 17, 2009, the morning he was arrested, Nick said, "I was laying in my bed. My mom walks in the room crying. It's like seven a.m. I already feel something in the pit of my stomach. She comes in my room and says, 'You need to get dressed. They want

you to come outside.' Just hysterical. I felt like the worse piece of shit ever."

His parents, Nick said, "knew something was not right but they didn't know anything" about why the police might be there. But, he said, he knew, "after, obviously, the Lindsay thing."

The heavily armed police detail that had been sent to the Prugo house was considered routine. In California, burglary is a "strike" offense under the state's "three strikes" law, and burglars, if convicted, can face sentences from 25 years to life in prison, so there's thought to be the potential for someone to try to run or fight arrest. "It was people with, like, machine-gun-looking guns pointed at my family," said Nick.

Under California's Penal Code Section 459, the definition of burglary is entering a structure with the intention to steal or commit a felony. Nick's house was being searched that day on suspicion of burglary and possession of stolen property.

"They didn't even come into my house," at first, Nick said. "I walked out to them. They patted me down—actually they patted my mother down. I felt like so responsible. I felt such shame."

Since he'd already moved most of his stolen possessions to his grandmother's basement, there wasn't much for the police to find—at least nothing they could recognize. "They searched my house and they left [stolen] property there 'cause they didn't know what they were looking for," Nick said. "I had shirts and jeans and T-shirts from these [celebrities] but they didn't know, so they left it." They took a pair of designer sunglasses they presumed belonged to Orlando Bloom—but actually, Nick claims, these were his. "I may have bought them with stolen money," he clarified, "but I didn't steal them."

"I just went quietly," he said. "I made it as easy as possible. I went down to Hollywood Station. I was there all day. Seven a.m. to eleven at night." His bail was set at $20,000. "Eventually, I was bailed out," he said. "I stayed quiet."

When he was grilled about the burglaries of Audrina Patridge and Lindsay Lohan, Nick told police he didn't know anything. That was what Rachel had told him to say if he were ever questioned, he said. "She was just like, keep denying it, there will be no evidence. There's no fingerprints. It's just your face. They can't prove anything with just a face."

Nick denied that he had done anything wrong, or that Rachel had, either. He admitted they knew each other and hung out together, but that was it. He covered for her.

After not finding Rachel at home that day, the LAPD didn't try to apprehend her in Vegas. Apparently they felt there wasn't enough evidence yet to warrant an out-of-state arrest. Immediately upon his release, Nick said, he called Rachel at her father's house. He said she sounded "relaxed. . . . She said she hadn't heard anything" from the police. She knew about Nick's arrest, having seen news of it all over the Internet. "Arrest Made In Lindsay Lohan and Audrina Patridge Burglaries," said People Online. "Yes, we have found [him]. God is good," Dina Lohan, Lindsay's mother, told the website.

Nick said Rachel also told him that she'd sent emails to several celebrity news outlets including TMZ, planting a story that Nick was a friend of Lindsay Lohan's and had been "hanging out" with her on the Burbank, California, set of the ABC Family film *Labor Pains* (2009). When asked why she had done this, Nick said, Rachel replied that it was to throw the police off the scent, to arouse suspicion that Lohan was involved in the burglary of her own residence. It seemed to work: "LiLo May Have Connection to Burglary Suspect," TMZ posted on September 22, 2009. "I think she's in on it," wrote one commenter. "He's probally [sic] her coke dealer," wrote another.

Rachel told Nick not to worry, he said, nothing was going to happen to him. It was all going to blow over.

And it might have blown over, if Nick had not confessed. The

police, at this point, did have very little evidence. They had no stolen property. They had some fingerprints they couldn't place. The Patridge video was grainy enough that some good defense lawyer conceivably could have argued it away. If Nick hadn't confessed to committing multiple crimes with his friends, it's possible that nothing much would have ever happened to any of them. Why he did confess is one of the most puzzling aspects of this story.

3

My early conversations with Sean Erenstoft, Nick's former lawyer, all took place when he was in his car. Once when we were talking, he told me he was "in [his] Porsche" and so, if I lost him, he would call me back.

"I'm in a unique position," Erenstoft said as he Porsched along. "I've got inside information about what's going on."

In the next few weeks, Erenstoft would share some of this information with the "Sunday Styles" section of the *New York Times*, the *Los Angeles Times*, *People*, The Daily Beast, and TMZ, to name a few of the places he was quoted. I started to wonder whether it was Erenstoft who was the source of the "inside information" about the Bling Ring that was flowing to TMZ, but there were so many other possible candidates—some of the other lawyers, who didn't seem averse to publicity; cops; and the Bling Ring defendants themselves, who seemed to feel no hesitation about trashing each other.

In our initial conversations, Erenstoft sounded like a sharp guy who knew how to help a reporter out while still protecting his client's interests. He would divulge details about the other Bling Ring suspects while minimizing Nick's role in the burglaries. "Rachel's in possession of a lot of property," he told me. "She stashed it before the cops could get to her.... Courtney Ames was sleeping with [Johnny Ajar]. She's the wannabe gangster type."

But every now and then the lawyer would say something that would make you want to squint. "Even I have been around Paris Hilton when she's snorted coke," he said. "If you're a night owl in L.A., you're gonna run into any one of these people. We all feel like we know Paris."

Erenstoft seemed to be bothered personally by what the Bling Ring kids had done and to feel that they should be punished. He told me a few times, "I've been a prosecutor." He said, "I don't know where people get the gumption to step in someone else's home. When I was a kid you weren't supposed to touch stuff that wasn't yours. I'm troubled by the new generation."

Nick met "Sean," as he called him, in late September at Miyagi's, a darkly lit Asian fusion restaurant on Sunset near Crescent Heights—it was the same place where Nick and Courtney had been drinking the night Courtney crashed her car in August 2009. Once a hot spot with a lot of celebrity clientele, it was now somewhat past its prime (and has since closed). Nick was close with someone who worked there, and his friends said they could get served drinks there even though they were underage. "They serve children at Miyagi's, when you're under eighteen," says the girl with Courtney in the TMZ video where Courtney's outside the Studio City tattoo parlor Obsession Ink in January 2010.

It was a chance encounter between Nick and Erenstoft. They were introduced through Nick's friend at Miyagi's. Hearing he was a lawyer, Nick started telling Erenstoft about his legal troubles. Nick had just been arrested and was out on bail. He had another attorney at the time. But somehow by the end of the conversation, he was convinced that Erenstoft was the lawyer for him, and had decided to hire him to defend him.

I've wondered if Nick, who'd been abandoned by Rachel, and seemed to crave the direction of a strong personality, had now found this in his new lawyer. Erenstoft is a guy with strong opinions who isn't shy about voicing them; there's something of the old movie cop about him; he actually looks a bit like Dick Tracy.

One night in November 2009, I met Erenstoft for dinner at Iroha, a Japanese restaurant in Studio City that he'd chosen. We sat at the sushi bar, where he kept ordering from the sushi chef with a pronounced Japanese accent. He wore a suit, and seemed to have recently had a haircut. He was all angles, square haircut, and square jaw.

That night, Erenstoft admitted to me that "the cops didn't know anything" about what Nick had really done before Nick confessed. "As far as the cops were concerned," he said, "Nick was [only] in receipt of stolen property. He had come and talked to me in private," at his offices, after their first meeting, "and he said, 'look, I saw the surveillance videos on TMZ. It was supposedly me and I went oh my God, oh my God, this is serious!'

"This was his reaction," the lawyer explained. "He realized he had some major issues to deal with, because now he wasn't sleeping. He thinks he's losing his hair over it; he's not eating; he can't hold food down—[he has] all of the nervousness of a very, very scared man. Basically, for the first time in your life, you realize this isn't child's play. It was Rachel's idea—let's go out and have some fun, and now he's being hunted," after the surveillance videos had been released.

"When I met [Nick] that night," at Miyagi's, Erenstoft said, "he talked to me. He said, 'Sean, I want to be able to sleep. I want to come clean. I want to figure out a way to do it. I don't trust the authorities.' And he said, 'Will you help me find a cop that you trust, because I have a feeling that I'm about to make this cop famous.'" His rendition of Nick's dialogue didn't sound quite like an 18-year-old boy to me, but I guessed this was just his interpretation of their conversation.

"No one has solved these capers up until now," the lawyer went on, supposedly quoting Nick, "and I need to come clean for my own life's sake . . . I need to make the victims whole," in other words, to confess and return their stuff. "I've realized this is fucking serious."

"So I met him the next day, I met him in private," Erenstoft

said, stabbing at a piece of pricey raw fish with his chopsticks. "He had gathered from meeting me that I was a sensitive kind of attorney. It wasn't just about deny, deny, deny—I happen to be a judge also here in L.A. . . . Sometimes I tell the D.A.'s I work with, my guy did not do it and I'm willing to do battle, and sometimes I say, my guy fucked up, I'm not gonna fight as hard on this one. . . . When Erenstoft's gonna try a case, he does. And then sometimes you want a guy like me saying, here's my sense of justice: I know the case better than you. I know my client better than you, and you need to take my lead. You need a guy like me to dole out what justice should look like."

Erenstoft said that after his second meeting with Nick, he contacted Brett Goodkin at Hollywood Station. He knew Goodkin was not a detective, he said, he'd just been one of the officers at Nick's arrest. "I knew he was a good cop," said Erenstoft. "Andy Griffith, that's who we're dealing with. . . . I said we're definitely not going to the detectives on this case 'cause these jackasses don't know what they're doing.

"After this he's gonna have a stripe," Erenstoft said of Goodkin.

But according to Goodkin, it was just a coincidence that Erenstoft reached out to him. "Sean called me 'cause Nick Prugo's mom had my business card," Goodkin told me. "I left it with her when we arrested him; it was standard procedure. That's the only business card they had." But because Erenstoft called Goodkin with Nick's confession, Goodkin became the lead investigator on the case.

4

On October 6, 2009, Goodkin and Detectives Steven Ramirez and John Hankins went up to Erenstoft's offices on Ventura Boulevard in Sherman Oaks. His suite was in a brown brick high-rise along a main drag dotted with palm trees and bank branches. The meeting

was voluntary, arranged by Erenstoft. The men met with Erenstoft first, without Nick there, in his office, where he laid out his client's general involvement in the crimes to which he was about to confess. Erenstoft asked if Nick's cooperation could be relayed to the District Attorney's Office. The detectives said that "should Prugo's level of cooperation rise to the level of which Erenstoft represented," they would write a "Letter of Accomplishment" to the D.A. and "would not oppose a disposition favorable to Prugo"; however they "did not offer immunity or otherwise promise leniency for Prugo," according to the LAPD's report.

After their initial conversation, the men went into a conference room to meet with Nick. He "seemed like a smart kid, very matter-of-fact," Goodkin said. In a straightforward manner, "like he was describing a trip to the store," Goodkin said, Nick proceeded to tell them a story that surprised even these seasoned law enforcement officials. He talked about doing a string of burglaries of the homes of some very famous people—Paris Hilton, Audrina Patridge, Rachel Bilson, Orlando Bloom, Lindsay Lohan. He said that he had also participated in the burglary of a house on Hayvenhurst Avenue in Encino (Nick DeLeo's). He confessed to robbing the home of an architect named Richard Altuna. He said that he'd mistakenly thought Altuna's house in the Hollywood Hills belonged to the celebrity D.J. Paul Oakenfold, but realized his mistake when he saw mail in the house that was addressed to its true owner. He said that he and his friends robbed the place anyway, taking a Nikon digital camera, which they sold to their fence for $700. They also discovered $5,000 in cash in the house, which, Nick claimed, they split among themselves.*

Nick said that he had been accompanied on these burglaries by several different accomplices—among them Rachel Lee,

* None of Nick's accomplices were charged in the Altuna burglary, and, due to legal complications, can't be named.

Diana Tamayo, Alexis Neiers, and Courtney Ames. (It was in a later meeting that he alleged the involvement of Tess Taylor.) He told of how Jonathan Ajar, a club promoter he knew, had acted as their fence, and how he—Nick—had planned out a bigger robbery of Paris Hilton's jewelry along with Ames and a bouncer he knew only as "Roy" (Lopez). (Ames and Lopez's attorneys, Schwartz and Diamond, again, deny their clients had anything to do with the burglary of Hilton.)

"He confessed to crimes we didn't even know he committed," Goodkin said. "He told the truth even when it only hurt himself. He seemed like he wanted to come clean."

"He went into it not getting any assurances," Erenstoft told me that night at Iroha. He seemed to be struggling with conflicting feelings about having allowed his client to confess. "I'm a righteous guy," he said. "I feel like I see justice. . . . I believe I have the pulse on what is right and wrong. . . . I know the difference between chaos and order and I have a complete true sense of how it should be helped. . . . I am pompous enough to think that I have a greater sense of justice here.

"I take a lot of responsibility," he said. "I know I have the respect of prosecutors and judges. *He's a fair guy. Justice seems to get done on his watch.* This is the first time I'm thinking, wow, my client's neck is so far out there and I'm letting him take so much responsibility—if he gets his neck cut off on this thing I'm going to scream bloody murder!"

As the night went on, Erenstoft told me about his past. He seemed haunted by his childhood. He said, "I got kicked out of the house at seventeen. You didn't deserve it but you still think you did something wrong—why do I feel so alone? I know Nick Prugo. When Nick said, 'I need to sleep, I don't know what to do,' I understood." Then he left the restaurant and went home in his Porsche.

5

After our meeting that night, I went back to my hotel and thought about Erenstoft's story; it seemed odd. Why would Nick confess to crimes the police didn't know about and might never know about? And why would his lawyer let him do that? Erenstoft claimed that Nick had confessed in order to ease his conscience, and that he, Erenstoft, had endorsed this plan because of his "greater sense of justice." It all sounded very noble. I wanted to believe it.

I called my friend Kent Schaffer in Houston. Kent's a well-known criminal defense attorney. I met him while doing another story. I wanted to know what he thought of Nick's confession. "In thirty years practicing criminal defense law," Kent said, "I've never told someone to confess. Once you confess, your options are down to nothing—you're at the mercy of the state. 'Okay, I did it, everything I am accused of doing'—there's not much the lawyer can do for you after that. You just have to hope that the state takes over representation of your client's interests. It makes no sense. If the guy had kept his mouth shut he never would have had a prosecutable case."

There's an argument for a client confessing, say other attorneys. Daniel Horowitz, Nick's current lawyer—also a well-known criminal defense attorney, practicing out of San Francisco—actually defended Erenstoft's strategy when I asked him about it. "[Erenstoft] counted (perhaps) on his relationships with prosecutors to cure the problem," Horowitz wrote in an email. "Most prosecutors will do 'what's right' and help an early cooperator regardless of whether promises were made."

And yet Horowitz and his colleague Markus Dombois still brought a motion in 2010 to have Nick's confession suppressed, based on Erenstoft's failure to adequately represent his client by encouraging him to talk to the police. The motion was denied.

When I asked Brett Goodkin what he thought of Nick's confession, he said, "It was the right thing to do."

6

Based of Nick's confession, the LAPD now moved ahead with searching the homes of the other suspects. Their search warrant for Courtney Ames, Alexis Neiers, Diana Tamayo, Roy Lopez, and Jonathan Ajar dated October 22, 2009, said they were looking for "hats, purses, designer bags and/or luggage, watches, silver and/or gold jewelry, sunglasses, coats, clothing, scarves, personal computers, laptop computers, gloves, photos, cameras, rugs, paintings, and Hilton Family heirlooms" allegedly taken from celebrities' homes; also "narcotics, dangerous drugs, marijuana, and paraphernalia related to the use and/or sale of such substances as hypodermic syringes, hypodermic needles . . . spoons, balloons, condoms, measuring devices, badges, pipes, cutting agents. . . . as well as large sums of cash." They were looking for any sort of communication "boasting about the burglaries." They were afraid the suspects would find out from each other that the heat was on and let each other know, so the searches were to be conducted simultaneously. So many cops were needed for the five-residence sting that Hollywood Station, which has a relatively small force, was pulling officers and detectives out of all its departments, including homicide. The Bling Ring was about to be busted.

7

When the police arrived at Diana Tamayo's Newbury Park apartment, only Diana was at home. They went in with guns drawn, as was their protocol. Diana was cool and collected as showed them into her bedroom, where they found several items they felt were "consistent with that taken during this crime spree."

They'd determined beforehand that they only needed to find

one thing in each residence in order to make an arrest. In Diana's room they allegedly found a Chanel makeup bag, Chanel No. 5 perfume, "a Louis Vuitton brown leather purse, stacks of assorted perfumes, including the Paris Hilton signature brand, a Hermes black leather purse, and designer shoes." They also found a photo album with pictures of Diana posing, out partying, with Nick Prugo and Rachel Lee.

At Hollywood Station, Diana repeatedly refused to consent to an interview with police. She said she would talk only in the presence of an attorney; her mother was working on getting her one. Diana allegedly told officers, "Those other guys were fuckin' stupid to talk to you guys. . . . All that stuff in my house I bought at the swap meet."

She was in jail for four days, until October 26, when she was released from LAPD custody to U.S. Immigration Customs Enforcement (ICE). Her lawyer, Behnam Gharagozli, would later complain that Goodkin, "with the assistance of Detective James Martinez," had "improperly obtained knowledge" of Diana's illegal status and given her over to ICE as a means of intimidating her into confessing. (LAPD Special Order 40 states that "officers shall not initiate police action with the objective of discovering the alien status of a person.") In July 2012, Superior Court Judge Larry P. Fidler dismissed the motion to drop the charges against Diana on this basis.

On October 26, 2009, Diana was released from ICE back into the custody of the LAPD. She had agreed to be interviewed. "You promise this ICE crap isn't gonna be on me, right? No ICE hold anymore?" she asked Goodkin, according to complaint filed by Gharagozli. "No ICE hold on you. I promised you. I promised your attorney," Goodkin allegedly said.

"Her confession was coerced," Howard Levy, Diana's lawyer at the time, told me. Levy was, however, present in the room when Diana admitted to cops that she had accompanied her friends

Nick Prugo and Rachel Lee on a burglary of the home of Lindsay Lohan. According to Gharagozli's complaint, Levy had told police, "Okay, she'll talk, but she's only going to cop to one of them, Lohan."

In her videotaped interview, Diana said that on the night of August 23, 2009, she and Rachel had decided to go out to dinner—"sushi or something." Diana said that Nick was with them in her Navigator, which she was driving, when Rachel suggested, "Let's go look at some really pretty houses." Diana said that she then overheard Nick and Rachel discussing the location of Lindsay Lohan's home. Nick directed her where to drive, Diana said; and then, all of sudden, there they were, on Lindsay Lohan's street. Diana said that Nick got out of the car and started walking toward a house—it was Lohan's house—and then suddenly they all were going toward it.

"What did you think you guys were gonna do when you walked up to the house?" Goodkin asked.

"Go into it," Diana said.

She said that Rachel had "told her things she had done in the past."

"Okay," Goodkin said, "so you figured that they were probably just gonna break in?"

"Yes," Diana replied.

She claimed it was Rachel, not she, who entered Lohan's kitchen through a window and then let her and Nick inside. Diana said that she took just one pair of the actress' shoes from the house that night, but later discarded them in the trash.

Diana said that she and Rachel had also approached the Toluca Lake home of Ashley Tisdale in late July. She said that Rachel rang Tisdale's bell, but when a housekeeper answered, they "ran away." Tisdale would later tell police that the two young women her housekeeper had seen had actually entered her residence before they fled.

8

"Nick was the brains, Rachel was the balls, and Diana was the look-out," Courtney Ames told the LAPD in her videotaped interview at Hollywood Station.

As the camera rolled, Courtney stonewalled the room full of cops and detectives asking about her alleged involvement in her friends' criminal activities. "She was tough. She was smart. She was almost like a lawyer," said a lawyer for one of the other defendants, who had viewed the tape. "She just kept saying, why should I answer your questions? How will this benefit me?"

But Courtney was willing to talk about her friends. She told police that she was friends with Rachel Lee, Diana Tamayo, and Nick Prugo; and that one night Nick called her up to say the three of them had burglarized the home of Lindsay Lohan. She said Nick said he had some items in his car from that burglary, and that he was going to bring them over to show her. She said Nick said he had some "presents" for her, and that he came over to her house and showed her the "presents"—designer clothing and jewelry, which Courtney said she couldn't identify because she didn't wear jewelry. But Courtney said she never took any of these things for herself. The police had found no stolen evidence at her home.

Courtney also said she knew that one of her friends had burglarized Paris Hilton, according to the LAPD's report, which also claimed that Courtney said that some of her friends had burglarized the home of actor Brian Austin Green and his fiancée, Megan Fox. She allegedly said that Nick told her he'd stolen a gun from Green's house and that the gun was eventually given to Johnny Ajar (her boyfriend at the time). The police were surprised to learn of this sixth celebrity burglary, as Nick had failed to mention it in his lengthy confession.

There seemed to be no love lost between any of the suspects.

"Ames was like, do you know what kind of people these are?" Vince, my cop source, said, "Ames for whatever reason doesn't have a sense of smell—she can't smell. And she said that [one of the other girls in the burglary crew] knew about this and took a can of tuna and put it in her car so it would rot so everything would end up smelling like rotten fish." Including Courtney.

9

Roy Lopez said from the beginning that he didn't want to rat out anyone. Brett Goodkin told the Grand Jury that after Lopez was arrested at a stoplight and taken to Hollywood Station on October 22, "He denied any involvement in any criminal activity at all. He did lay out how he knew Ms. Ames," from working with her at the Sagebrush Cantina in Calabasas. "He did lay out how he had met Ms. Lee and Mr. Prugo at the Sagebrush initially, because they were friends with Ms. Ames. But during that interview, he would not admit to any crime. So I concluded the interview, and I moved him to, like, a holding tank, which is a tank that is just a little closed-off room with a glass window and a bench, and I sat him in there to get him ready to book him. And at one of the points when I was walking back and forth, he stood up and waved me over. I opened the door and, you know, asked him if everything was okay. I figured he needed to use the restroom or what have you. And it was at that point that he said, 'Hey, if'—the best of my recollection was, 'Hey, if you let me make a phone call, I can get all of Paris' stuff back.'

"And he went on further to say that he wasn't a rat and that he wasn't going to tell me who his accomplices were or what they did, but that he was going to take responsibility for this burglary.

"So I walked Mr. Lopez back to my desk, and I asked him what number he wanted to call. And he gave it to me and I called that number, handed the phone off to Mr. Lopez, and he proceeded

to describe to this person on the other end of the phone, 'Hey, I need you to go into your garage. Remember that place where I keep my stuff? There's a bag,' and he described it, 'and I need you to bring it to Hollywood Station.' And then he put the man on the phone with me and I gave him the address.

"About forty minutes, forty-five minutes later, a young man arrived at Hollywood Station and handed me a very large, garish bag that was filled with jewels."

Lopez's lawyer, David Diamond, says the LAPD lost the audio recording of its interview with his client, "thus preventing us from showing the police report was embellished." But Diamond did not respond directly to my question of how his client came to be in possession of the Louis Vuitton bag full of Paris Hilton's jewelry. All he said was, "The bag was returned. No one ever knew the entire contents of the bag."

10

On the morning of October 23, TMZ posted footage of Courtney, Diana, and Alexis being taken away in the back of a police car after they were all arrested. They were being transferred from Hollywood Station to Van Nuys Station to be held pending bail. They all looked tired and greasy, as if they needed a shower. "Did you do it?" a videorazzo shouted through the car window. Diana sat forward, scowling, apparently answering in an unfriendly fashion. Alexis and Courtney sat back, looking stunned and scared. They said nothing.

"They put me in the cop car to transfer me to Van Nuys," Alexis said when I spoke to her at the Polo Lounge in December 2009. "And when I sat in the car, Diana and Courtney were next to me and in that car ride it was extremely unpleasant and not so nice. Words were exchanged on Courtney's end." Alexis began to get tearful.

"When we got to the station," she said, "when they were booking me and putting me in a cell, they said do you fear for your life? They ask you a number of questions about your health and at that time I said yes I do! And they said with who? And I said with Courtney. I went into the medical facility to get checked up on 'cause I was still feeling dizzy and sick 'cause I still hadn't eaten at that time. When they gave me my clothes and my blanket, they took me to the cell and they bunked me with Courtney on the top bunk and me on the bottom." Now Alexis was crying. "And I believed it was intentional. I had just said I feared for my safety because of Courtney! I felt the whole time they were being really tough on me...." (Ames' lawyer, Robert Schwartz, had no comment.)

Jeffrey Rubenstein, Alexis' lawyer, said, "That day I saw her, she looked very young, very frightened, she hardly had any clothes on, and was, like, soaked in sweat and tears. She appeared very frail and vulnerable, not somebody you needed to traumatize anymore."

"I looked so fragile," said Alexis.

"She looked like she was twelve," said Rubenstein.

"Like a baby," said Alexis.

"And when Courtney threatened you," said Andrea, "didn't she use—" I wondered if she were going to mention Johnny Ajar.

"Stop it," Rubenstein said.

"Stop!" Alexis told her mother. "We're not talking about that! That's why you need to keep your mouth shut!"

While Alexis was being put in a cell, Tess had already been released. At first, she said she didn't know what the police were talking about, according to the LAPD's report; but then she relented and said she knew her friends Nick, Rachel, and Diana had been robbing the homes of celebrities. She provided a list, which included Paris Hilton, Lindsay Lohan, Rachel Bilson, Orlando Bloom, Brian Austin Green, and Megan Fox. Tess said that once Nick had been arrested, and she learned he wasn't really a stylist, as

she said he'd claimed, she packed up all the clothing he had given her in boxes and ordered him to come and remove them from her garage—which, she said, he did.

"Yeah. That never happened," Nick said.

11

Rachel Lee's father, David Lee, lived in a large white house with a red tile roof in a quiet suburban neighborhood in Las Vegas. There was a pool in the back. There were few trees on the streets, which provided a vista of some lumpy gray hills in the distance. Everything was blue sky and bright sunlight and emptiness.

Rachel was home alone when the police arrived with guns drawn on the morning of October 22. Detective Ethan Grimes of the Las Vegas Police asked Rachel if she knew why they were there, and he said she calmly told him, "Yes."

"My friend Nick was arrested about three weeks ago and he called me from jail and told me that the police had done a search warrant on his home," Rachel said, according to Grimes. She said that she had been watching TMZ and " 'they' [were] saying she [was] a 'person of interest'" in the burglaries of the homes of celebrities, the detective said. Grimes said that when he asked Rachel if she'd been involved in any of the burglaries or been in any of the celebrities' homes, she said, "No"; and when he asked if the police were going to find any stolen property at her house that day, she said, "No."

"While we were waiting for the LAPD detectives," Grimes wrote in his report of the warrant service, "I had explained to Lee that it appeared that the LAPD had a strong case against her and that her cooperation in helping us recover any of the stolen property might help her in the long run. She said she didn't know anything about the stolen property. Before the LAPD detectives ar-

rived, she asked me, 'Hypothetically. Let's say I might know where this property is located and who has it, how could that help me?'"

Grimes said that he told Rachel that detectives on the case were "trying to recover hundreds of thousands of dollars worth of property for these victims," and that if she could help them locate it, he was sure that "they would definitely say that her cooperation helped them locate it."

Then, he said, Rachel fell silent, and sat and watched as the police arrived and began to search her father's home for evidence.

Detectives from Las Vegas and Los Angeles found pairs of "high-end designer jeans," a custom-made black mink coat, and a box containing less than an ounce of marijuana that Rachel admitted was hers. "I have a prescription for it and bought it in California," Grimes said she told them.

In a residential trashcan outside the back of the house, Detective Steven Ramirez from Los Angeles found two photos among the trash. They were photographs of Paris Hilton, nude from the waist up. Rachel "saw me bring the photographs in from the outside and put them on the table with the other recovered items," Ramirez said.

"And did you notice any change in her demeanor from the time when you arrived to the time that those items were placed in front of her?" asked Deputy District Attorney Sarika Kim during Grand Jury proceedings on July 22, 2010.

"She seemed deflated at that point in time," said Ramirez. "Her shoulders slumped, and she kind of put her head down when she saw me bring those in."

At that point, police felt they had enough evidence to arrest Rachel, and they did so, handcuffing her.

"If I tell you guys where the stuff is, will you let me go?" Rachel allegedly asked.

Rachel's father, David Lee, a middle-aged man with a long ponytail, arrived at home while the police were searching his house. "Don't say anything, Dad," Rachel allegedly told him.

Meanwhile Officer Craig Dunn of Las Vegas was canvassing the neighbors for information. Dunn reported that he spoke with Judy Shott, a neighbor down the street, who said that "over the past two months she has seen suspicious activity at [Lee's] residence. Shott said she has seen several Asian subjects loading boxes" into the back of two different pickup trucks, and described one of the subjects as being "a middle-aged Asian male with a long ponytail." (David Lee did not respond to requests for comment.)

Rachel "wanted to help us get the property back," Detective Ramirez said, "but ... she wanted to speak to her attorney." Between "half a dozen and ten" times, she said she wanted to speak to her attorney.

Police also found a sheet on which "Rachel had written her name out several times, but used different middle names," reported Detective Grimes. There was another piece of paper, Grimes said, which had "a circle drawn in the middle with line spoking [sic] out from the edge of the circle and at the end of the various spokes were names." They were the names of the other subjects in the crime ring. Rachel's name was not on the paper.

Detective Leanne Hoffman from Los Angeles found a white fedora with a dark band in the hallway by the front door; the L.A. District Attorney's office would say that this was the same hat that Rachel can be seen wearing in the surveillance video of the burglary of Audrina Patridge's home.

"That's my hat," Rachel allegedly told Hoffman. "I can show you receipts for that." But Rachel did not provide detectives with any receipts.

"If I tell you guys where the stuff is, will you let me go?" Rachel allegedly said again and again. "If I tell you where the stuff is, will you help me out?" she allegedly asked.

Detective Hoffman found "a large sum of money"—around $20,000 in cash. "That's my dad's," Rachel allegedly said. "If I tell you where the stuff is, will you leave it here?"

"Just throughout the entire search warrant it was like she con-

stantly was asking us . . . for some type of leniency or release if we wouldn't arrest her or take her to jail," Hoffman told the Grand Jury.

"We were standing outside waiting for the patrol car to come pick her up and take her to the station, and I explained to her that this is a very serious matter," Hoffman said. "She didn't seem like she thought the situation was real until we actually brought her outside," to take her to the station to be booked. "Continually as I was walking her outside, she kept looking around, kind of perplexed. She was saying, 'What's going on? I told you I would tell you where the stuff is.'

"She didn't seem like she thought the situation was real until we actually brought her outside," Hoffman said.

"I really, really want to tell you guys where the stuff is, I just can't," Rachel allegedly told her.

" 'You have to understand burglary is a . . . big deal to people,'" Hoffman said she told Rachel, " 'and despite the fact these are celebrities, it's hard for somebody to lose property. And it might just be things, and you might think that these people have a lot of money or jewelry, but some of these items were very important to them.'

"She immediately asked me, 'Did you talk to them?' You know, inquisitive and in almost like a hungry manner she wanted to know. And I said, 'Yeah, I talked to them all.' And she said, 'Did you talk to Lindsay?' And I said, 'Yeah,' and she goes, 'Well, what did she say?'

"And the way she asked me that . . . not out of concern. It was almost like, I don't know, almost like a gossip column, like an excitement to know or have knowledge of what a celebrity would have said about her."

12

In the early hours of October 23, TMZ trailed Courtney Ames as she was released from Van Nuys Station on $50,000 bond. Courtney looked exhausted; she was wearing an oversized leather jacket (not Paris Hilton's) and keeping her head down.

"Who are the conspirators?" a videorazzo asked, jostling along beside her as Courtney walked across a parking lot to a waiting car. "Who planned it all? You guys only do celebrities' houses?"

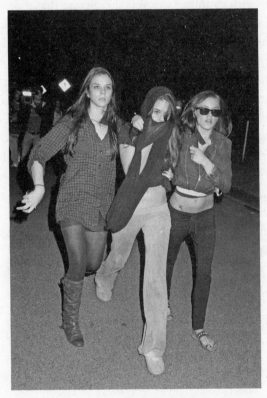

Gabby Neiers, Alexis Neiers, and Tess Taylor leave the Van Nuys Area Jail the morning of October 23, 2009.

"Anything to do with Kourtney Kardashian's place?" a second photographer asked.

Courtney smirked. "You guys are hilarious," she muttered.

"We just want answers," said the photographer.

"Sorry. I'm not giving you any," said Courtney.

That same morning, TMZ followed Alexis Neiers and Tess Taylor as they ran down the stairs from the station. Gabby Neiers was with them, too—in most news reports she was cut out of the picture taken from this moment, perhaps because she hadn't been questioned by police, or perhaps because she was younger, and covered up with clothing. This was the picture that made the Bling Ring hot, with the hot girls with bare midriffs who looked like celebrities, one arrested for burglary and one questioned on suspicion of burglary, one a Playboy model and one a pole dancing instructor, both literally running from the law. It would appear on the cover of the "Sunday Styles" of the *New York Times* and on gossip sites across the blogosphere.

Tess was giggling, kissing Alexis on the forehead as they hurried down the stairs. The girls seemed giddy, overcome by the excitement of the cameras flashing and the swarm of photographers shouting at them. It was their first real taste of tabloid fame.

"How was it inside?" a videorazzo called.

"It was *terrible!*" Alexis said from underneath the scarf she had draped across her face, giving her a refugee look.

"Did you do it for Nick? Did Nick trick you into it?" the videographer asked.

"She did nothing! I *told* you guys!" said Tess, and to Alexis: "Don't talk!"

13

That same day, October 23, the Las Vegas police went back to the home of David Lee to seize a custom-made black mink coat

from his daughter's closet. They'd discovered the coat during the warrant service the day before, but hadn't taken it, as they weren't sure if it was stolen. They sent a digital photo of the coat via cell phone to Lindsay Lohan's assistant, who showed it to Lindsay, who confirmed the coat was hers. The police then obtained another search warrant and went back to the house to retrieve the mink.

Rachel was home; she'd only been questioned the previous day and released. (That same day, October 23, Rachel's lawyer, Peter Korn, was in contact with the LAPD. When told by Detective Leanne Hoffman of Rachel's promise to return the victims' stolen property, Korn allegedly said, "If she told you that, I'll make sure that property is returned.") Rachel's grandmother, Janelle, and her cousin Jennifer were home with her when the police came the second time. It was about 11:30 a.m. when they arrived, guns drawn again and pointed at Rachel and her family.

Rachel "was a little startled," said Officer Craig Dunn of the Las Vegas Police, "a little surprised that we were there. Once we explained the circumstances and went through our protocol, she seemed to be very cordial toward us. She didn't seem upset. She didn't seem frightened at all.

"It seemed like she was just getting up," Dunn told the Grand Jury on June 22, 2010, "and she asked if she could use the bathroom. . . . She had asked about putting makeup on. . . . She wanted to put makeup on. And I said, 'You could,' as in 'Why? Because TMZ is outside?' And she got all bubbly like it was her birthday." But the policeman was only teasing her.

"And then I told her [TMZ] really *wasn't* [outside]," Dunn said. "There was no news there, and her whole body motion went from up to down. . . . She was under the impression that there would be media there."

When Rachel found out that there was not, Dunn said, "She was very upset. She was sad. Just the whole look [on her face was] similar to just a child not getting a present."

14

A partial list of what the LAPD reported it recovered in the search warrants: "Pearl-style necklace, several rings with yellow metal and white stones, a ring with white metal and green stones, a ring with yellow metal and red stones, a ring with yellow metal and green and white stones, a Marc Jacobs purse, a Louis Vuitton purse, 2 Chanel purses, 1 Hermes purse, a Steve Madden shopping bag, a Blackberry Edge cell phone and an LG cell phone, 4 pairs of BCBG and Marc Fisher heels, a pair of True Religion pants (which are connected to Rachel Bilson), 2 bottles of Paris Hilton perfume, 2 bottles of Chanel perfume, an Apple laptop, Gucci eyeglasses, Chanel eyeshadow, a Chanel makeup brush, Dior mascara, a Mexican passport, and a Washington State driver's license."

15

On October 24, two days after she was arrested, Alexis spoke to TMZ.

"I know for a fact Nick did all of these burglaries," Alexis told the gossip site. "He did every single burglary, he told me this after the police let him go. Nick is blaming people, trying to get the blame off himself. . . . Rachel Lee was his main accomplice and they brought Diana Tamayo into this. Diana, Nick, and Rachel did the burglaries together. Roy Lopez was the one who sold the stuff they had taken . . . and he's friends with Courtney Ames and that's why she was arrested. The only reason they came to my house was because they thought I was holding property for Nick; they even searched my house and found nothing. I'm innocent in all of this and feel terrible for all the people who got robbed."

The post was accompanied by a black-and-white photo of Alexis looking sultry, provided by Alexis.

"Put all these RATS in jail until they rot to death," one of the comments on the post said. "Several years behind bars will make them squirm. Vermin. Nasty foul vermin."

Another commenter took a more radical view: "Take that Hollywood! I hope you have enjoyed your days in the sun . . . These modern-day Robin Hoods shall all be found innocent and released to lash the backs of those who have trod upon the backs of such peasants as we, heroes, every last one!"

16

On October 26, Nick met with Brett Goodkin again at Sean Erenstoft's office in order to return more stolen property. This was the second load of goods Nick would give back to the police. He had already returned a TV and DVD player he had stolen from Rachel Bilson; luggage he had rolled out of Audrina Patridge's house; artwork and luggage he had stolen from Lindsay Lohan; the iMac computer he had taken from Nick DeLeo; and clothing he had stolen from Orlando Bloom. Now, he gave back some jewelry he said he'd removed from Lindsay Lohan's house and a Rolex watch he had taken from Brian Austin Green.

"Prugo opened the meeting by apologizing profusely for not mentioning the burglary of Brian Austin Green and Megan Fox's residence," said the LAPD's report. Goodkin said, "He was legitimately sobbing."

"Prugo explained that he was fearful that because he . . . had stolen a firearm from Green's residence and sold it to [Jonathan] Ajar," the LAPD's report went on. "Prugo also explained that after she posted bond, Ames called him and stated that she had spoken with Ajar and [he] told her to forward a threat to Prugo. Ames

stated to Prugo that he should leave town because Ajar was going
to send people to Prugo's home, tie up, torture and eventually kill
Prugo's entire family as Prugo watched."

(Ames' and Ajar's lawyers, Robert Schwartz and Michael
Goldstein, had no comment.)

17

By the time I met Nick, in December 2009, he was already famous;
or infamous, sort of. A picture of him walking along looking jaunty,
wearing aviator shades and a trucker hat, had appeared on the
cover of the "Sunday Styles" section of *New York Times*. ("Going
for the Bling," the paper said. "Were teenagers too enthralled by
stars?") Another picture of Nick wearing a ski cap and flashing
his megawatt smile had appeared on page 5 of the *New York Post*.
("Rachel Lee, above with fellow suspect Nicholas Prugo, is accused
of masterminding the thefts. . . .") The *Los Angeles Times* had done
five stories on the burglaries and given the crew its catchy name.
(" 'Bling ring' confession helped break celebrity burglary case . . .")
TMZ had been relentless, posting items almost daily, including the
video of Nick doing a stripper-style dance in his bedroom to "Drop
It Low." ("Miss Thang . . . Go girl!!" a commenter teased. "His par-
ents failed," said another.)

After many inquiries, Sean Erenstoft finally said that Nick
would talk to me; he wanted to tell his story, Erenstoft said, in
order to "clear his name." "He's being called a rat, and that's unfor-
tunate," the lawyer said, "because all these kids are ratting on each
other."

I was invited to dinner at Erenstoft's house in Encino, in the
Valley, one coldish night in December. It was a large modern house
with modern furniture and a bright, open living room with high
ceilings; there was a fire crackling in the fireplace. Erenstoft's girl-

friend, the one who came with him to Nick's hearings, was there with her two little boys. We had a conversation in the kitchen about being single moms while I helped her set the table and make a salad. She and Erenstoft had been dating for less than a year, she said, but she was very sure of him, and that's why she was comfortable involving him in her children's life. She mentioned a couple of times how successful he was.

All the while, Nick sat nearby at the dining room table, smiling from time to time while he drank a soda. A couple of times he went out on the back patio to smoke a cigarette. He struck me as different than he looked in pictures. He was the same angular kid with thinning hair; but there was something about him that photographs didn't capture. In pictures he looked like a party boy, always posing with pretty girls draped around him, kissing him, sticking their tongues in his ear. In person he seemed nervous, as if he were trying to keep from jumping out of his skin. Maybe it was the effect of having been charged with eight counts of residential burglary and potentially facing 16 to 48 years in prison. His dark eyes glittered with anxiety. He was very thin. His barely concealed jitteriness and thinness struck me as being reminiscent of a drug addict, but I didn't know he was struggling with addiction yet. He wore a plain white button-down and jeans. He seemed to want to make a good impression.

After dinner we went and sat on the living room couch. I took my tape recorder out. Erenstoft lay on the floor with his girlfriends' kids, playing a board game, while she was in the kitchen, cleaning up.

"Why did you agree to be interviewed?" I asked Nick.

"The media writes all these things, puts judgment on what happened," he said, in a way that was both tense and calm; he had a surprisingly deep voice for such a skinny kid. "I'd like everyone to know the real truth and not to cover up anything I've done or anyone else has done. Everyone is guilty of something."

I asked him how they all knew each other—he, Rachel, Court-
ney, Diana, and the others allegedly in the burglary ring. He talked
about meeting them and the trouble in school that had sent him to
Indian Hills. He talked about how he had always felt that he was
"ugly."

"And now you're a star," I said.

He laughed. "On my Facebook page recently I had eight hun-
dred friend requests," he said. "I accepted them all. I didn't even
look at them. Then I noticed someone had created a fan page for
me. . . . I start getting these messages from these fourteen-year-old
girls. 'You're so hot. I wish I was part of the Burglar Bunch. I love
you.' Just like insane stuff. And this girl's like messaging me, 'I made
a fan page for you. You have like 50 fans.' And then I looked at it
and lo and behold, I have a fan page."

" 'I wish I was part of the Burglar Bunch?' " I said.

"If it had been for something good or something I had done
to help the community or benefit something I'd love it," Nick said,
"but it's just kind of awkward for me that these people are loving
me for something that's looked down on in society. It's kind of
showing that America has some sick fascination with a Bonnie and
Clyde kind of thing. And then I have pedophiles that are trying to,
you know—it's kind of disturbing and I delete that obviously. But
it's weird. People are fascinated with me."

I asked him about his family.

"I don't really want to talk about my family," he said. "They're
so supportive and so wonderful; everyone wants to blame the family
or the parents or the upbringing. My family's been so great; I can't
even blame them. Whatever I've done, it's been me. My family's
always been there to support and motivate me. It was me and my
own issues; it definitely wasn't my family, it was my issues with me
as a person."

Alexis had told me that Nick's dad "was very stern . . . he was
really tough on him . . . he didn't trust him at all. He was just like
very strict about keeping the house clean, very anal." Erenstoft had

said that Nick's father was "kind of a hothead." He said he thought his dad "pretty much stayed out of Nick's business, not knowing about the turmoil Nick might be suffering." "His mom was a sweetheart," Alexis said. "Nick cussed at her all the time. He was just really mean and constantly arguing."

Nick's current lawyer, Daniel Horowitz, said Nick had a warm relationship with both his parents.

I asked Nick about Rachel.

"I've really, like, cried over the fact that I've been so attached to her," he said, "and this whole thing's been really hard 'cause I still care for her. I still love her to this day, but it doesn't excuse what happened."

And then he started talking about the burglaries. He said, "If you look at the celebrities that have been victimized, they're all women with, like, you know, fashion sense. . . . These women were all very successful and they all had expensive clothes." He talked about how he and Rachel "started getting into checking up on these celebrities, all the websites and everything—she would be on it, I'd be on it, we'd be like a little high-tech research team." He talked about robbing Paris Hilton's house and burglarizing Audrina Patridge, Rachel Bilson, Orlando Bloom, Miranda Kerr, Brian Austin Green, Megan Fox, Nick DeLeo, and Richard Altuna. He told it all in a restrained, unemotional way; he didn't seem to want to glamorize it.

"Why are you telling me all this?" I asked.

"I've been charged with eight burglaries," he said, "I've got nothing to hide. Open book here. I want to make everything clear. Everything I've been in possession of, I've returned, even down to . . . a little picture of some Ed Hardy skull from Lindsay Lohan's house, I gave it back. Like I gave every single thing back and my friend—I don't want to name her name, she's not involved in this at all—she made me realize maybe the reason I'm not sleeping at night is I'm sleeping in a room full of all this beautiful gorgeous stuff but it's not mine, and getting rid of it made me feel I can sleep

at night. I feel so much better. I had like ten Louis Vuitton suit-cases. I had the most gorgeous, like, Marc Jacobs, Gucci, Yves St. Laurent—it was really hard for me to do that, give it all back, but it wasn't mine anyway so I'm a piece of shit for taking it, that's why I gave it back. I shouldn't have taken it in the first place. I could breathe. I could sleep at night; when this all first came out I wasn't sleeping, I was even losing hair. . . . It was really hard for me to be comfortable with myself and now that I've helped the police—I've given everything back, I've really tried to make amends with these people; I'd love to maybe get some apology out to them at some point that I'm sorry."

"You mean you want to apologize to the celebrities?" I asked.

"Yeah, yeah," Nick said. "I mean I don't even know how they'd take it 'cause I don't know what they're thinking."

"What would you say to them?"

"You know, I'm sorry—I mean, personal invasion, to be a vic-tim like that, to have someone in your house where it's your most personal of sanctuaries; your most private of things go on there. If someone did that to me, I'd have to move. I wouldn't want to sleep there another night. I know it's such a high level of privacy invasion—I don't blame them."

"So why'd you do it?" I asked.

"At the moment I wasn't thinking," he said. "I was following Rachel. This was the person that I loved, the person I trusted to have my best interests at heart, and I put all my faith in that person. I learned late in life how to make friendships, how to trust people, and I kind of messed up about that."

18

A man and a woman, connected by crime . . . Nick was right that it was a scenario that has long attracted the American imagination.

Bonnie and Clyde, with their gang of outlaws, robbing banks and killing cops at the height of the Great Depression, were two of the first celebrity criminals of the modern era. In their abandoned Joplin, Mississippi, hideout, in 1933, police found rolls of film the pair had shot of each other, posing with Browning Automatic Rifles; there was Bonnie toting a pistol and smoking Clyde's cigar. Like Nick and Rachel, they liked to take pictures of each other. They clearly saw themselves as very glamorous. Personal photography was relatively new and it was exhilarating in its power to assist in the creation of a self—for Bonnie Parker and Clyde Barrow, a criminal self. You have to wonder what they would have done with Facebook.

"The Joplin photos introduced new criminal superstars with the most titillating trademark of all—illicit sex," Jeff Guinn writes in *Go Down Together: The True, Untold Story of Bonnie and Clyde* (2010). "With her sassy photographs, Bonnie supplied the sex-appeal, the oomph, that allowed the two of them to transcend the small-scale thefts and needless killings that actually comprised their criminal careers."

Like Nick and Rachel, it was Bonnie and Clyde's penchant for drawing attention to themselves that led to their undoing—and eventual demise. Their gang seemed to go out of its way to make a ruckus wherever it went, partying in hideouts, running loud, drunken card games into the night. They were kids: Bonnie was 20 and Clyde 21 in 1930, the year they met at the home of a mutual friend. Pretty blond Bonnie was a waitress in the then backwater town of Dallas; she loved the movies and dreamed of the life of a movie star, as she would write in a diary she briefly kept. Clyde, born into a poor farming family that had moved from rural Tellico, Texas, to the slums of West Dallas, was sent to Eastham Prison Farm in April 1930 after a series of arrests (he robbed stores, stole cars, and cracked safes). In prison, he beat to death an inmate who had repeatedly raped him. He vowed to get even with the Texas

Department of Corrections, to liberate Eastham Prison, which he did, to some degree, in 1934, orchestrating the escape of several inmates.

Bonnie and Clyde were said to be instantly smitten with each other. Bonnie was the follower, passionately in love, and devoted to Clyde no matter what he did. They knew their crime and killing spree meant death in a shootout or on the gallows, and historians have speculated whether it were not one long suicide mission on the part of Clyde Barrow. Bonnie's 1932 poem, "The Story of Suicide Sal," tells the story of a "gangster gal" who vows to follow her outlaw lover to the end: "For him even now I would die." Twenty thousand people attended Bonnie's funeral in Dallas after she and Clyde were gunned down by police in Bienville Parish, Louisiana, in 1934.

There has been speculation, too, as to whether Clyde Barrow was gay. Arthur Penn's 1967 movie *Bonnie and Clyde* starring Faye Dunaway and Warren Beatty alludes to Clyde's possible impotence with women. They were in love, that was for sure, but not necessarily physically intimate. Thinking of them made me remember how a lawyer for one of the Bling Ring kids said his client said that Nick and Rachel used to take showers together.

19

"It was weird," said Nick, "like, I was just, like, I loved her—like she was the first person that befriended me. She was the first person that, like, actually paid attention. I'm sure it wasn't the best judgment, but I really felt she cared for me."

He talked a lot about how deeply drawn he was to her and how much he needed her approval; how he "didn't want to upset her"; just "wanted to please her"; and "loved her . . . loved her."

What he didn't love was doing the burglaries, he said. "Like,

the process was tolerable, but then actually going in—it was just so stressful. But then after the fact, when I walked out, I guess was the only part that was, like, enjoyable, because I could breathe. I was relaxed. It's like, it was over. I guess that was the best part. When it was over."

I asked him if doing a burglary was scary.

"Oh my God," he said, "just like being there and the feeling of hearing a noise—just like anything you'd hear, like a car driving by or a little creak in the floorboard, I would jump, I'd run for the door. Rachel was just like, it's okay. I was terrified all the time."

"Does it scare you now to think back on what you did?" I asked.

"Oh my God," he said, "every day. Any time I walk into someone else's house, even when I'm invited, it's weird. It's like a haunted feeling. I don't know if that makes sense, but it's like I'll walk in and I'll feel uncomfortable. Like I don't why. Maybe I'll learn that later in life, but it haunts me. To this day. . . . It brings back really uneasy feelings, bad memories. . . .

"I couldn't sleep at night," he said again. "I was so stressed out, I was so, like—everything [stolen] had been moved. . . . And then I made a decision to just make an inventory of everything I had and give it back—come clean with everything just so it wouldn't haunt me and I could breathe at night. I could sleep, actually, for the first time in years. I felt comfortable with myself. I felt okay, and like I was a good person. I was doing the right thing—which was really hard, especially when I felt like I was also betraying all these people that had been my best friends."

"At first you tried to protect Tess and Alexis," I said.

He said, "At first I tried to minimize their roles." It wasn't until after Tess appeared on X17 Online, distancing herself from Nick that Nick alleged to police that she had been involved. (Again, Tess was never charged with any crime and denied ever being involved in a burglary.)

"Why them and not Rachel?" I asked.

"Like, they were my current friends. Rachel moved to Vegas. She wasn't really in my life as much," Nick said. "Tess and Alexis kind of filled that void."

20

Did Nick confess, in part, because he was angry at Rachel for leaving him? I wondered.

It was just a couple weeks after he came back from moving Rachel to Vegas that he was arrested. "And then," he said, "we were on the phone doing constant communication. Her dad came out here, talked to me, went back. . . . He called me to meet with me, to give me advice on what to do. . . . Rachel told me he was coming. . . . He came here for some business, or to pick something up, but he stopped to see me, to help me. . . . He was trying to help me I guess. So he suggested to me, you know, stay out of the limelight. Maybe join the military. Move to Idaho, because I have a house in Idaho. . . . I think he was just trying to really help and make it go away. I don't know if that was necessarily right. I feel like his heart was in a good place, but he maybe could have executed it differently."

(David Lee did not respond to requests for comment.)

"Have you talked to Rachel since you confessed to the police?" I asked.

"No. God, no," Nick said.

"Have you tried to contact her?"

"I feel like it would be in vain," he said. "I think, 'What's the point?' I know that she has preconceived notions about everything. As do I. . . . It was a real friendship, and this whole thing's been really hard."

After he got arrested, he said, "I had no idea what to do. I went at this alone. As soon as I was arrested everyone was kind of like,

'You're on your own.' Which also made me feel abandoned. . . . No one was trying to help me. Everyone was just, like, okay, it's all on you. And I didn't know what to do. So I was like, what do I need to do for myself?

"And then, I met Sean," he said. "I met him at a restaurant; I introduced myself to him. I saw him. . . . And I talked to him a little bit; clicked with him. I felt like he would, you know, be a better attorney than what I had. And I went to his office the next day. I met with him. He advised me to come clean. And I did. I really think that was the right decision. To this day, I really—even though I was charged with more, you know, things, or whatever—I really feel like it was the right thing to do. I feel like I'm a better person for it, and I will be a better person in the future for it. I have nothing over my head. I feel like that was the turning point in my life.

"I feel like it was the turning point in my life," he said again. "It really made me. I had no respect for authority. I hated the police. I just had no respect for anything. And after meeting Sean, I really had a respect for the law. I had a different outlook on life and how to be a good citizen and not just to defy everything just because you want to defy it, but to actually try for something and be a good person and have morals and just, you know, it's a completely different outlook on everything. And like, I'm so grateful. It saved me. Really, it saved me—because if I had continued with Rachel and I didn't get caught, who's to say where I would end up? Who's to say where I could have been when I was twenty, twenty-five—it would have been a lot worse. So, I'm almost grateful for this. You know? What happened. It sucks, of course."

21

"For young people, where do you think the obsession with fame comes from?" I asked.

"The media. The Internet," said Nick. "America is just focused on—I mean Paris Hilton is famous for what? A sex tape? The values and stuff that America has are so wrong—people should focus on the politicians and the inventors and the important people. It shouldn't be about fame and celebrity and people famous for doing things that are not really important and are not helping society."

He talked about how Rachel loved celebrity, how she followed the stars and where they lived and what they wore; what parties they went to, who they were dating, where they ate and vacationed.

Erenstoft was sitting with us on the couch, now, listening; his girlfriend was putting her kids to bed. "Was there anyone, any talent that was off-limits in your mind?" he asked Nick.

"Like anyone I just respected too much to—?"

"To even entertain scoping or, or doing?"

"No," said Nick. "Rachel gave me a name, pretty much, and I'd Google it, see what I could do with it."

"Was there anyone you said 'No' to? 'That's out of the question,'" Erenstoft asked.

"No," Nick said, "because everyone that she said was either Paris Hilton, or some, like, you know—I don't want to say 'airhead,' but someone that's not—not that I didn't have *respect* for them—"

"Were there ever any discussions between you," I asked, "to the effect of, 'Oh, they have so much, it doesn't matter.'"

"Rachel kind of had that thinking," said Nick. "I never really thought that. I mean, they did earn it in some way or another—it is theirs. And I never really thought that way. Rachel kind of instilled that in my mind."

I asked him if they ever discussed the morality of what they'd done. "Did you ever say, 'This is wrong?'"

He sighed. He didn't answer.

"Do you think that she has a sense of right and wrong?" I asked.

"I think she does," he said, "but I think she thinks that these

people, being celebrities, like you said, they're so rich...." He
talked about how Rachel herself "had money," how she drove a
"brand new Audi. [Her family] lived in like a million-dollar house.
The thing about Calabasas and Malibu is the parents are gener-
ally well-off people ... People had nice clothes—and *I* had nice
clothes before this; it wasn't like I didn't—the appeal to have *more*
is what it was I guess with Rachel; it was so easy and there were no
consequences...."

"I guess my thought was always, you know, 'Take a little bit
so they don't notice,'" said Nick. "Don't take everything and really
screw them over, but just take a little bit so they don't notice.

"And I guess Rachel was kind of always, 'let's go in, take what-
ever we can and leave.'"

22

More than anything, he said, it was about friendship, times when
he would be riding around with Rachel in her car, just listening
to music and enjoying being together. "There was one song called
'Satellites,'" by September, he said, "it's kind of a techno-y song,
it reminds me of me and Rachel driving on P.C.H. kind of high."
There was a melancholy feeling to their life sometimes, because
of the problems they had with their parents and at school. "I love
music, music like really helps me emotionally," he said. "I love Billy
Joel's 'Vienna.'" (*Slow down, you crazy child/You're so ambitious for a
juvenile*").

"Now that I look back on it," he said, he understood the seri-
ousness of it—"obviously"—but "when this was going on, it was
made so it was, like, so unserious. It was just like, not a rush, but it
was so nonchalant.... We just did it."

I asked him about how everyone in their circle came to know
what they were doing.

"People knew because Rachel would tell one person, I would tell one person, people would talk and it *was* very interesting," he said. "People would talk and eventually I guess it led to a tip to the police."

I asked him about how it felt to be exposed.

"Like the one thing that pissed me off about Courtney," Nick said, "was she said that I danced and like wore Paris Hilton's shoes."

("He didn't just want to steal celebrities clothes—he wanted to wear them!" said the *New York Post*. "Hollywood burglary suspect Nick Prugo was so giddy after getting a hold of hot celebrity goods that he slipped his dainty feet into Paris Hilton's stolen shoes and did a little victory dance, according to another accused member of a teen robbery gang. 'He could fit into her shoes,' Courtney Ames, 18, told *The Post* in an exclusive interview yesterday. 'He put them on and got into a dance and said, 'Don't I look good?'")

"We didn't even *take* any shoes from Paris Hilton," Nick said, frowning. Because they were too big.

I asked him how it felt when Tess talked to X17 Online.

"You know what," Nick said, "I took a lot from [Tess and Alexis] with their beliefs in Buddhism and stuff. But I really don't think that they genuinely believe that. I think they just use it as a front, because if they really did believe that, they'd be living a lot differently. . . . But, like, I still love them. I still love them, I still care for them, I still want the best for them, every one of my friends.

"Actually, my friend saw Tess at Wonderland a week ago," Nick said. "And my friend told Tess just to mess with her that I was coming. And Tess freaked out, I guess. I know they still go out. They're still carefree. Rachel's carefree. She just has a possession of stolen property charge"—so far.

"I think if they haven't charged [Rachel] up to this point," Erenstoft said, "it's because they're holding out hope that she might

do the right thing and give up the property that she has. . . . She sort of confessed that she has property."

"Do you think she just wants to keep it?" I asked Nick.

"Yeah," he said. "I know she does. . . .

"It sounds like she likes having it," I said.

"I liked it too," he said, "but I gave it back."

He seemed bothered that his former friends were living the same glamorous life as they had before, as if nothing had happened—as if he weren't sitting here facing years in jail. "I'll see comments [on Facebook] between people," he said, "like, 'We're meeting up. We're going to go out.' Like, Diana is going to have a party this weekend. On her Facebook page, she's writing, 'I'm having a party this weekend.' On Facebook, for anybody to see! . . . Everything's just like, normal for them. Rachel's the same: 'Let's go hang out.' It's like nothing is affected."

He and Rachel were no longer Facebook friends, he said, but he had heard of her postings from other people. Rachel was back in L.A., he said, living at her older sister's apartment.

"Do you know how her mother reacted to everything?" I asked.

"Unfavorably," Nick said dryly.

"So you're saying they're living like nothing has changed."

"Yeah," he said, "it's, like, all on me."

"You think they think it's all going to be all on you?" I asked.

"Yeah," he said, "and you know, I hope not. I hope it's not all on me." He laughed again, but he sounded emotional.

23

He said he was getting help now, trying to figure out why he'd done what he did. "I'm seeing a psychiatrist once a month, therapist every week. We talk," he said. "She's really helpful. We really just talk about normal things, like school.

"I'm supposed to start in January," he said. "It's the University of Phoenix . . . I think I'm going to do it online, just so I don't have to deal with people in my area. I'm trying to just get away from the social group that I was in. I want to branch off and start something new for myself. It's difficult because I don't have any friend support system, but my family is there for me. And I keep myself busy with school and try to get through this legal stuff, and—I'm really trying. There's not much more I can do I think. You know?

"I'm really just trying to stay positive and do everything I can," he said. "I do AA meetings. . . . I had a possession charge, so I enrolled in a program where if I complete it it's expunged from my record. I'm doing that. I'm really busy. I have things to do so I'm not getting in trouble. I'm not out partying. I don't have a car. I can't drive anywhere.

"And I'm just trying to do my best," he said, "and I'm trying to help the police as much as I can. To this day, I'm in constant communication, helping them every day. Whatever questions they have, I answer. I'm really there for them. I'm really just trying to pay back my debt to society. I gave everything back. I'm just really trying to make whatever amends that I can, especially to these celebrities that I victimized. I really want them to know that I'm sorry. . . . I'm not really sure how I'm going to do that yet. But I really plan on making some formal apology to them—something to just let them know that I am sorry. I really—I am."

"What did you want to become? What do you want to become?" I asked.

He gave a small laugh. "When I met Rachel, I wanted to do fashion," he said. "Designing. Clothing line. . . . I wanted to be an actor at some point. I wanted to be a plastic surgeon. My career ideas have changed forever. I've just been kind of trying to find myself and what I want to do."

"What about now?" I said.

"Now," he said, "I want to go to school. . . . I'm taking travel,

tourism, and hospitality. And maybe I'm going to open up some kind of hotel or restaurant and do something like that. I don't necessarily want to do entertainment because I think that possibility, um, may be ruined.

"I just want to be happy, you know?" he said. "I guess my first goal when I was trying to pick a career was for the money or the fame or whatever. But now I've realized, just go be happy. It's about the relationships in your life. It's not about who's making the most money or who's the most famous or whatever. It really is about your family. And I have much more respect for my family and appreciation. They're the biggest support system I have."

He was wearing a pair of good-looking shoes, shiny black sneakers. I asked him where he got them. "A thrift store," he said ruefully. "Thirteen bucks."

24

Throughout October, November, and December 2009, a parade of celebrities came into Hollywood Station to identify and retrieve their stolen goods; they also identified items of clothing worn by alleged members of the Bling Ring in photographs. Paris Hilton retrieved the Louis Vuitton tote bag full of her jewelry. Audrina Patridge and Rachel Bilson got back clothes and purses and luggage and electronics. Lindsay Lohan recovered some clothing and jewelry and her custom-made black mink coat. Brian Austin Green got back his Rolex watch and his handgun. Detective Steven Ramirez visited Orlando Bloom at his home and returned his recovered Rolexes and his clothes. Many things were returned, but all of the celebrities said in Grand Jury testimony that they only got back a fraction of what was stolen. Many said they were still finding things missing.

I noticed in the news on December 1, 2009, there was a story

about the socialite Casey Johnson, heiress to the Johnson & Johnson fortune, robbing the home of a friend. "Heiress in Theft Scandal," said the *New York Post*. Johnson—whom I'd seen around New York when I was covering celebrities and the nightclub scene; she was a friend of Paris Hilton's—had stolen clothing, jewelry, and other items from a model named Jasmine Lennard, a rich girl and reality star (Britain's *Make Me a Supermodel*, 2005–2006).

Johnson, who had reportedly been cut off from her family after refusing to seek help for her drug addiction, had also taken Lennard's underwear and shoes. "I believe she was obsessed with me," Lennard told the *Post*. Johnson was arrested in Los Angeles and was being held on $20,000 bail at Van Nuys Station. In a month she would be dead, in West Hollywood, of diabetic ketoacidosis.

25

Alexis arrived at the Polo Lounge in late 2009 wearing velvet tights, a black blazer, six-inch Christian Louboutin heels, and a cloche hat. She looked like a 21st century flapper. I remarked on the heels. "I got them at a secondhand store," she said offhandedly. " 'It's A Wrap.'" It was a place that sold extras from movie and TV sets.

"Dude," Andrea said, settling into the booth. "I got the most amazing Armani suit there for two hundred dollars."

We were meeting there with Alexis' lawyer, Jeffery Rubenstein, to finally discuss Alexis' case and see what she had to say about the accusation that she had burglarized the home of Orlando Bloom. Her preliminary hearing was coming up in a couple days. She ordered a cappuccino.

"I met Nick back in March of this year," Alexis began with a deep breath. "I was never friends with Nick." This was a slight variation on her story so far, but I figured I'd just let her roll. "I didn't care for Nick because he took all of Tess's attention," Alexis said, "and I didn't like the amount of partying and stuff that they did

together. I wasn't comfortable with it and I didn't really ever trust him; he had a rumored past. He was not the greatest kid." She'd told me earlier that she liked Nick and thought he was a "good guy," but never mind.

"He took a pair of my shoes and ruined them," said Andrea. "Fucking hot heels."

"Ruined them doing what?" I asked.

"Walking around in them," Andrea said.

"He would try on our high heels and walk around and stuff like that," Alexis said. "They were like, pointed stiletto heels, like five-inch. When I would go over to his house to get ready with Tess when we were getting ready to go out in big groups, he'd be doing his makeup and hair—'Does this look good?' He would always style me and Tess in our clothes and come over and look in our wardrobes."

Asked about this, Nick's current attorney, Markus Dombois, a colleague of Daniel Horowitz, characterized the girls Nick surrounded himself with as "mean girls—they're right out of that movie. They'll say anything about each other. They're pretty ruthless. They have few scruples."

"So you believed [Nick] when he said he was a stylist," Rubenstein interjected.

"I did believe him completely," Alexis said. "I mean he dressed to a tee—polo sweaters and perfect belts to match your shoes and your hat and your glasses. He would always dress us . . . come over to our house."

"He accessorized," said Andrea.

"He accessorized," Alexis said. "He was like, 'I wanna put this on with this.'"

"I was like, 'Tessy, where are my high heels?'" Andrea said. " 'Oh, I left 'em at Nick's house.' When I got them back they were scratched up way beyond their size. I'm so sad 'cause I can't replace them now. They were the perfect nineteen-forties-style heels."

"She didn't like Nick," Alexis said.

Andrea made a face and mouthed the word "No."

"Then we had a falling out," Alexis said. "I didn't like the influence that he was on Tess and I chose after a while that I didn't want to be associated with him—especially when all of the news stuff started coming out. I completely stopped hanging out with Nick and I told Tess I'm not gonna be a part of that anymore. . . .

"I would never want to surround myself with someone like that ever," Alexis said. "When I found out that all of this was going on"—she meant when Nick was arrested—"I wasn't a part of his life anymore by choice."

But the problem with the timeline here is that Nick was exposed in the Patridge and Lohan videos months before his September arrest, in February and August 2009. If people in Tess and Alexis' circle of friends knew of his involvement in the burglaries—and Tess told police she knew—then how is it that Alexis didn't know, especially by July? July was when Alexis was temporarily living at Nick's house and when the Bloom burglary occurred. When I attempted to bring all this up, Rubenstein told me, "We're not answering that."

"And I did receive threatening phone calls from [Nick] just saying that I'm a 'stupid reality girl' and I'm never gonna get anywhere in life," Alexis went on. "He mentioned some things about my body. He could be very insulting. He threatened me about this situation that he was having, saying you better keep your mouth shut.

"He gave Tess and I clothes to borrow and we gave them back," Alexis said. "I remember a little blue vest and a butterfly necklace and a couple of dresses. . . . He said he purchased them when he was doing shoots for magazines and TV shows and he got to keep the clothes. He said he worked for his dad's company.

"He really tried to put on a persona in my eyes," she said. "He was a con artist. He was putting on this act, pretending to be someone that he really wasn't. . . . I completely believed this, basically,

this actor to say who he was. I mean, it's common. Women go out with men for years until they really figure out who a man is." She sniffed.

"And he tried to get into a show that we were eventually going to be in," Andrea said. She was talking about *Pretty Wild*. According to Andrea, Nick had tried to get in on the show, to be a character on it.

Alexis said, "He's shaking his head 'no'"—meaning Rubenstein—"and he's been shaking his head 'no' at you this entire time because you keep talking!"

"Shut up," Andrea muttered.

"You just told me to shut up!" said Alexis, eyes flying open. "Don't tell me to shut up!"

They glared at each other.

"I am looking forward to my day in court," Alexis said, "and I can't wait to kick some ass and get this all cleared up and get found not guilty and tell my story 'cause it's powerful."

"Then why don't you tell it to me now?" I pressed. "I thought that's what we came here for—"

Rubenstein cut in, offering, "If I can put it to you this way: you're stuck in the rain and you need to get home and a friend drives up and offers you a ride and you're cold, you're wet, you want to get out of the rain and get home and your friend gets drunk and gets in a car accident—do you get hurt? Yes, but was it your fault? No. I would analogize that to Alexis' involvement."

26

Alexis brought her reality crew to her preliminary hearing on December 1, 2009. I sat with the *Pretty Wild* supervising producer, Gennifer Gardiner, on a bench outside the entrance to Department 30 before the proceedings began. Gardiner—wearing her usual

walkie-talkie and yoga gear—didn't seem concerned about the fate of the star of her show. "They think it's all good," she said of Alexis and Tess. "They said they weren't in the surveillance videos. They were celebrating. They say they had no idea" what Nick was doing.

Gardiner said that Alexis and Tess were now "in a fight" and not speaking, and that Tess was "living with friends." I asked her what they were fighting about, but she said she didn't know: "They're teenage girls."

Alexis wore jeans and ballet flats that day; her hair was in a braided bun. She frowned and rolled her eyes throughout Brett Goodkin's testimony about how she could allegedly be seen on the surveillance videos from Orlando Bloom's home; how Nick Prugo had identified her as one of his accomplices in the burglary; and how she allegedly came and went from the house carrying bags of goods to Prugo's car. Detective Jose Alvarez testified that Alexis said that she was drunk and didn't know what was going on during the three hours of the burglary. He also said that at first Alexis said she didn't know it was Orlando Bloom's house her friends were robbing, but then she said she did.

Alexis' lawyers attacked Prugo's credibility: couldn't he have lied? How many burglaries was he charged with? Eight? On the witness stand, Goodkin countered that "everything Prugo said proved reliable through investigation." Judge Darrell Mavis rejected the motion to dismiss based on the argument that Alexis never knew she was involved in a burglary and that she never intended to commit a crime.

In the parking lot after the hearing, Andrea was upset at the negative decision. She told me she truly believed Alexis' legal ordeal would be over that day. I walked with her to her car. She was wearing a fashionable suit and heels. She seemed to really believe that Alexis was innocent and that this whole thing was the result of Nick Prugo's lies.

"I never liked Nick," Andrea said, standing by her SUV, "but I never thought he would do something like this. I left home at four-

teen. I had a mentor, a gay man I called 'Uncle Kit.' He basically raised me. I was his little protégée and he taught me how to dress, how to walk, how to do my makeup and hair. He was what we were hoping Nick would become for the girls. Teach them how to dress."

"But why did you kick Alexis out of the house?" I asked.

"I never kicked Alexis out, I kicked Tess out," Andrea protested in her breathy voice. (Tess did not respond to requests for comment.) "I gave both of the girls two weeks [to prove] that they were serious about their professional careers. . . . Then they started socializing with the professionals in the industry and they were staying out and not waking up and getting started with their day and going out in Hollywood at night. I was paying all their bills. I said if you're going to develop your careers, then you'd better be up and out of bed at seven in the morning. This had been going on for months. . . . I had them in therapy. . . . And the therapist said to me if they weren't going to get serious I had to kick them out and they had to get jobs. . . . My therapist said the only way they'll take you seriously is if you kick them out. I knew they had a place to go. The day I decided I was kicking Tessy out, Alexis decided to go with Tessy. It had nothing to do with [drugs]. Alexis was not kicked out of the house. It had nothing to do with drugs at all.

"They both moved in with Nick, but then Tess was getting jealous of the growing friendship of Alexis and Nick, and she moved out so Alexis was there alone with Nick," she said.

27

In December 2009, as I was closing my story, I persuaded Jeffrey Rubenstein to let Alexis give me a statement about the Bloom burglary. If she wasn't going to talk about it openly, after all this talk, I wondered if she could at least offer something prepared. So Alexis read me this statement over the phone, with Rubenstein listening in on the three-way call:

"I was staying with Nick Prugo for a short time in the middle of July two thousand nine," Alexis said. Her squeaky voice was trembling, and I wondered if she were going to start crying again. "I did not know what he was up to," she continued. "There were personal reasons for why I needed to spend some time away from my home and unfortunately the week that I needed to take a break from the drama at home, was the same week in which Orlando Bloom's home was robbed. On July thirteenth, Nick got me involved into a situation that I had no part of or knowledge of. I was very, very drunk, and after drinking with Nick at Beso I was so drunk that I threw up. I did not do this. I did not take anything. I never disguised myself or wore a hoodie. It is not me in the surveillance videos or photos. Nick Prugo is very troubled and I hope that someday he gets the help that he needs but at this time he has only caused harm. I have learned a great deal of lessons based upon what has occurred. I used to be a trusting person, but I am now more guarded. . . . It is risky for me to make this statement with a pending case and my lawyers advised me against it"—I wondered whether Rubenstein had asked for this wording—"but I am hoping that by telling you this will help me clear my name and will help others as well. Thank you for listening to me and my story."

Later I asked Vince the cop if he believed her. "I don't know if I believe any of them totally," he said. "They're just pretty little liars, all of them."

28

On January 13, 2010, I saw that Rachel Lee turned herself in at Hollywood Station, whereupon she was re-arrested and finally charged with three counts of residential burglary, for Paris Hilton, Audrina Patridge, and Lindsay Lohan. Apparently, it had taken this long for Rachel to be charged because she'd continued to dangle the prospect of returning stolen property.

But "Rachel Lee never returned any property," L.A. Deputy District Attorney Christine Kee told me on the phone. "A lot of property is still missing." Rachel was released on $150,000 bail. She still hadn't spoken in an interview with the police. She hadn't ratted out anyone, nor had she discussed her own involvement in the crimes— and never would. She still had not given an interview to any member of the media, and her lawyer, Peter Korn, had said very little to anyone.

Rachel Lee leaves the Los Angeles Superior Court, February 3, 2010.

29

My story, which my editor headlined "The Suspects Wore Louboutins," appeared in the first week of February 2010. The day it came out I got a text message from Andrea's phone: "What r u u r not even human."

I thought it was a pretty straightforward story, so I didn't reply. One night a couple days later my phone started ringing. I saw it was Andrea calling so I didn't pick up. I had some friends over, and wasn't able to talk.

Later I listened to my voicemail and heard it had actually been Alexis calling; she'd left several messages. They were kind of strange: she would stop and start again, saying the same thing over and over, until she would be interrupted by her mother and they would start screaming at each other.

Message One: "Nancy Jo, this is Alexis Neiers calling."
She sounded choked up. "I'm calling to let you know how
disappointed . . . *fuck!*"

Message Two: "Nancy Jo, this is Alexis Neiers. I'm calling to let
you know how disappointed I am in your story, how horrible you—"

Then I could hear Andrea screaming: "You lied!"

Alexis: "Just stop! Stop it!"

Andrea: "You lied! She didn't do it!"

Alexis: "Stop it! Stop it, Mom!"

Andrea: "You lied!"

Alexis: "Stop! Goddammit!"

Message Three: "Nancy Jo, this is Alexis Neiers calling. I'm
calling to let you know how disappointed I am in your story. There's
many things that I read in here that were false. Like you saying that
I wore six-inch Louboutin heels to court with my tweed skirt, when
I wore four-inch little brown Bebe shoes—"

Andrea: "Twenty-nine dollars!"

Alexis: "Every time you [fucking] yell I have to re-record it!"

They were actually filming a scene for *Pretty Wild*—the epi-
sode, which would air on April 25, 2010, was entitled "Vanity Un-
fair." I didn't know this yet. All I knew was Alexis seemed to have
prepared a script for what she wanted to say.

The Soup ran the clip, which shows Alexis, tearful, sitting on the
living room couch as she makes the call. Tess looks on sympatheti-
cally, wearing something skimpy. Andrea stalks around the living
room in an orange sweatsuit with earphones dangling from her
ears. The background music is heavy and dramatic. *The Soup*'s Joel
McHale introduced the clip by saying, "On Sunday's all new *Pretty
Wild* perp-utante Alexis Neiers, who is awaiting trial, has given an
interview to *Vanity Fair* that turned out to be a hatchet job. She
must feel so violated! It's like coming home to find you've been
burglarized!"

"I don't want to live on this planet anymore," said one of the

commenters on the clip after it was posted on YouTube. *The Soup* would vote it the best reality show clip of 2010.

30

With the publication of the story, the Bling Ring was in the news again. Since Nick had spoken to a magazine, now all the TV news shows were after him to do an interview. They wanted Nick, and he was torn about whether he should appear on television. He called me and said that Erenstoft was against it. I told him he should listen to his lawyer; but Nick was talking with producers at ABC, too, and they convinced him to go on. I thought he might also still be sold on Erenstoft's idea that he should publicly make amends for his crimes.

Later I would find out that Erenstoft had made a promise to appear on NBC's *Dateline,* and I wondered if that was the real reason he was against Nick appearing on NBC's rival, ABC. But no, Erenstoft said, he was irritated at Nick for "pushing himself out into the limelight. . . . During my representation of Nick," he said, "I kept observing him chomping at the bit to make public appearances and be captured be paparazzi. This served to complicate my strategy of having Nick be the sympathetic hero who had ratted out his fellow culprits." I wasn't really sure what any of this had to do with the law. It was Erenstoft who seemed wrapped up in media considerations; or maybe both he and his client were.

George Stephanopoulos—who did the *GMA* interview on February 3, 2010—was tough on Nick. "Nick, you've confessed to the crimes but you're pleading not guilty," he said. "Are you sorry for what you've done or sorry you got caught?"

"Well I'm definitely sorry for what I've done," Nick said slowly and deliberately. He was wearing a brown shirt and a bulky silver tie. Suddenly, he didn't look like a teenager anymore. He looked

tense and uncomfortable, like a guy who was wearing clothes that didn't belong to him (I have no evidence that that was actually the case).

"I'm trying to take early responsibility for my crimes," Nick said, "and I'm just trying to make amends with all the victims. I feel really bad for what I did."

"You're sneaking into people's houses, you're trying to get by security cameras, these are some of the most famous people in the world," Stephanopoulos said. "In what kind of universe does that feel okay?"

"It wasn't okay. It definitely wasn't okay," said Nick.

"You seem sincere," Stephanopoulos said. "But [people] are wondering now, 'He's confessing now to keep himself out of jail, but once the trial's over he's gonna cash in on what he did.'"

"I'm not going to try and cash in on what I did," Nick said. "It's not about that for me. When I confessed, it was for my own conscience and for me to be able to sleep at night. . . . I've just embarrassed myself and my family so much and I'm just really sorry."

Chris Cuomo, who interviewed Nick on ABC's *20/20* on March 4, 2010, seemed more interested in the wider implications of the story. "Every once and a while there's a crime that goes on even beyond the importance of the facts," Cuomo said, in his energetic way. "How they did this is very impressive, but the big question that this crime reveals the answer to for us is *why* they would do something like this.

"Where was the shame?" Cuomo asked Nick.

"I guess it really wasn't there," Nick said, hanging his head.

"Where were their families?" asked Brett Goodkin, who was also interviewed on the show. "As a parent, I would think that if my kid doesn't work, and his closets are full of designer clothing, where is all this stuff coming from?"

"You're the parent. Where were you guys?" Cuomo asked Nick's mother, Melva-Lynn Prugo.

Melva-Lynn started to cry.

"Are the kids sorry?" Cuomo asked. "Don't write them off as just some goofy teens. These kids are a window into this world of celebrity obsession."

"Damn . . . I wish I was part of 'the Bling Ring,'" said a commenter on a YouTube clip from the *20/20* show.

31

On March 13, 2010, Jonathan Ajar pleaded no contest to three felony counts, including possession of cocaine for sale, possession of a firearm by a convicted felon, and receiving stolen property. He was sentenced to three years in state prison. "It should be noted that Mr. Ajar was not involved in the residential burglaries and was found to be in possession of some of the items that were later returned," Michael Goldstein, Ajar's lawyer, told the *Los Angeles Times*. "Unfortunately, because of his prior criminal history, my client was left with little choice but to reach a negotiated agreement with the district attorney."

"I think Johnny Ajar is misunderstood," Goldstein told me.

32

On April 9, 2010, NBC *Dateline*'s Bling Ring segment aired. Erenstoft figured prominently. Nick did not appear. Erenstoft, looking very square-jawed, held forth on his theories about the robberies. He said, "These kids would wear the fruits of their crimes. That's pretty much a guiding light in trying to help get into the psychology of where this was going. . . . The kids, looking in, [saw] a lifestyle that they wanted to emulate."

Goodkin was on *Dateline*, too. "This group of criminals was so comfortable," he said. "It's almost like a sense of entitlement. This house, we have just as much right to be in here than the owner."

Susan Haber, Jeffrey Rubenstein's colleague, also made an appearance. "Alexis is an eighteen-year-old, bright, educated, and aspiring woman [who wants] to make good with her life and to impact the lives of others in a positive way," she said.

"Fair to say that she's fascinated with Hollywood celebrities?" asked *Dateline*'s Josh Mankiewicz.

"Who isn't?" Jeffrey Rubenstein replied cheerfully. "She's a young, attractive girl whose mother and parents were in the industry. . . . The reality show just happens to be her career. If somebody was an airline pilot and they were facing a criminal charge, would you expect them to stop flying?"

Roy Lopez's lawyer, David Diamond, got a taste of fame as well. Discussing the Bling Ring burglaries on the show, he said, "I think the . . . belief . . . is that you're going to somehow be famous from this incident."

Around this time Nick called me up and told me he'd really like to write a book about his experiences. Alexis was already shopping a book proposal, which read: "Think *Gossip Girl* goes to Hollywood—it is a cautionary tale as well as a guilty pleasure; the reader is plunged into the crazy, out-of-control world of one of Hollywood's most infamous party girls."

33

On May 10, 2010, Alexis pleaded no contest to one count of felony burglary and was sentenced to six months in county jail. She received three years probation and agreed to stay away from Orlando Bloom and his house in the Hollywood Hills. Jeffrey Rubenstein told reporters that, while he had been prepared to go to trial, "the fact that Orlando Bloom [would testify], and the weight of a celeb testifying against Alexis, made us realize the odds were stacked against us."

From the beginning Rubenstein had been rushing Alexis' case through the court, on the grounds of her right to a speedy trial. He told me this strategy, unique among the Bling Ring defendants, was based on his belief that it was better for Alexis to have her proceedings separated from the others, bifurcating her from their hearings. His decision to seek justice quickly also happened to accommodate the *Pretty Wild* shooting schedule; and having Alexis appear in the courtroom alone made her the star of her own legal show. Having the other defendants on camera might have complicated the ability to air the footage, as they might not have wanted to sign releases with *Pretty Wild*. When I asked him about this in an email, Rubenstein declined to comment. The cameras were in the courtroom on the day when Alexis entered her plea. Someone who was there observed that, "After Alexis was sentenced he turned to her and started giving her this fatherly lecture, and the judge just told him to stop it." Rubenstein had no comment. The deal he got for Alexis was considered favorable to her.

Meanwhile, Alexis continued to maintain her innocence. Before going to jail, she appeared on *E! News* with her mother and Susan Haber. "I didn't do anything wrong!" Alexis said, crying. "No one knows my truth; no one knows my side of the story yet. . . . I keep telling myself, 'If Buddha can sit under a tree for four days and meditate, I can do this!'"

She entered the Century Regional Detention Facility in Los Angeles on June 24, 2010. By some strange twist of fate, she was put in the same cell that Paris Hilton had occupied when she was there in 2007 for probation violation. And in an even bolder stroke of starlet irony, Lindsay Lohan was moved into the cell next door to Alexis a few weeks into Alexis' sentence, to serve time for probation violation (she failed to attend her alcohol education classes).

Alexis was released from jail after serving just 29 days. When

she came out, the celebrity news shows still wanted to talk to her—but now they wanted to know what it was like to be in jail in a cell next to Lindsay Lohan.

"It was mayhem that day," when Lindsay entered the jail, Alexis told *E! News*. "It was crazy. She came in, she obviously didn't look happy—it's very scary, you have to go through strip searches, body cavity experiences—it's *not* fun, it's petrifying. And these girls are screaming, 'I love you Lindsay!' and 'I want to be your girlfriend!'"

E!'s Michael Yo remarked that he had heard that Lindsay had been "verbally abused" by other inmates. "Oh, I'm sure," Alexis said, "just as *I* was.... I would have girls come up to my cell door and just *stare* at me."

34

The celebrity victims came in secret to the Grand Jury proceedings at the Los Angeles Criminal Court on June 18, 21, and 22 of 2010—Paris Hilton, Audrina Patridge, Rachel Bilson, Lindsay Lohan, Orlando Bloom, and Brian Austin Green. They came incognito, some wearing sunglasses, with no media in attendance; it was all very hush-hush. Even TMZ didn't know about it.

Some of the lawyers for the defendants complained that the celebrities were being treated like, well, celebrities. It wasn't actually necessary to have a Grand Jury, since the defendants had already been charged; but in doing so, the D.A. eliminated the possibility of a preliminary hearing. At a preliminary hearing, the celebrities would have been forced to testify in public and potentially treated to a media circus. By testifying in secret, they were protected from this sort of exposure.

"In the bigger picture, I think that this case reveals how political the L.A. D.A.'s office can be," said Behnam Gharagozli, Diana Tamayo's attorney. "I just don't think the D.A.'s office would have

invested as much time, energy, and resources if the alleged victims were regular people. It appears as though there's a double standard for how these alleged victims were treated. If a regular person with Lindsay Lohan's criminal history was allegedly burglarized, I doubt the L.A. D.A.'s office would have cared this much. Lindsay Lohan, however, makes a mockery of the D.A.'s office and yet prosecutors rushed to her aid here. Quite frankly, I think certain individuals in the L.A. D.A.'s office were simply using this case as a means to propel themselves upward, because the case was getting so much media attention and the victims were celebrities."

"I think that this case was blown out of proportion," said David Diamond, Roy Lopez's attorney. He called it a "public spectacle," complete with "bodyguards, court security walking Prugo into court. It became a joke."

"In L.A., I think the publicity value of the case was to send a message that the [entertainment] industry would not tolerate stalking-type attacks," said Daniel Horowitz, Nick's lawyer.

When I asked about these criticisms via email, Jane Robison, the Assistant Public Information Officer for the L.A. County District Attorney's Office, wrote, "We can't comment since it's still a pending case and it would [sic] inappropriate."

35

Deputy District Attorney Sarika Kim was having a different problem with the issue of the celebrity victims during the Grand Jury proceedings. Throughout the three days of testimony, the jurors wanted to ask the victims questions (which are allowed in a grand jury) about why they didn't have better security. They seemed to be suggesting that the victims themselves had been somehow guilty of not protecting their very valuable valuables. They asked Audrina Patridge and Paris Hilton why they hadn't set their alarms and

Lindsay Lohan why she didn't know what type of lock was on her safe, a combination or a key. "I think it was a combination *and* a key," Lohan said, sounding a bit flustered. "I think."

In her closing statement, the Deputy District Attorney addressed the issue of the victims being rich and famous head-on, arguing that they were still victims of serious crimes, even if they were celebrities. "If the victims can afford to replace their stolen property, guess what? Not an element. Not relevant. Doesn't matter," said Kim, a tiny, dark-haired woman with a tough, no-nonsense manner.

"The victims should have turned on their alarms?" she asked. "It's commonplace to think, 'God, why wouldn't somebody turn on their alarm? Why wouldn't someone in this day and age lock their door?' It's fortunate that in this day and age we kind of, as a society, still think, you know, if you want to sit with your porch door open, unlocked, and just let the breeze come in, you can. It doesn't make it okay for somebody to come in and steal your stuff.

"So you don't need to have your alarm on. You don't need to have your door locked. It doesn't make it okay for someone to enter and take your property. So that's not an element of burglary. . . .

"[It's] not an element that the victims here were celebrities. It doesn't matter. The fact that you are able to replace property doesn't matter. And, in fact, we heard evidence that in this case some of the folks weren't able to replace any of the property. Some folks lost items of sentimental value.

"And I think the one thing that was abundantly clear from listening to the testimony of all of the victims was what they lost, most importantly, was a sense of security. We tend to think, as a society, that celebrities, you know, people are invading their privacy all the time, taking photos and chasing them around. . . . But you heard from somebody, I think Ms. Lohan said, at different points in your life your home is really the only place you feel private and safe and secure. So whether property is taken, replaced, not taken, returned,

is not the issue. The issue is [that] you never really regain that sense of security. . . .

"The question is simply, did these kids, all five of these targets, plan and conspire to burglarize these houses numerous times, and at the very least in the times that are charged in this indictment? And in conspiring, did they then go one step further and enter these residences? Did they do so with the intent to actually steal from these residences? Did they at different times after having entered these residences and taking property from these residences, were they at some point thereafter in receipt of stolen property from these residences? That's all."

On July 2, 2010, Prugo, Lee, Ames, Tamayo, and Lopez were indicted. The D.A. added conspiracy to all their charges. Prugo was now charged with seven counts of first-degree residential burglary (the D.A. had decided not to pursue the burglary of Richard Altuna, so Nick went down from eight to seven counts) and one count of conspiracy. Lee was charged with two counts of first-degree residential burglary, two counts of receiving stolen property, and one count of conspiracy; Tamayo with one count of first-degree residential burglary, one count receiving of stolen property, and one count of conspiracy; Ames with one count of first-degree of residential burglary, two counts of receiving stolen property, and one count conspiracy; and Lopez with one count of first-degree residential burglary, one count of receiving stolen property, and one count of conspiracy. Their new bail was $200,000 for Prugo and Lee, and $90,000 for Tamayo, Ames, and Lopez.

36

"Burglar Bunch Dude—I Got Screwed" said a headline on TMZ on May 3, 2010. The website had gotten access to court documents showing that Nick's new lawyer, Markus Dombois, had filed a mo-

tion to dismiss the charges against Nick based on his cooperation with police. Dombois' motion claimed that police and prosecutors had betrayed Nick by using information he gave them to charge him with additional crimes. Dombois argued that he had an "implied contract" with prosecutors in return for Nick's cooperation. The "prosecution has chosen to exploit Nick Prugo's cooperation" instead of offering him a deal, the motion said. The motion was denied.

"Mr. Prugo and his attorney came forward voluntarily," Deputy District Attorney Kim said in court.

Nick had fired Sean Erenstoft after finding out that he was being accused of committing several felonies. "When Nick's parents called in me and Dan Horowitz it was like that scene in *Pulp Fiction* where they call in the cleaner [Harvey Keitel]," said Dombois. "Nick's brains were already all over the walls."

37

In July 2010, Erenstoft was barred for life from practicing law in the state of California. When the news came out, people I'd spoken to on the Bling Ring story were suddenly emailing and texting me again—"Did you hear?" Prosecutors said that while representing a defendant in a stalking case, Erenstoft filed a civil case against the victim in order to pressure her not to testify against his client. They further alleged that Erenstoft then offered to drop the civil case in exchange for favorable testimony at his client's sentencing. He was originally charged with three felony counts, including attempting to dissuade a witness. "The crime is a felony and because it involves 'the specific intent to impede justice' it also involved moral turpitude," says Erenstoft's profile on the State Bar of California website. Erenstoft pleaded no contest to one charge of attempting to dissuade a witness, thereby avoiding possible jail time.

I called Nick and asked him what he thought of this news. "I didn't even want to confess," he moaned. "It was Sean's idea."

I asked him if his confession were true.

"Yeah, it was all true," Nick said. "I told the truth. But if Sean hadn't told me to confess, I never would have said anything. I'm so upset right now."

When I later asked Erenstoft whether he had pressured Nick to confess, he strenuously denied it. "Nick was adamant to tell his story to Goodkin," he emailed. "Nick reported he couldn't sleep and wanted to come clean—but most importantly, he said he wasn't going to go down alone and was obsessive about the fact that his cohorts were running free."

38

Nick had been texting me, sounding upset, when it was in the news that *Pretty Wild* was going to air in March 2010. "Should I be upset, because I kind of am," he wrote. And in another text: "I guess I'm mad because there [sic] using my misery and making profit off it." And in another: "Please tell me this crap isn't getting ratings! What is the world coming to?? :)."

The fame monster was raging and leaving him out of the limelight. He seemed even more perturbed when the Lifetime movie *The Bling Ring* was announced in the spring of 2011. "I had no prior knowledge of this and am not affiliated in any way," Nick told TMZ. "I want to sue if possible." (He never did.) Meanwhile, Tess Taylor asked the gossip website, "Where's the casting? I want to audition for the role."

The Lifetime movie, which aired on September 26, 2011, starred Austin Butler (formerly of *Zoey 101*) as a kid who appeared to be based on Nick and Jennifer Grey as his Melva-Lynn Prugo–like mom. The last lines in the last moment of the film gave me

pause. They seemed to glamorize what the Bling Ring had done, in a way, by suggesting that having access to a certain lifestyle was irresistible, no matter what the costs. Butler, as the Nick character, stares into the camera in his computer screen and says, "I got to be a completely different person"—cut to images of him wearing stylish clothes, partying in nightclubs. "I was the cool one. I had friends. All I had to do was go through. . . ." He'd been talking about going through the "door" of his computer screen, on the other side of which there was another glamorous dimension, full of celebrities.

"Wouldn't you?" he asks.

39

Sofia Coppola didn't seem at all worried that Lifetime was doing a movie with the same name, on the same subject as the one she was working on. "Oh," she said when I spoke to her after it came out. "I didn't watch it."

In March 2012, she began filming in Calabasas. When I was in L.A., I went out to watch her film one day. It was striking how very much the set of "Nicki's house" was like Alexis' house, complete with Buddhist statues and a brass gong. Nicki was being played by Emma Watson, the then 21-year-old star of the Harry Potter films. Watson, doe-eyed and beautiful, was outfitted like Alexis in a hot pink sweatsuit and Ugg boots. She told me she had been working with an accent coach on how to speak Valley Girl.

They filmed a scene where Nicki accepts a water delivery from a hunky water delivery guy, coming on to him, giving him sultry looks. Leslie Mann, as Nicki's mother, comes over and angrily zips up the front of Nicki's pink hoodie. "Back to work," Mann snaps, telling her daughter to come back and do more homeschooling; their lesson of the day: a study of their role model, Angelina Jolie,

complete with cutout magazine pictures of her on a "vision board." In a single moment, Sofia had managed to capture several of the themes we'd been talking about over the several months when she was writing the script.

(The real Alexis, by the way, had signed on as a consultant to the film, and seemed to be getting excited about seeing herself portrayed; she'd been re-tweeting Emma Watson's tweets about Nicki, including this one: "Nicki likes Lip Gloss, Purses, Yoga, Pole Dancing, Uggs, Louboutins, Juice Cleanses, Iced coffee and Tattoos.")

I had lunch with the cast and crew out in the backyard on picnic tables. Sofia told me she had met with Nick to hear his story. "He wanted us to send a car service to pick him up like he was a celebrity," she said smiling.

Before I left the set that day, Sofia told me that Brett Goodkin was coming out the next day as a consultant on the scene where Nicki is arrested.

40

Goodkin—who in the last year had been promoted from officer to detective by the LAPD—had been hired as a consultant on *The Bling Ring*, but the plan was never to have him appear onscreen. He was just supposed to oversee the scenes of the Bling Ring defendants' arrests and make sure that everything was done according to the LAPD's procedures. Coppola had met with Goodkin previously in L.A. in order to interview him about the case. But on the day he came to the set, it occurred to her and her producers that Goodkin, with his big frame, shaved head, and actual cop clothes, had such a classic cop look that it might add something to the scene. They asked him if he would like to do it and he agreed. He would not be playing "himself," but a random cop on the scene.

Goodkin went through the motions of arresting "Nicki," just

as he had arrested some of the real Bling Ring defendants in real life (Prugo, Lopez, and Ames). He came into the house, gruffly told Nicki's mom (Leslie Mann) to secure the dog (a Yorkshire terrier). Goodkin, an eight-year veteran of the force, had had another life as a jazz musician and singer as well as a radio announcer, so he had some experience in the entertainment world. And he was a pretty natural actor, especially when he shoves a tearful Nicki into the back of a cop car by the back of the head.

The problem was that Goodkin didn't tell the L.A. District Attorney's Office that he had appeared in a film—a film that fictionalized an open case in which he was the lead investigator—and that he was a consultant on it. He apparently had mentioned his consulting work to his captain, but he never received the proper approval. When it somehow broke in the news that he had appeared in *The Bling Ring*, some of the lawyers for the other defendants jumped on this as a way to discredit Goodkin as a witness. David Diamond, the lawyer for Roy Lopez, subpoenaed payroll records from *The Bling Ring* production office, which revealed that Goodkin had received $12,500 for his consulting gig rather than the $5,000 to $6,000 he had told his bosses. " 'Bling Ring' Consulting Cop, Could Have Inadvertently Ruined His Own Case," said The Huffington Post. Goodkin became the subject of an internal investigation and was placed on desk duty.

"His judgment is as poor as it gets," Superior Court Judge Larry P. Fidler said in court on July 20, 2012, responding to Diamond's motion to have the entire case dropped due to Goodkin's allegedly "outrageous" and "egregious" behavior.

"It's not outrageous. It's not flagrant. It's not egregious," Fidler said. "It's stupid. You can have a field day with him."

"My client would certainly agree that in retrospect he was ill-advised, but nothing my client did impaired the integrity of the prosecution," said Ira Salzman, Goodkin's lawyer.

"Goodkin's media attention went to his head," said Robert

Schwartz, Courtney Ames' attorney. "He got too big for his britches. He thought he was impervious to everything. As the case unfolded in the court system, Goodkin was seen as a hero in the district attorney's office because he was the guy who put this case together. But eventually that picture started to crack. He was reading his own press clippings."

"I get what the D.A.'s upset about," Goodkin told me on the phone. "But the hyperbole never subsided, I do get what they're pissed about it—I messed up. But it has nothing to do with the facts [of the case]. It has to do with perception. I was never alone with any of these people," meaning the defendants. "Whenever we interviewed anyone, there were about six of us sitting there. Nothing happened in darkness. It was not me against a crime ring—it was me and many detectives."

But perception seemed to be on the District Attorney's mind. The prosecution, led by Deputy District Attorney Barbara Murphy, now seemed to back down in the wake of Goodkin's blunder. In the latter half of 2012, the three remaining defendants in the case—Tamayo, Ames, and Lopez—were all handed exceptionally good deals. "The D.A. actually came back to us with a better deal than what we had counter-offered," said Behnam Gharagozli, Tamayo's lawyer. "I was a little shocked, but really happy for my client."

On October 19, 2012, Tamayo pleaded no contest to one count of residential burglary of Lindsay Lohan and received three years probation and 60 days of roadwork. (Her current immigration status is unclear.)

On November 8, 2012, Roy Lopez pleaded no contest to one count of receiving stolen property and was sentenced to three years supervised probation plus time served in the county jail. "You got a break because of what's happened with this case," Judge Fidler told Lopez from the bench, apparently referring to the Goodkin mess.

"This was a joke at the end of the day," said one of the other lawyers in the case. "If this were in any other court in any other

county, the D.A. would have shrugged and said, 'And?' about that
stuff with Goodkin. The offers would have gotten a little bit better,
but not this much better. The L.A. District Attorney's office was
worried about their image, so they just tried to sweep everything
under the rug." (Jane Robison, the publicist for the D.A.'s office,
had no comment.)

And then there was Courtney Ames. On December 14, 2012,
Courtney pleaded no contest to one count of receiving stolen
property—it was that leather Diane Von Furstenberg jacket of Paris
Hilton's, the one Courtney's wearing in the photograph from Les
Deux, the same jacket Nick Prugo said she stole from one of those
early missions to Paris' house in the fall of 2008, when the Bling
Ring had first discovered "going shopping."

Courtney received three years supervised probation. "You
caught a break and you know it," Judge Fidler told Ames in court,
again referring to the Goodkin affair.

"The prosecution never developed the position that Courtney
Ames entered the home of any of the crime victims," said Robert
Schwartz. Courtney is now back at Pierce College and "getting
straight As," according to her stepfather, Randy Shields.

41

"Goodbye world," Nick tweeted on April 15, 2012, before entering
the Twin Towers Correctional Facility in L.A. His $200,000 bond
had reportedly been revoked by his parents, who had formerly put
their house up as collateral. It seems they had grown frustrated
with Nick's repeated drug use (he'd been in and out of rehab pro-
grams since being arrested) and thought jail might be the best place
for him until he was sentenced.

Nick had pleaded no contest on March 2, 2012, to two counts
of residential burglary for Audrina Patridge and Lindsay Lohan.

His plea deal was two years. "My hope is to keep him in the local jail as much as possible," his attorney, Markus Dombois, told me. "I hope it drags out and Nick, with good time credits, will only serve a year."

Before he went into jail, Nick came out to his parents, according to his other lawyer, Daniel Horowitz. "Nick is gay and being able to say it and say it to his parents was a tremendous watershed for him," Horowitz emailed. "He believes that keeping this hidden led him to act in ways that were self-destructive, e.g., the drinking, partying, trying to seem important, etc. He came out to his parents and there was no resistance by them. They were immediately and tremendously accepting. This is not just Nick saying it. Shortly afterward, I was with Nick and his dad. His dad was so supportive that it touched me . . . a lot."

"It's like this whole Bling Ring thing was one long complicated way of coming out for him," said a friend of mine who's gay. "It's sad."

42

Rachel Lee is now living in the California Institution for Women in Corona, California (she was originally sent to Valley State Prison in Chowchilla, but was later transferred). On September 24, 2011, she pleaded no contest to one count of burglary of Audrina Patridge, and was sentenced to four years in prison. "The last two years of my life have changed me from an irresponsible and childish drug and alcohol addict towards becoming a responsible adult," Rachel wrote in a letter to Judge Larry Paul Fidler before she was sentenced. "I was really messed up from so much substance abuse as well as poor choices of friends."

At CIW, Rachel may be doing clothing and textile manufacturing, making shirts, shorts, jeans, smocks. Or she may be learn-

ing construction. She may be taking computer training or adult education classes. She may be involved in the Drug Treatment and Diversion program or the Prison Puppy program.

Before entering jail, Rachel reportedly received some coaching from Wendy Feldman, a celebrity "prison consultant" and founder of Custodial Coaching. Feldman has appeared on *Today, Nancy Grace*, and other news programs. CBS Radio called her the "go-to girl" for people going into custody.

Just before Rachel entered jail on October 21, 2011, Feldman gave an interview to Fox News' FOX411 Pop Tarts column online. "[Rachel] is a very little scared girl, and she had a drug problem, a self-esteem problem," she said. "Rachel is also extremely shy and this gang became a way for her to make friends. It became a rush and it was so easy, but obviously she has learned a lesson. . . . Rachel has gotten lots of therapy; she's gotten clean and sober and become much closer to her mom. She has taken full responsibility for her actions.

"To be honest, Rachel has a learning disability," Feldman went on. "She doesn't have a particularly high I.Q. and I find it hard to think she could have been the one to instigate the whole thing. She wants nothing to do with the movies or with the media. She accepts full responsibility for what she has done, but she was a young girl who was absolutely fascinated by celebrities."

The Rachel who had been described to me by multiple sources—schoolmates, friends, co-defendants, cops—didn't sound that dumb. I wondered if, faced with the daunting prospect of jail, Rachel was playing the helpless "pretty girl," again, as Nick said she did when she needed things to go her way. Feldman's characterization of Rachel's motivation also sounded a lot like what Nick had been promoting about himself with journalists—including me: she did it because she had a drug problem, she did it to make friends, it wasn't her idea.

Although she has never spoken to a reporter, Rachel has al-

ready been depicted in two films: Lifetime's *The Bling Ring* (2011), and Sofia Coppola's *The Bling Ring* (2013). In neither film does she appear to be shy or unintelligent. Without ever saying a word to anyone, Rachel came to symbolize the spoiled, celebrity-obsessed American teenager. It will be interesting to see, when she comes out of jail, if she has anything to say about that.

43

In April 2012, then 20-year-old Alexis married a handsome 37-year-old Canadian businessman, Evan Haines, in Mexico, in front of 20 guests. She told *E! News* they had met in Alcoholics Anonymous. "It's amazing to be in a happy marriage with such a loving husband," Alexis tweeted in October of last year. She was already pregnant. She Instagrammed a picture of her "baby bump," as the celebrity magazines call it. "I felt like I've always had motherly instincts," she told E! Online. "So it's been a very joyous experience."

Alexis seemed to have come a long way since she spent time in jail. After she was busted for probation violation on December 1, 2010, and found to have black tar heroin in her home, she was sentenced to a year in rehab. She checked into the SOBA Recovery Center in Malibu, a celebrity rehab center, that same month. She seemed to take her recovery seriously, vlogging about it frequently, sharing her tips for staying sober with her "fans."

And then in December 2011, Alexis declared that she had been sober for a year and had completed a course to become a drug and alcohol counselor. She did a very candid interview with her former nemesis, Nik Richie of The Dirty, on his online Nik Richie Radio. Richie was the one who had posted pictures of both Alexis and Tess smoking Oxycontin from a bong. He's sort of a wannabe Howard Stern, a tough-talking exposer of pseudo-celebrity secrets.

"I was a drug addict," Alexis admitted on his show. She said that she had had her first drink at 12, and that by her teens she had become a user of "I.V. heroin, I.V. cocaine, major Valium, major Adderrall." She said that she was "drinking, drinking, drinking, it was out of control.... I was major into Oxies"—the pill form of Oxycontin.

"I was smoking twenty eighty-milligram Oxies a day," Alexis said. During the filming of *Pretty Wild*, she said, she was actually living "at a Best Western at Franklin and Vine," staying in the hotel room and doing drugs with her "user friends."

"Yeah, but you were famous," said Richie.

"I don't even call myself famous, I was a fucking drug addict," said Alexis.

"It was about getting as far from reality as possible," she said. "Drugs and alcohol were" a way of "seeking acceptance. That goes hand in hand with this whole celebrity thing.... Our culture as a whole idolizes this behavior." She attributed her problems to the sexual abuse she said she had experienced as a child by a person close to her family; and to the influence of Tess: "We are like fire and gas."

Alexis seemed almost like a different person now. The squeaky baby voice was gone. The spiritual clichés had vanished. She seemed sober. And then Richie started asking her about her involvement in the Orlando Bloom burglary—for which Alexis had already done her time.

"I was not there for it," she said flatly. She denied that the LAPD had ever found any stolen items in her house. She said she was "not on any surveillance" footage. "I only knew Nick [Prugo] for four months really, during this whole thing," she said.

44

"I'm in this recovery journey and it's been an incredible learning experience for myself," Alexis had said in one of her post-rehab blogs. She was sitting on her bed, wearing a blank tank top, showing off an armful of new tattoos. She looked as glamorous as ever, if in a different mode. She was recovery Alexis. She was styled like her idol, Angelina Jolie.

"I *know* who I was," Alexis said of her former incarnation. "I was a dope fiend, alcoholic, lying, cheating girl, and it was not a pretty picture by any means."

And then she started talking about Tess. "It's nice when you find out stuff about your sister on a media outlet," Alexis said, laughing softly. She was referring to how TMZ had reported that Tess had been arrested in January 2012 for drug possession. Alexis said she hadn't spoken to Tess since Tess left the SOBA Recovery Center, where she had briefly spent time in 2011 getting help for her own addiction problems. "I'm really, really happy to say Tess checked herself into treatment again," Alexis said. "She checked into the Pasadena Recovery Center....TMZ did another story about that. She's not doing the whole celebrity rehab thing. I've gone to visit her several times now and I can really see the growth and the change and the lightbulb really starting to turn on. And it's really an incredible thing to watch. To see someone really getting to know who they are is a beautiful, beautiful thing."

Alexis tweeted that she's having a daughter.

AUTHOR'S NOTE

In researching this book, I relied on many sources, including L.A.P.D. officers, officials in the L.A. District Attorney's office, and defendants in the Bling Ring case, including Nick Prugo, Alexis Neiers, and Courtney Ames. I spoke to their friend Tess Taylor, as well as Alexis' mother, Andrea Arlington Dunn; her father, Mikel Neiers; and her sister, Gabrielle Neiers. I interviewed Ames' stepfather, Randy Shields, and Elizabeth Gonet, the mother of co-defendant Jonathan Ajar. I interviewed friends and classmates of several of the defendants. I spoke to lawyers for all of the defendants, sometimes multiple lawyers for a single defendant.

As further sourcing I used police documents such as the L.A.P.D.'s report on the case and search warrants for the defendants' homes. I viewed surveillance footage of the burglaries at the homes of Audrina Patridge and Lindsay Lohan, which were made available publicly, and Orlando Bloom, which was shown to me by an L.A.P.D. detective. I read the Grand Jury proceedings which took place in June of 2010, at which all of the celebrity victims testified. I used accounts from newspapers, magazines, and online news outlets.

I did not speak to Rachel Lee, although I made many attempts to do so through her lawyer, Peter Korn. I spoke to Korn only once, when he told me that he did not wish to participate in any media regarding the case, and did not want his client, Lee, to do so either. The case against Lee is detailed in the Grand Jury proceedings and in the report of the L.A.P.D.'s investigation. I sent Lee a letter to

her prison address, asking her to respond to allegations made in those documents as well as allegations made by other sources, but she did not respond. I sent letters to Lee's mother and father, Vicki Kwon and David Lee, neither of whom responded.

I have relied here on interviews I did with Nick Prugo in the fall of 2009. I communicated with Prugo in person and, later, by telephone and text messages. As Prugo was himself charged in multiple burglaries, his credibility as a witness was called into question by some of the lawyers for other defendants. However Prugo's confession was the basis for the L.A. District Attorney's case, and his testimony led to the discovery of stolen goods in some of the defendants' homes. The participation of some of the defendants in the burglaries was then verified by other police work.

I relied very little on Detective Brett Goodkin in telling this story, mostly via the L.A.P.D.'s report on the case, which Goodkin wrote. The report was not his work alone, however, but the product of several other detectives on the case, including Detectives Steven Ramirez and John Hankins. The basis for the report was largely Nick Prugo's confession, which, again, was a jumping-off point for further investigation.

In the last year Goodkin has been the subject of media attention and criticism from some of the attorneys in the case for having appeared in Sofia Coppola's film, *The Bling Ring*. However, several of the lawyers involved told me that they did not think Goodkin's movie appearance diminished the credibility of his police work. "Goodkin's movie participation has nothing to do with his conduct at the time," wrote Daniel Horowitz, Prugo's current lawyer, in an email. "I'm still not sure what he did wrong. Certainly he did nothing that would affect his investigation of the case."

The Bling Ring case, involving several teenage defendants, became one of "he said-she said," as criminal cases often do. De-

fendants made allegations about each other's participation in the burglaries. As I researched, I made all of the defendants aware of any allegations that were being made against them, and gave them an opportunity to respond. In some cases their lawyers chose to respond and in other instances they declined.

BIBLIOGRAPHY

Blake, Jeanne, Collins, Rebecca L., Lamb, Sharon, Roberts, Tomi-Ann, Tolman, Deborah L., Ward, L. Monique and Zurbriggen, Eileen L. *Report of the APA Task Force on the Sexualization of Girls.* Washington, D.C.: American Psychological Association, 2010.

Campbell, W. Keith and Twenge, Jean M. *The Narcissism Epidemic: Living in the Age of Entitlement.* New York: Atria Books, 2010.

Corner, Lena. "Teenage Kicks: How the 'bling ring' gang used Twitter to burgle Hollywood homes." *The Independent,* June 2, 2012.

Ebner, Mark. "Breaking Into Hollywood." *Maxim,* December 14, 2009.

Freeland, Chrystia. *Plutocrats: The Rise of the New Global Super-Rich and the Fall of Everyone Else.* New York: Penguin Press, 2012.

Ghebremedhin, Sabina, DuBreuil, Jim and McNiff, Eamon. "Exclusive: Inside Hollywood's Bling Ring." *ABCNews.go.com,* March 4, 2010.

Greenwald, Glenn. *With Liberty and Justice for Some.* New York: Metropolitan Books, 2011.

Guinn, Jeff. *Go Down Together: The True, Untold Story of Bonnie and Clyde.* New York: Simon & Schuster, 2010.

Halpern, Jake. *Fame Junkies: The Hidden Truths Behind America's Favorite Addiction.* New York: Mariner Books, 2008.

Hine, Thomas. *The Rise and Fall of the American Teenager.* New York: Harper Perennial, 2000.

Hoff Sommers, Christina. *The War Against Boys: How Misguided*

Feminism Is Harming Our Young Men. New York: Simon & Schuster, 2001.

Inglis, Fred. *A Short History of Celebrity.* Princeton: Princeton University Press, 2010.

Kindlon, Dan. *Too Much of a Good Thing: Raising Children of Character in an Indulgent Age.* New York: Miramax, 2003.

Kindlon, Dan and Thompson, Michael. *Raising Cain: Protecting the Emotional Life of Boys.* New York: Ballantine Books, 2000.

LaPorte, Nicole. "The Kids Who Robbed Hollywood." *TheDailyBeast,* October 26, 2009.

Lasch, Christopher. *The Culture of Narcissism: American Life in an Age of Diminishing Expectations.* New York: W. W. Norton & Company, 1979.

Lee, Ken, and Dodd, Johnny. "Burglary Suspect's Dad: Daughter Caught Up In 'Bad Situation.'" *People,* October 26, 2009.

Lewis, Michael. *Liar's Poker.* New York: W. W. Norton & Company, 2010.

Marshall, P. David. *The Celebrity Culture Reader.* London: Routledge, 2006.

Massarella, Linda, Dahl, Julia, and Venezia, Todd. "Teen gang busted in celeb burglaries." *New York Post,* October 24, 2009.

McVeigh, Tracy. "Can Iceland lead the way towards a ban on violent online pornography?" *The Observer,* February 16, 2013.

Mintz, Steven. *Huck's Raft: A History of American Childhood.* Cambridge: Belknap Press of Harvard University Press, 2006.

Orenstein, Peggy. *Cinderella Ate My Daughter: Dispatches from the Front Lines of the New Girlie-Girl Culture.* New York: Harper Paperbacks, 2012.

Palladino, Grace. *Teenagers: An American History.* New York: Basic Books, 1997.

Paul, Pamela. "From Pornography to Porno to Porn: How Porn Became the Norm." "The Social Costs of Pornography" conference at Princeton University, December, 2008.

Payne, Tom. *Fame: What the Classics Tell Us About Our Cult of Celebrity*. New York: Picador, 2010.

Piazza, Jo. *Celebrity, Inc.: How Famous People Make Money*. New York: Open Road, 2011.

Pinsky, Drew and Young, S. Mark. *The Mirror Effect: How Celebrity Narcissism Is Seducing America*. New York: Harper, 2009.

Sales, Nancy Jo. "Hip Hop Debs." *Vanity Fair*, September, 2000.

———. "Hugh Hefner's Roaring 70s." *Vanity Fair*, March, 2001.

———. "Lindsay Lohan Adrift." *Vanity Fair*, October 2010.

———. "Make Moves, Blow Up, Get Paid." *New York*, August 24, 1998.

———. "Prep School Gangsters." *New York*, December 16, 1996.

———. "Sex and the High School Girl." *New York*, September 29, 1997.

———. "The Suspects Wore Louboutins." *Vanity Fair*, March, 2010.

Salkin, Allen. "Going for the Bling: Hollywood Burglars." *The New York Times*, November 13, 2009.

Sax, Leonard. *Boys Adrift: The Five Factors Driving the Growing Epidemic of Unmotivated Boys and Underachieving Young Men*. New York: Basic Books, 2009.

———. *Girls on the Edge: The Four Factors Driving the New Crisis for Girls—Sexual Identity, the Cyberbubble, Obsessions, Environmental Toxins*. New York: Basic Books, 2011.

Simmons, Rachel. *Odd Girl Out, Revised and Updated: The Hidden Culture of Aggression in Girls*. New York: Mariner Books, 2011.

Spalding, Peter J. "The Strange Case of Leopold and Loeb: Part One." *ChicagoHistoryJournal.com*, March 11, 2011.

Sternheimer, Karen. *Celebrity Culture and the American Dream: Stardom and Social Mobility*. London: Routledge, 2011.

Twenge, Jean M. *Generation Me: Why Today's Young Americans Are More Confident, Assertive, Entitled—and More Miserable Than Ever Before*. New York: Free Press, 2007.

Walter, Natasha. *Living Dolls: The Return of Sexism.* London: Virago UK, 2011.

Wiseman Rosalind. *Queen Bees and Wannabes: Helping Your Daughter Survive Cliques, Gossip, Boyfriends, and the New Realities of Girl World.* New York: Three Rivers Press, 2009.

ACKNOWLEDGMENTS

Many thanks to my editor Carrie Thornton for suggesting this book and for all her great questions and answers which helped me figure out how to make it work. Thanks too to Sofia Coppola for seeing something bigger in the story, which became her wonderful film. Thanks also go to my agent Sarah Burnes for taking me through the process of book writing for the first time, for her humor and unfailing support.

Much gratitude also goes to Graydon Carter for assigning the Bling Ring story and for his incredible kindness over the years, and to Dana Brown, my editor at *Vanity Fair*, for editing that story and for always encouraging me to be myself.

Thanks also to Jenny Allen, a talented writer whom I was lucky to have as a fact-checker and confidant. Thanks to Brittany Hamblin at HarperCollins for all her help with acquiring photos and generally making things happen.

Thanks to my sparkling daughter Zazie for putting up with many nights of take-out from Wild Ginger when I was busy working, and for keeping me laughing and dancing. And thanks to my darling Henry for saying "yes, you can," when I was worried that I couldn't. Thanks to my mom Alice and my dad Ronny (may he rest in peace) for everything, especially teaching me how to work hard (and not burgle). Thanks to my dear friend Calvin Baker, a great writer, for all his good advice, and my late friend Donald Suggs for talking me through this story even on the night he died, making me laugh on the phone by saying, "This is upper-middle-class crack-head behavior." I miss his wisdom and bon mots.